# Landscape Painting

### Konstantin Bazarov

Octopus Books Limited

First published in 1981 by Octopus Books Limited
59 Grosvenor Street, London W1

© 1981 Octopus Books Limited

ISBN 0 7064 1230 3

Produced by Mandarin Publishers Limited
22A Westlands Road,
Quarry Bay, Hong Kong

Printed in Hong Kong

BAZAROV, Konstantin

Landscape Painting

758.1

# Landscape Painting

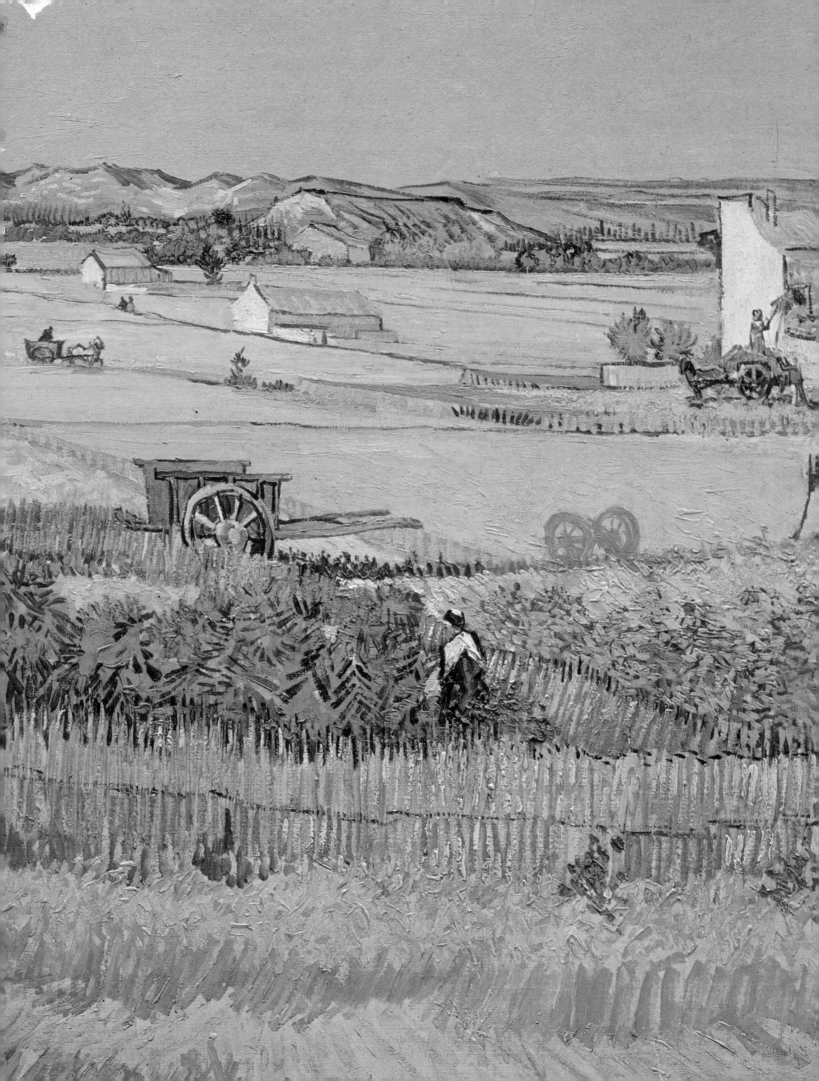

# Contents

*Title page* Vincent van Gogh (1853–90), *Harvest – The Plain
of La Crau*, June 1888 (detail, complete painting p. 162).
Rijksmuseum Vincent van Gogh, Amsterdam.

*Contents page* Claude (1600–82), *Pastoral Landscape with
Cephalus and Procris*, 1645 (detail, complete painting p. 47).
National Gallery, London.

# Author's Preface

It is surprising that there is really only one work in any language that attempts to consider European landscape painting as a whole – Kenneth Clark's *Landscape into Art*, first published in 1949. The reason for this neglect of such an apparently obvious subject probably lies in the fact that investigating why landscape painting is such a late development in European art, and why it then flowered so vigorously, involves grappling with some basic and puzzling questions about art, society and nature.

Landscape painting and nature poetry have played such a significant role in European culture in the recent past that it may seem at first sight that the emotional response to nature embodied in them is an instinctive one. That this is not the case was first emphasized by Ruskin in the 19th century. His great five volume work *Modern Painters* began as an attempt to show that Turner was the supreme landscape painter. But by the time he came to write the third volume of that book, Ruskin had realized that the appreciation of nature was something quite new in European culture, as if mankind had almost acquired a new sense.

Ruskin here threw down a challenge which all later writers on landscape painting must face. Was this development really new in European culture, and if so how and why did it occur? Kenneth Clark rightly made this the starting point of his own investigation, which was, however, confined to European Art.

But one of the key questions I set out to explore is why landscape painting developed so much earlier in China and had become absolutely central to the whole tradition of Far Eastern art – the very reverse of the situation in Europe. Such differences show clearly that responses to nature are cultural rather than instinctive, and the development of landscape painting in Europe can then be seen to result from profound changes in European attitudes to the natural world. This was, indeed, just one aspect of a human adventure which included the scientific revolution and the European voyages of exploration, both of which made possible the European domination of the world.

The essential paradox is that the appreciation of nature which is reflected in landscape painting and nature poetry has developed along with an unprecedented destruction of the environment. Yet Leonardo provides a brilliant example of the artist's emotional response to nature being closely linked with that curiosity about the processes of movement and change in the natural world which is at the root of science. And many of the Romantic poets and painters were accomplished naturalists, who were not so much anti-scientific as opposing an organic view of nature to the reductionist view of the universe

as a giant clockwork mechanism – a view which has itself been rejected by the revolution in 20th century physics. The recent development of environmental art shows how the issue of man's relationship to nature which is at the centre of landscape painting remains of crucial relevance, with implications far outside the sphere of art history.

KONSTANTIN BAZAROV

6

# Foreword

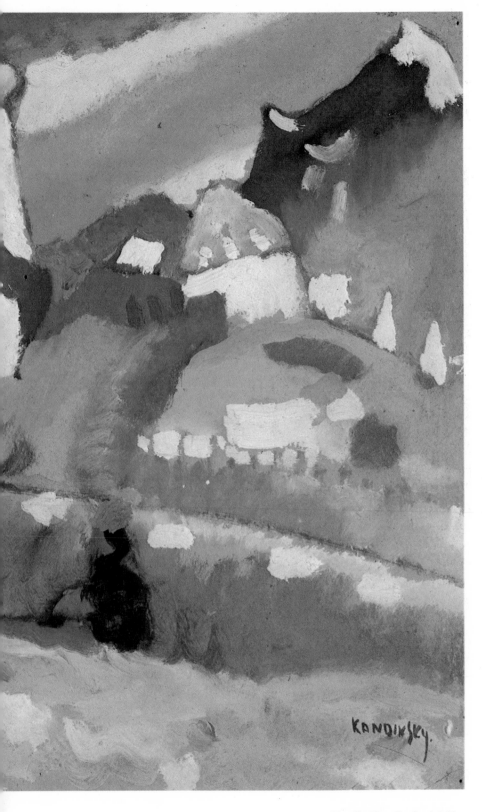

by Sir John Rothenstein, CBE, KCSG

This is a wide-ranging and in several respects an original book. One of its most interesting features is the way it demonstrates the effect upon landscape painting of questions not usually related to the arts at all. The author relates art to the history of ideas – science, politics, literature and other subjects. Indeed, one of the book's qualities derives from the author's wide reading in several languages. Another is that although due attention is given to the masters there are many lesser known artists, at least in the English speaking countries, Caspar David Friedrich and the Chinese painter-poet Wang-Wei among them, whose significance is emphasized.

Dr Bazarov's broad approach is summed up in the opening paragraph, in which he quotes Darwin's champion T. H. Huxley: 'The question of questions for mankind – the problem which underlies all others, and is more interesting than any other – is the ascertainment of the place which man occupies in nature and of his relation to the universe of things'.

JOHN ROTHENSTEIN

Vassily Kandinsky (1866–1944), *Winter Study with Church*, c. 1910–11. The Soloman R. Guggenheim Museum, New York.

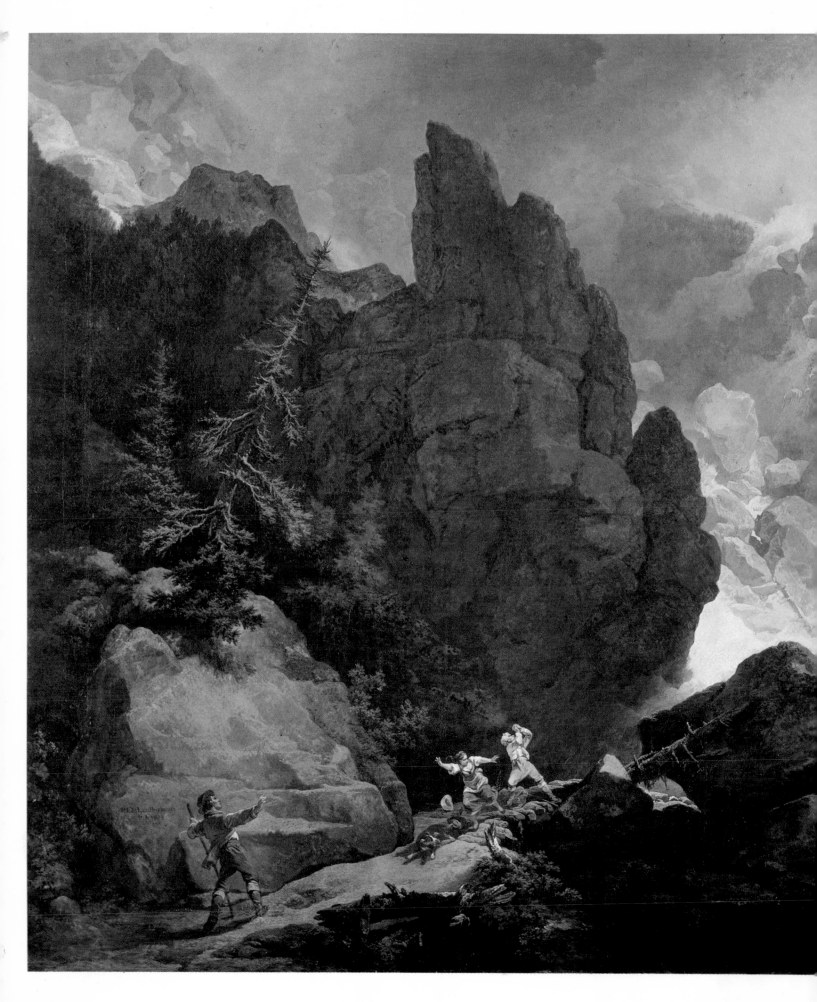

# Chapter One
# Changing Attitudes to Nature

Philip James de Loutherbourg (1740–1812), *An Avalanche in the Alps.* Tate Gallery, London. This is a typical painting of the 'Sublime', a magnificent image of the awe-inspiring ferocity of nature and the powerful forces at work in it. In striving to show these natural forces in action, de Loutherbourg in other works felt the need to go beyond the effects possible with oil paint, anticipating the moving pictures of the cinema with his device called the Eidophusikon. This was a miniature stage with moving scenery, dramatic lighting and sound, with which he entertained the public with shows of 'Various Imitations of Natural Phenomena, represented by Moving Pictures'. Its admirers included Gainsborough, who helped in working the effects, which included thunder-storms, shipwrecks, Alpine hunting scenes, and the Niagara Falls. Before it was burnt down early in the 19th century it had inspired a whole family of panoramas showing majestic nature at work.

9

'The question of questions for mankind – the problem which underlies all others, and is more interesting than any other – is the ascertainment of the place which man occupies in nature and of his relation to the universe of things.' So wrote Charles Darwin's great champion T. H. Huxley at the height of the controversy over evolution, which first defined man himself as a product of nature, not – as Christianity had insisted – a special creation with dominion over it. And man's place in and relationship to nature remain central questions, even more so now that millions of people live in cities and our despoilation of the natural world has created an ecological crisis.

The history of landscape painting reflects man's changing attitudes to nature. In the European tradition the appreciation of nature as scenery to be contemplated with awe or delight, and along with it the rise of a true school of naturalistic landscape painting, was a surprisingly late development which began only with the Renaissance. Enthusiasm for wild and mountainous scenery, which was associated with the idea of the 'Sublime' – the exhilarating terror inspired by precipitous crags, roaring waterfalls, rushing torrents – came even later, only during the last half of the 18th century. Earlier attitudes were thoroughly unromantic, typified by Dr Johnson's distaste for the 'hopeless sterility of the Scottish Hills', which had been 'dismissed by nature from her care'. But later English travellers, as they passed through mountains such as the Alps on the Grand Tour, would stand in awe gazing at these embodiments of the wild, grand and terrifying aspects of nature.

These feelings, and the painting and poetry which expressed them, were something completely new in European thought. The medieval attitude was quite different, for the idea of contemplating nature for enjoyment or for enlightenment had not developed in Europe as it had in China and Japan, except for the period in the classical world when Greek science had flourished. To the medieval mind, forests and mountains were associated rather with thieves, wild animals, and superstitious dread of the unknown. The Italian poet Petrarch's ascent of Mount Ventoux in 1335 became famous because it was so unusual for a European to go up a mountain just to look at the view. Petrarch was in many respects, including his curiosity and scepticism, one of the first modern European men. But even he took with him a copy of St Augustine, which reminded him that for the Christian the proper object of admiration was the spiritual rather than the physical world.

St Augustine *did* regard the natural world as God's creation, for Christianity has always just drawn back from the sort of Manichean dualism which regards it as the creation of the Devil. Indeed, the Biblical tradition still retains something of the ancient and universal nature mysticism which made mountains like Olympus and Parnassus the homes of the gods; for example,

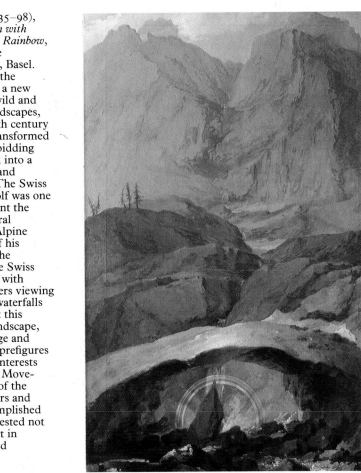

Caspar Wolf (1735–98), *Mountain Stream with Bridge of Ice and Rainbow*, 1778. Öffentliche Kunstsammlung, Basel. The aesthetic of the 'Sublime' meant a new enthusiasm for wild and mountainous landscapes, so that in the 18th century the Alps were transformed from a dark, forbidding obstacle to travel into a source of visual and emotional awe. The Swiss artist Caspar Wolf was one of the first to paint the spectacular natural wonders of the Alpine scenery. Some of his paintings show the beginnings of the Swiss tourist industry, with groups of travellers viewing the mountains, waterfalls and glaciers. But this extraordinary landscape, with its ice-bridge and glacial rainbow, prefigures the profounder interests of the Romantic Movement, for many of the Romantic painters and poets were accomplished naturalists, interested not just in a view but in natural forms and processes.

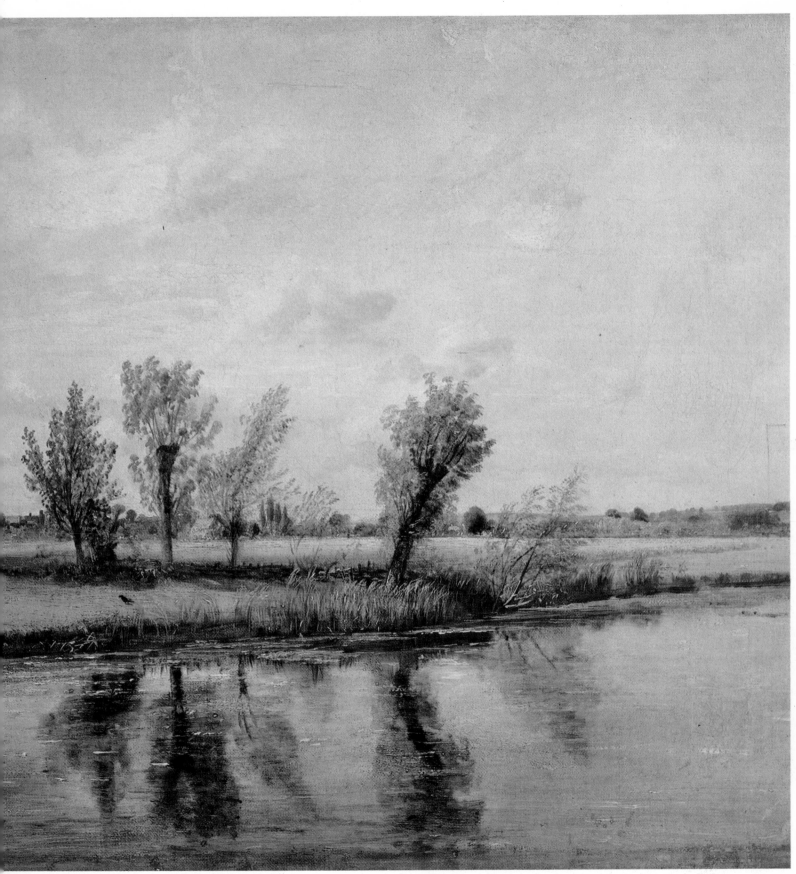

with the medieval revival, an attempt to regenerate German religious art which resulted in a brief flowering of inspired landscape. To these artists, as to Samuel Palmer and other followers of Blake in England, nature was a spiritual revelation, bringing an awareness of the infinite and the divine.

*Above* John Constable (1776–1837), *Watermeadows near Salisbury*, 1830. Victoria and Albert Museum, London. Constable's vision of nature, which now seems so natural that most people look at the English countryside through his eyes, was the result of a long struggle to see in a new way. This simple study of willows by a stream was part of his attempt to be a truly natural painter, but it was rejected by the Royal Academy as 'a nasty green thing'.

Ma Yuan (active 1190–1225), *Scholar by a Waterfall*. Album leaf. Ink and light colour on silk. Metropolitan Museum of Art, New York. Chinese painting has always centred on landscape, since no conception of a personal deity competed with the idea that natural beauty was itself divine. Nature and mountains were regarded as sacred because the cosmic forces, the energy and ceaseless renewal shaping the universe, are made manifest in them. To wander through the mountains was an act of meditation and adoration for the Chinese scholar, who was often also a poet, painter and philosopher. And the scholar contemplating a waterfall became a favourite subject because waterfalls thundering over the rocks are a vivid example of the hidden energies and forces of nature being made visible.

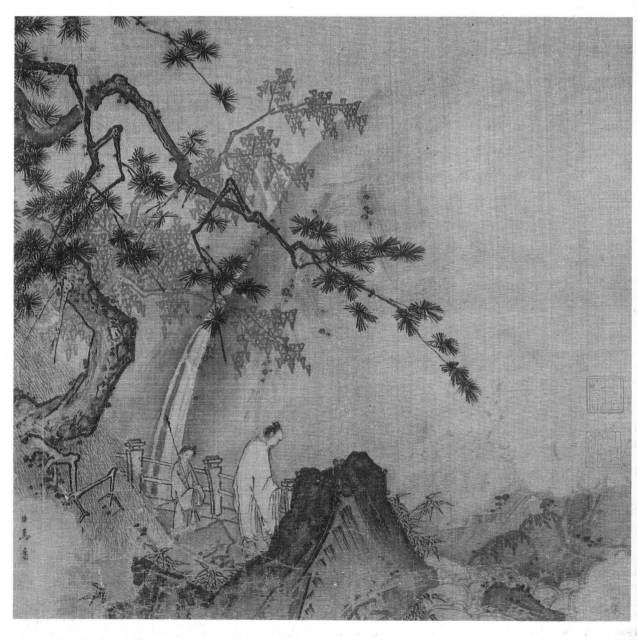

rejected any line of research involving mathematical equations he thought ugly, since he could not believe they would have any physical equivalent in the natural world. The idea that art helps to shape human consciousness does not of course imply that there is any progress in art in the aesthetic sense. The first artists, the Palaeolithic cave painters, made drawings whose expressive power would be difficult to rival. But the sort of change and evolution that does occur in art is particularly clear in the development of landscape painting, where innovations which were once revolutionary or even shocking, such as the Impressionist response to painting in the open air and observing the changing play of sunlight, become accepted once the public has learnt to see in the new way.

Constable's landscapes may now seem to represent a natural vision, because they played such a central part in the later development of art, and have done so much to create our image of English landscape, that it requires an imaginative effort to see just how revolutionary he was. Yet Constable, who was well aware of his struggle to see in a new way, himself said that 'the art of seeing nature is a thing almost as much to be acquired as the art of reading the Egyptian hieroglyphics.' And what now seems a natural and even obvious way of looking at nature would not have been possible for earlier artists, and resulted only from a long series of changes in ways of seeing.

Throughout most of his evolution man has been as much a part of nature as any other animal. But the growth of his brain and of consciousness, and thus the development of cultures, meant that he has no longer remained just a creature in a landscape, as all other animals are, but has become a shaper of the landscape, changing his surroundings to fit his requirements. The first artists, the cave painters who lived at the end of the Old Stone Age, were already expressing their relationship with the world about them by painting the animals on which they depended for food;

and it is commonly thought these paintings had some sort of ritual significance intended to ensure success in hunting. But with the domestication of plants and animals in the Neolithic Revolution man could change from being a hunter-gatherer to an agriculturist, and could eventually become – temporarily, at least – ruler of an earth which he is now polluting, despoiling and even in danger of destroying. This destructive process had already begun in the Neolithic, when improved hunting techniques led to what the American geologist Paul Martin has called 'prehistoric overkill' – the complete extinction of most of the larger mammals, including the mammoth, the woolly rhinoceros and the giant Irish elk, the last survivors of which were wiped out in Roman times.

Man has therefore become unique, for while other creatures are adapted to their environment, he is able to change it, and also able to explore nature both mentally and physically. And the fact that attitudes and responses to nature are cultural rather than instinctive is shown not only by changes over the course of time within the western cultural tradition, but also by the wide variations between different cultures.

In China, for example, the Taoist philosophy of man living in harmony with nature led to landscape painting becoming the major tradition, practised and encouraged by the scholar-officials who ran the Empire. Such men wrote poetry and painted with the same brush, the poems being written in beautiful calligraphy, often on to landscapes with which they fused to form an integral whole. And so the typical Chinese painting became a highly poetic scene which might show a mountain towering above the mist, and a tumbling waterfall that often vanishes into vaporous obscurity, with the tiny figure of a scholar-poet lost in rapt contemplation or raising his glass of wine in enjoyment. One crucial reason for this difference from the western tradition was the absence of a personal god in Chinese thought. Most early religious beliefs included a pantheistic or animistic response to nature as itself divine. But in the desert religion of the Hebrews, which became the ancestor of Christianity and Islam, the sky god gradually became a dominating patriarch, the authoritarian ruler of the tribe. In China, however, there was no such personal god to compete with the idea that natural beauty was in itself awesome and divine. Of course the Chinese were also concerned with life in society and the problem of its moral regulation. But they were unique in developing two complementary philosophies to appeal to the two basic sides of human nature. Man is, to use Dr Jacob Bronowski's convenient term, a 'social solitary'. He has remained what evolution made him, a social animal, and without the cumulative knowledge that societies build up, civilization would not be possible. Complementary to his social needs, however, man as a conscious being has strong individual needs, including the need to find purpose and meaning

Hua Yen (1682–1765), *An Autumn Scene*, 1729. Album leaf. Ink and colour on paper. Ch'ing dynasty. Freer Gallery of Art, Washington, D.C.
Chinese landscape painting is essentially poetic rather than naturalistic, aiming to catch a lyrical mood which is also often expressed in an accompanying poem written with the brush on to the picture. Here it is an evocation of autumnal feeling, as a scholar gazes contemplatively across the water at a distant peak, while the last few red leaves hang on the trees or drift down into the lake. Hua Yen was most admired in his own day for his pictures of animals, birds and flowers. But his landscapes were criticized by contemporaries for 'leaving out too much', since he simplified almost to abstraction in trying to catch the essence of a scene.

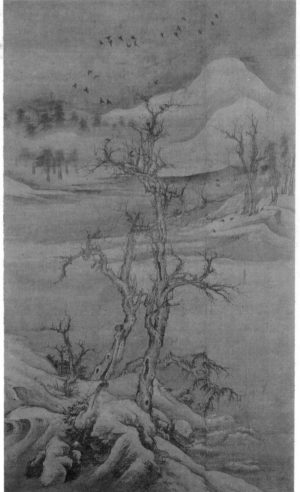

Lo Chih-ch'uan (active c. 1300–30), *Crows in Old Trees*. Hanging scroll. Ink and light colour on silk. Yuan dynasty. Metropolitan Museum of Art, New York.
Lo was one of the scholars who left the Chinese court after the Mongol conquest to retire to the mountains and live the life of a hermit. This painting is a vivid illustration of the dark mood of the times, for the artist uses a realistic style to convey a heavy sense of gloom and desolation. Bare wintry trees, contorted with spiky branches, rise gauntly from the snow-covered banks of the icy river. Pheasants and other birds huddle in the snow, pecking for food. And the sombre feeling is heightened by the sinister black crows perched in the trees and circling against the stormy sky.

*Right* Ch'ü Ting (active 1023–56), *Summer Mountains*. Handscroll. Ink and light colour on silk. Northern Sung dynasty. Metropolitan Museum of Art, New York.
This large handscroll, which was in the Chinese Imperial collection for 800 years, has always been regarded as one of the finest examples of the Northern Sung style of monumental landscape. It unrolls to give a panoramic view of range upon range of rugged mountains, deep gorges and tumbling waterfalls. The subject of such paintings is creation itself, the attempt to capture the energy and power of mountains thrust up by earth movements and volcanic action. Yet this nature is not alien to man, since along the lower slopes and rivers are tiny details of human activity – a woodman carrying a load, a traveller on a donkey, boats returning to a fishing village. And the prospect, seen on a summer evening, invites the viewer in to follow its meandering paths into solitude and communion with nature.

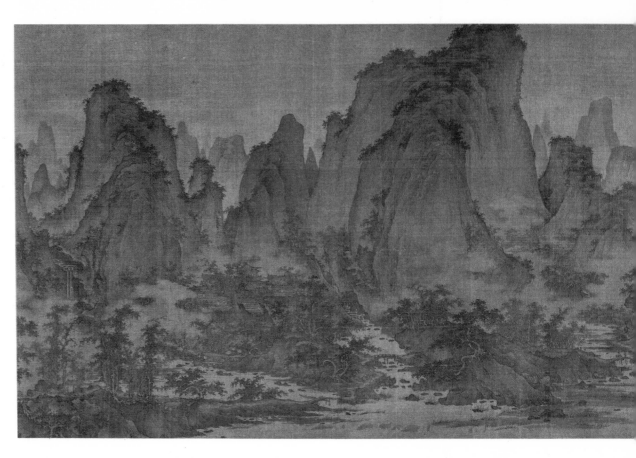

*Right* Follower of Hsia Kuei, *Windswept Lakeshore*, c.1250. Fan. Ink on silk. Southern Sung dynasty. Metropolitan Museum of Art, New York.
Whereas the landscapes of the Northern Sung painters depict the vastness of a nature which overawes the onlooker, those of the Southern Sung reflect the softer environment of the south, becoming more intimate, with closer views and larger figures.
*Windswept Lakeshore* is still a wild, rugged scene, but the fishermen are not dwarfed by the overhanging cliff and the windswept oak tree, which is exquisitely sketched in with tremulous brush strokes.

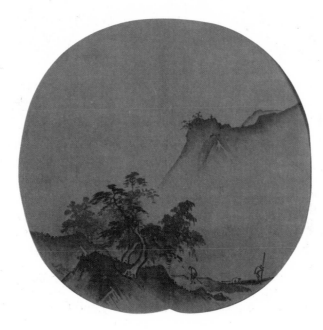

in life. All religions have developed mystical sides to satisfy those impelled to strive for higher states of consciousness. But in China during the 6th century BC these two complementary aspects of thought, the social and the solitary, crystallized into two philosophies: Confucianism, concerned above all with life in society, and Taoism, centred on the solitary contemplation of nature and the discovery of its *Tao* or way – how to live in intuitive harmony with the world of nature and the natural world of the instincts. Although these two philosophies represent opposite poles of thought, they have always been seen in Chinese thought as complementary, each appealing to deep-rooted human instincts.

It was Taoism which inspired Chinese nature poetry and landscape painting and the passionate love of scenery, especially wild mountain scenery, which went with them. Mountains and torrents were adored as part of a wild nature unsullied by man's scheming and competitiveness, into which the poet-painter could escape to restore his soul in contemplation. And so it was never simply the visual side of landscape that inspired Chinese artists, but the mood, the spiritual content of the scene: Chinese landscape was always essentially poetic. When Buddhism was introduced into China its attitude of reverence for life reinforced the Chinese love of nature. The first great poet who was also a great painter was Wang Wei, born in 701 and an exact contemporary of another great Chinese poet, Li Po, who wrote most of the poems which in German translation were set by Mahler as *The Song of the Earth*. Wang Wei was a Buddhist, and his strong feeling for nature infused both his writing and his landscapes; the two were so closely linked that they inspired a famous remark by the later poet-painter Su Shih: 'In his poetry there is painting, in his painting, poetry.' There have of course been a few great poet-painters in Europe, notably Michelangelo and Blake, but they were exceptions; indeed, Blake's painting has often been attacked by narrow-minded art critics as too 'literary'. But the aim of the Sung painters who regarded Wang Wei as their ancestor was precisely to embody in a landscape painting the sort of emotion caused by reading a poem.

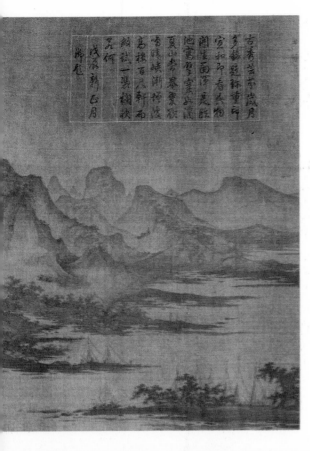

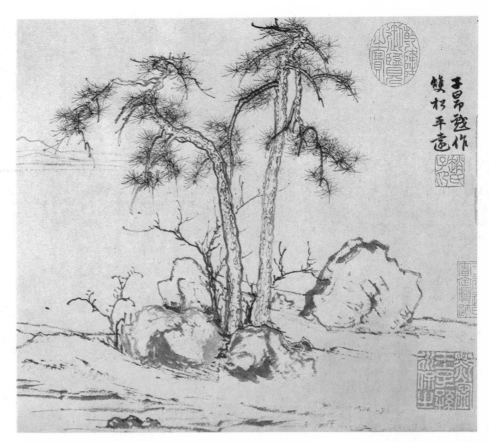

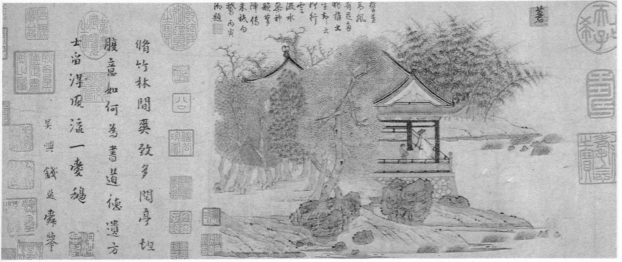

*Above* Chao Meng-fu (1254–1322), *Twin Pines*. Handscroll. Yüan dynasty. Metropolitan Museum, New York.
Chao abandoned the realistic intimacy of Southern Sung landscapes, with their illusionistic atmospheric effects, for an unromantic style whose austerity of mood verges on bleakness. In this superb evocation of a pair of spiky pines the painter has admirably achieved his aim not of describing nature but of acting out the characteristics of the trees, achieving a heightened sense of life energy in the very physical act of drawing.

*Left* Ch'ien Hsuan (c.1235–1300), *Wang Hsi-chih Watching Geese*. Handscroll. Metropolitan Museum, New York.
After the shattering experience of total Mongol conquest, some painters began to reassert traditional Chinese values under the alien rule by looking afresh at past works for new inspiration. This charmingly nostalgic handscroll looks back to the decorative green-and-blue colours and schematic landscape style of the T'ang dynasty.

The Sung and Yüan (Mongol) dynasties, ranging from the 11th to the 14th centuries, span what is usually regarded as the greatest age of Chinese painting, which was also one in which crucial changes took place that may roughly be correlated with political events. The Sung dynasty began in 960 with the proclamation as emperor of a general who reunited China after one of her periods of fragmentation at the hands of contending warlords. During the early, or Northern, Sung, a monumental mode of landscape developed which captured the mountainous reality of northern China, the view being almost always dominated by a towering, distant mountain. But it is not a view in the sense of being topographical, for Chinese landscape is conceptual, a scene created by the imagination of the artist to express his own vision, taking elements from actual scenes but fusing them in the mind's eye before painting – an attitude which was to occur much later in Europe in the work of the German Romantic landscape painter Caspar David Friedrich. The ideal was not so much the description or imitation of a scene but the creation of nature anew by the simplest means of brush and ink. As Wang Wei put it, 'in painting a landscape, the idea must precede the brush'. In contrast to the huge canvases of some recent western painters, the whole idea was to convey the vastness, power, order and harmony of nature on a very small scale.

Meanwhile the nomadic Chin Tartars had been pressing in from the north beyond the Great

Wall, and in 1127 they overran the whole of north China, establishing their own dynasty there. Chinese rule survived only in the south, where the court withdrew to a new capital at Hangchow, south of the River Yangtze. Whereas the landscapes of the Northern Sung painters are monumental, depicting a nature which overawes the onlooker, those of the Southern Sung reflect the softer environment of the south, becoming more intimate, with closer views and illusionistic atmospheric effects.

To the north another of the nomadic peoples, the Mongols under Jenghiz Khan, began their dramatic expansion and by 1271 they had conquered the whole of China and established their own Mongol or Yüan dynasty. They were, however, eager to assimilate the superior Chinese culture, so under the great Emperor Kublai Khan (who was ruling during Marco Polo's travels to China) the arts, including painting, continued to flourish. But many Chinese artists and intellectuals stayed away from this foreign-ruled court out of patriotism. Paradoxically, they strengthened Chinese painting under alien rule by creating a new style, as so often in China through a return to earlier models but with a new emphasis – in this instance, on individual expression achieved through calligraphic brushwork. This fulfilled the scholar-painters' ideal of art as a means of individual expression through the 'writing of ideas' achieved through brushwork which would be the 'heart print' of the artist. The profoundest contribution to this revolution was made by Chao Meng-fu, one of the scholar-painters who did accept the summons to go north to the Mongol court. Here he was again in touch with the northern scenery, and also with the Northern Sung tradition of landscape painting which Southern Sung painters had abandoned for a more intimate and atmospheric style.

As the Mongol empire in China fell apart in chaos, many of the leading painters of the late Yüan retired to live and work as hermits in the mountains, where they tried to preserve the critical and spiritual values of Chinese civilization. But their work also became an exaltation of the scholar's own virtues in a period of national and social collapse, and it often became very personal. It was never so eccentric, however, as the work of some earlier masters of the T'ang period in the 8th century; their extreme forms of experimentation included spreading silk on the floor and spattering ink freely on to it, or painting with the artist's own braided hair dipped in ink, or facing in one direction while painting in another by waving the brush in time to music. It is strange to think that such twelve-hundred-year-old antics would have seemed new and trendy in New York during the 1950s.

In about 1280 Marco Polo visited Hangchow, which had been the Southern Sung capital, and found this city of lakes, parks, waterfalls and pavilions a paradise compared with anything he knew in Italy or Europe. China was not only an ancient civilization in which the arts had flour-

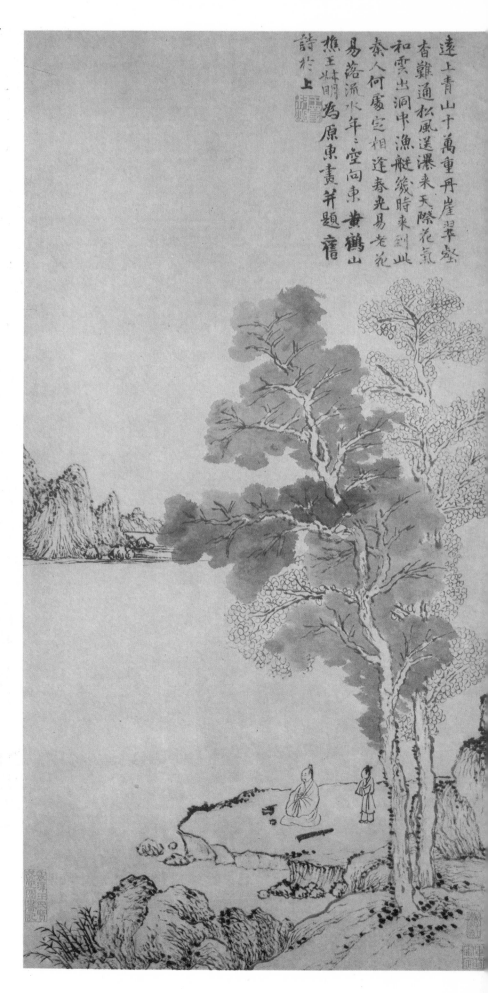

ished for thousands of years, but it was also scientifically more advanced than Europe. For European technological dominance is of very recent origin, beginning only with the scientific revolution of the late Renaissance. Before that, inventions usually came to the West from China – not just such wellknown discoveries as printing, gunpowder and the magnetic compass, but the hundreds of others discussed by Joseph Needham in his pioneering series of books on *Science and Civilization in China*, ranging from clockwork to the stirrup. It is a much discussed question why China did not maintain its scientific lead. I suspect that a large part of the answer lies in the different attitudes to nature in China and Europe. Western civilization has exhibited an extreme and seemingly irreconcilable split between the spiritual and the material, between the supposed 'other world' of theology and the actual world we live in, which just because it *had* lost its spirituality could be viewed, and exploited, mechanically. In China, on the other hand, though neither the

Taoists nor the Confucians had much use for the supernatural, neither did they view the world mechanically. The perennial philosophy of China has been an organic naturalism, in which man's aim has been not so much to conquer nature as to live in harmony with it. But it was that very European dualism which views the world in terms of a transcendent creator-deity on the one hand, and on the other a created universe which can be treated as a gigantic clockwork mechanism, that helped to produce the Newtonian scientific revolution of the 17th century. For that mechanistic world-view, in which the creator-deity could be ignored once he had performed his initial act of creation, was very useful in simplifying the task of posing scientific questions – and the key problem in the history of science has always been that of asking the right questions. But now the mechanical Newtonian world of classical physics has broken down into the relativity and quantum world of the 20th century, and currently physics has developed into some-

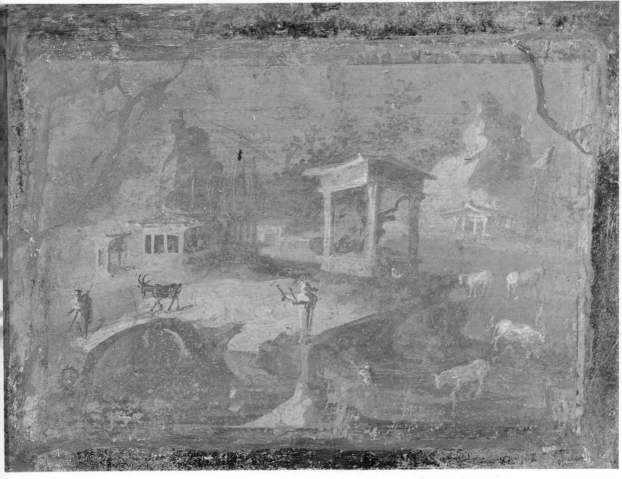

Wall painting from Pompeii, *Rocky Landscape with Herdsman and Goats*, before AD 79. Museo Nazionale, Naples. The villas of Pompeii contain some very varied landscapes, including an exotic one of the Nile with date palms, lotus flowers, a crocodile and a hippopotamus. But this Italian pastoral scene shows an idealized rustic shrine. Before the divinity was driven from nature by the relentless other-worldliness of Christianity, Roman religion, like most religions, regarded all nature as numinous. And the countryside was filled with sacred groves and sacred springs, with rustic shrines like the one in this pastoral scene set within a rocky landscape with trees.

*Left* Wang Meng (1310–85), *Red Cliffs and Green Valleys*. Hanging scroll. Ink on paper. Yuan – early Ming dynasty. Metropolitan Museum, New York. Wang Meng was the youngest of the Four Great Masters of the late Mongol period, hermits who used free brushwork to 'write out' their feelings of exhilaration in contemplating nature. This painting of a scholar by a riverbank does not show the 'red cliffs and green valleys' of the artist's own accompanying poem, but concentrates on suggesting the melancholic longings and feelings of resignation at the transience of life which are the essence of the poem. 'Springtime is brief and flowers are soon over, and year after year the river flows futilely into the Eastern Sea.'

thing so close to the organic naturalism of China that one American nuclear physicist, Fritjof Capra, has actually written a book called *The Tao of Physics* (1975).

This difference between the organic naturalism of China and the dualism of the Judeo-Christian tradition was also crucial for the history of landscape painting. This was a natural development in China. But while Chinese landscape painting was flowering in the Sung dynasty, in medieval Europe all art was subordinate to the Christian church and had to be religious: landscape painting simply did not exist. The Biblical directive that is at the root of the Judeo-Christian attitude is for man to 'go and dominate over nature', that is to set himself above the rest of the natural world as its master. This view eventually led to a definition of man as an animal with a soul, a unique organism, separated from a mundane nature which he can treat as he likes. Although nature had in fact existed for thousands of millions of years without man, in this religious tradition it came to be regarded as existing solely for man, to be used by him and exploited as he pleased. Judeo-Christian man no longer considered himself part of the whole community of organic nature, interacting with it in mutually beneficial ways, as the Chinese Taoists and most other peoples have done. He was instead its owner and master, justified in treating it like any other property. The difference is seen in all the arts – not just in painting but even in the art of the garden, where the Chinese and Japanese never believed in coercing nature into neat geometric forms, but in working with it organically. When at last in the 18th century the English started to cultivate irregular 'picturesque' gardens, these were automatically linked with the Chinese irregular gardens and given the name 'Anglo-Chinese'.

In ancient Egyptian art natural life is recorded in detail but always in relation to human activity. But the earliest European paintings, the wall frescoes of the Minoan palaces of Crete, included many scenes of nature shown for their own sake, such as flying fish leaping out of the water, a cat stalking a bird, monkeys gathering flowers. The miraculous, in the literal sense of that which transcends the natural order, played a comparatively small role in ancient Greek religion. And the Greek appreciation of nature, like the Chinese, led to the asking of scientific questions about its workings. However, Greek art was so completely humanistic, centred on the glorification of the human figure, on man as the measure of all things, that it was only in the Hellenistic and Roman periods that landscape painting developed, partly out of scene painting for plays. This late classical landscape painting, consisting mainly of wall paintings, is largely a lost art. Nevertheless, the emergence of European landscape painting as an independent art form in the 15th and 16th centuries was partly inspired, at least in Italy, by a return to these classical models. And in the Hellenistic and Roman worlds, as in

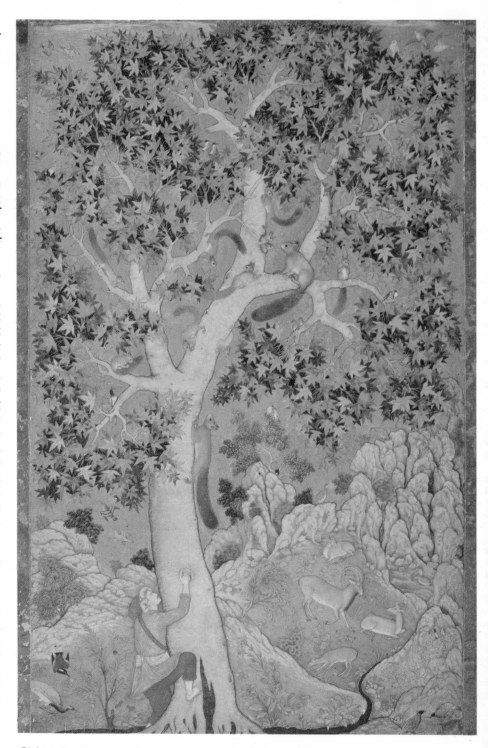

China, landscape painting was closely linked with poetry – though not in this case the short lyric poem but pastoral poetry and the landscape descriptions in romantic epics like the *Odyssey*. Again there is a chicken-and-egg situation, since some authorities think Virgil's richly detailed landscape descriptions may have been inspired by paintings.

The stringent, transcendental form of medieval Christianity allowed only an allegorical appreciation of nature. But the vigorous Arab civilization created by the impact of Islam in the 7th century, and soon extending from Persia to Spain, not only preserved much of the ancient scientific learning, but made new discoveries of

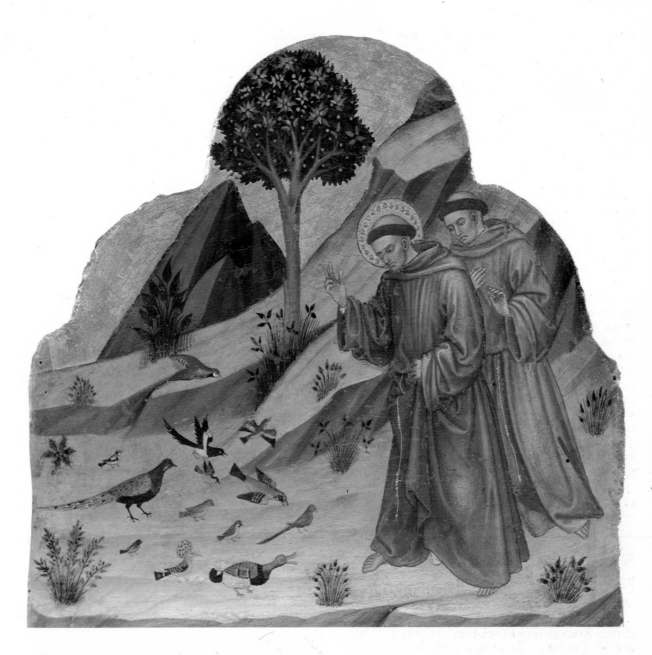

*Left* Abu'l Hasan, *Squirrels in a Plane Tree*, c.1610. Mughal album painting. India Office Library, London.
Landscapes in Persian and Mughal miniatures are mainly backgrounds to the poetic romances which are the most popular subjects illustrated. But they also occur as backgrounds to animal studies. Under the Mughal Emperor Jahangir, for whom Abu'l Hasan was court painter, these reached the amazing degree of naturalism shown here. For the artist has not used dead animals as models, but has carefully observed and captured a wide variety of the squirrels' natural gestures in their natural habitat, giving a real insight into their character. The plants, and more than a dozen different species of birds, are equally accurately observed.

*Right* Taddeo di Bartolo, *St Francis' Sermon to the Birds*, 1403. Niedersächsische Landesmuseum, Hanover. The new joy in nature which St Francis of Assisi brought into Christianity is shown in such paintings belonging to the Franciscan cycle. He preached his sermon to the birds in 1216 near the village of Bevagna, urging them to praise their Creator for such gifts as feathers for clothing and wings for flying. And to his early Italian biographers this sermon came to epitomize that 'rapture of devotion' with which St Francis embraced all nature, and which he expressed in his *Hymn to the Sun*.

its own in chemistry and mathematics. The ban imposed on image-making meant that Islam never expressed its spirituality through iconography, and Islamic art consists primarily of beautiful and intricate decorative patterns. But the survival of a distinctively Persian tradition of miniature painting for illustrations to books, and its spread to India under the Mughal emperors, allowed many beautiful landscapes to be painted – less for their own sakes than as backgrounds to the historical chronicles and poetic romances which were the books mainly illustrated.

Islamic learning, including its borrowings from other eastern civilizations such as China and India (which in fact invented the numerals now known as 'Arabic'), gradually helped to stimulate a reawakening of interest in nature among Europeans. Men like Roger Bacon (*c*.1214–94) began to seek knowledge not just from books, but by observation, relying on the evidence of their senses rather than entirely on tradition. But Bacon's ambition to pry into the secrets of

nature, experimenting with chemicals and making magnifying glasses, led to accusations of sorcery, and in 1278 his books were condemned by the Church and he was imprisoned for 14 years. It is no accident that he was a Franciscan, like other scholars of the time who leaned towards empiricism, including William of Ockham, who was one of a number of Franciscans excommunicated by the Pope in 1328. For St Francis of Assisi had responded with uncompromising joyousness to the natural world, celebrating the divine presence in nature in his hymn to the sun and his sermon to the birds, so that the paintings and picture cycles devoted to his life and legend are inevitably full of landscapes and natural imagery. The new joy in nature also expressed itself in a contemporary flowering of naturalism in the Gothic art of the north, seen for instance in the exquisitely carved plant leaves that twine round the capitals of columns in such cathedrals as Southwell and Rheims. However, the 14th century Sienese paintings attributed to Ambrogio Lorenzetti are

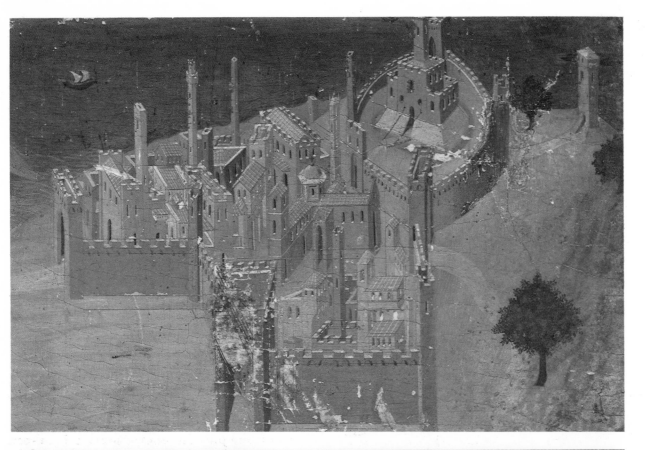

*Left* Ambrogio Lorenzetti (active 1319–47), *A City by the Sea*. Tempera on wood. Pinacoteca Nazionale, Siena.
This, and especially its companion picture, *A Castle on the Shores of a Lake*, are the earliest examples of pure landscape painting in western art. Enzo Carli attributes them to Ambrogio Lorenzetti because of their similarity to the landscapes which form the background of the frescoes of *Good Government* in the Palazzo Pubblico, Siena. These do not however seem to be fragments of larger paintings, but probably they once adorned a coffer in which documents were kept. In both paintings the bird's eye view completely excludes the sky, and in the companion picture this leaves a little empty boat rocking lazily on the green waters of the lake as an enchanted picture of the solitude of the country.

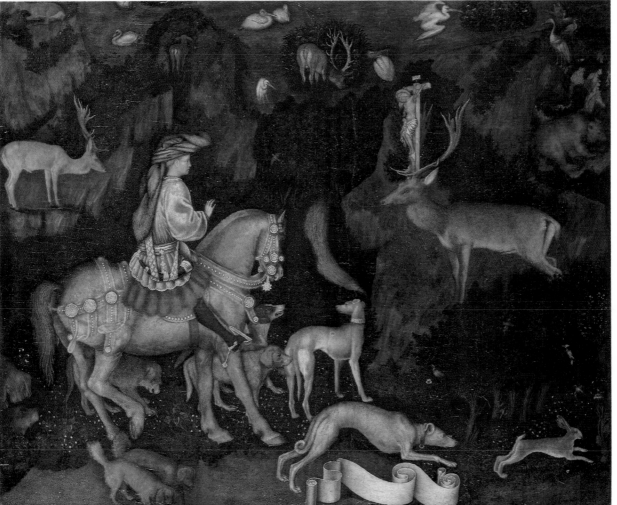

*Left* Pisanello (1395–1455), *The Vision of St Eustace*, 1436. National Gallery, London.
Pisanello was the most brilliant Italian master of the International Gothic style, which arose in the ducal courts of France and Burgundy, and revealed a growing interest in secular scenes of courtly and rural life. This hunt is still a religious picture, for the fashionably dressed future saint is confronted by a stag bearing the crucifix. But the dark wood is crowded with beautifully observed animals which show the artist's feeling for nature and his keen eye for natural detail.

*Opposite The Unicorn in Captivity*, (French *c.*1510), the 7th and last of the series of the Unicorn Tapestries. The Cloisters, Metropolitan Museum of Art, New York.
This is not a natural landscape, but a good example of the medieval landscape of symbols. The hunt of the fabulous unicorn was an allegory of the incarnation, and later the legend of its capture by a virgin became an allegory of courtly love. Every detail of the landscape background has

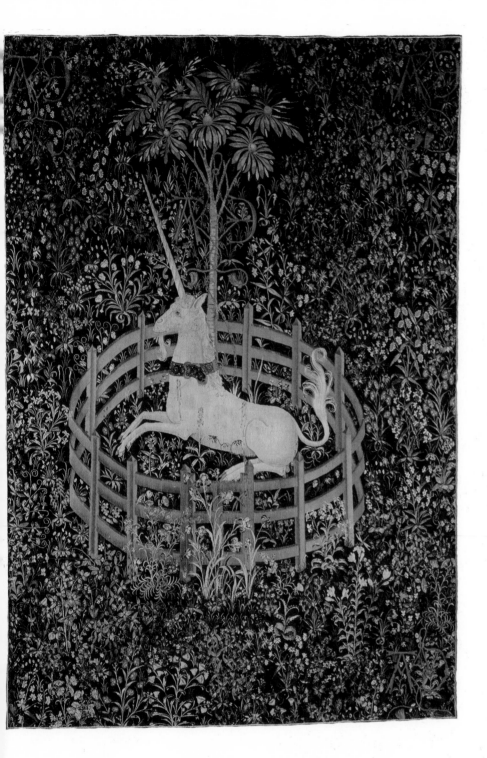

a symbolic as well as a decorative significance. Yet the plants are all so beautifully observed that almost all have been identified.

paintings and tapestries mostly belong to what Kenneth Clark has called 'the landscape of symbols'. There is a sense in which Chinese or European Romantic landscape is symbolic, not in the allegorical terms of the medieval landscape of symbols, but at a more fundamental level. For the Chinese landscape painter always tried to represent not merely the outward and visible forms of nature, but the inner life and harmony that pervades it – those mysterious forces that make the seed germinate and grow, and the planets revolve, and the seasons change: all that makes up the Tao of Nature, or what modern physics still likes to call the Laws of Nature, though in our strange universe of relativity and quantum theory we are no longer so certain that we have any really fundamental understanding of them.

By contrast with the Taoist attitude, the allegorical interpretation of nature was a matter of attaching specific meanings to natural objects which they would not otherwise have possessed, for example making the lily a symbol of purity associated particularly with the Virgin Mary. Whereas in Chinese or European Romantic landscapes the mute stones speak for themselves, in the landscape of symbols you need to look up what they are saying in one of the many useful dictionaries of symbols in Christian art. A marvellous example is the series of late Gothic unicorn tapestries, where the hunting and capture of the fabulous unicorn have a complex meaning and intricate iconography to which every detail of the background and the plants contributes. But these tapestries are especially effective because although they are clearly heavily symbolic, everything in them from the birds, beasts and flowers to the activities of the hunt is also intensely real and concrete. Nearly all the trees and flowers in the set, over a hundred species in all, are so exactly pictured that the majority have been identified by the New York botanists E. J. Alexander and Carol Woodward in their booklet *The Flora of the Unicorn Tapestries* (1941).

Since hunting was a popular courtly sport which took place out of doors, it often features in the medieval illustrations which give such a good picture of the life of the times, for example the famous *Très Riches Heures* of the Duc de Berry which were painted by the Limbourg brothers between about 1409 and 1415. These scenes of country life are not only one of the great achievements of the International Gothic style, but they mark an important stage in the development of northern interest in landscape. For in them the medieval landscape of symbols is almost left behind, giving way to detailed factual observation. The Limbourg brothers came from Flanders, and the painters of the Low Countries were already becoming famous for their marvellously accurate representations of nature. During the following century their landscapes were to play an increasingly important role, emerging from the backgrounds of paintings to become dominant over the figures.

isolated examples of pure landscapes at such an early date, perhaps because they were not regarded as independent paintings but simply as decorations for a coffer holding documents.

The story of the rise of landscape painting in Europe is the story of how the landscapes which so often form richly decorative backgrounds to the human action in medieval paintings gradually become more naturalistic and take on increasing importance until pure landscape begins at last to emerge, especially in northern artists such as the German painter Albrecht Altdorfer. In its stringently transcendental form medieval Christianity allowed only an allegorical appreciation of nature, so that the decorative landscapes in Gothic

Joachim Patinir (died 1524), *Charon's Boat*. Prado, Madrid.
Patinir was the first European artist to make landscape more important than figures, in paintings which offer a wonderful mixture of fantastic scenery with naturalistic detail. The small figures usually represent hermits, saints, or biblical scenes, and in at least one case are known to have been added by another artist. Here however the figure is more important in determining the actual structure of the painting. Patinir has fused the classical myth of Charon ferrying the dead across the river Styx into the realm of Hades with the Christian idea of heaven and hell. Heaven on the left is a typical Patinir winding river landscape, but hell is more exotic, from the tempting fruit trees of its garden in the foreground to the city in the background belching smoke and flames – a fiery effect pioneered by Bosch in several of his paintings.

Chapter Two

# Northern and Southern Landscape in the Renaissance

For the medieval Christian world, truth was a matter of faith and the authority of the Church. Martin Luther, who initiated the Protestant Reformation in 1517, dissented from this by making the ultimate appeal to the Bible, which he believed was demonstrably the work of God, overriding any established authority. But Copernicus began the scientific revolution in the 1540s with the even bolder proposition that there is a yet more fundamental work of God to which appeal may be made: the great work of nature. Nature thus became, as it has remained for modern science ever since, the ultimate authority against which any theory or observation must be tested.

The history of European landscape painting as a separate art really begins in the Renaissance with the increasing importance of nature and the subtly changing feeling for it as the natural world was gradually allowed to emerge from the background of religious paintings. Perhaps the earliest mention of landscape as a separate branch of painting is Dürer's reference in 1521 to the Flemish artist Joachim Patinir (1485–1524) as 'Joachim the good landscape painter'. For Patinir was the first artist to make landscape more important than figures, though he still put in tiny figures who provided the nominal religious subject. His saints and hermits are set amidst rocky shores and jagged mountains forming vast panoramas which offer a wonderful mixture of naturalistic detail and fantastic general effect.

By Patinir's day, the marvels of Flemish landscape backgrounds, with their meticulous detail, had long been famous throughout Europe. They were already known from manuscript illuminations and miniatures such as those by the Limbourg brothers, and they then became an important feature of Flemish oil paintings. Whereas Renaissance Italians were inclined to Platonic idealism, the practical northerners were more concerned with natural man in the actual world, and so with a more direct observation of nature. But the divergence was also encouraged by the use of different techniques. The fresco method of painting so commonly used by the Italians had to be carried out swiftly, while the plaster on the wall remained wet. Therefore, it could not be as highly detailed as the oil painting developed in the north, the slow drying of which permitted a painstaking naturalism. Thus Jan van Eyck could create in his paintings an almost eye-deceivingly real world, a revolutionary naturalism which included the subtlest effects of light

Konrad Witz (1400–47), *Christ Walking on the Water*, 1444. Musée d'Art et d'Histoire, Geneva. Religious scenes were increasingly set in the real world, and this is the first landscape in European art to be identifiable as a real place. For the Gospel story is here shown taking place in a recognizable location on the shores of Lake Geneva, shown with great topographical accuracy. Nor is it only the landscape background, with its tree-lined meadows and distant mountains, which is realistically depicted, the precise naturalistic observation extends to the tiniest details of bubbles in water and the way solids bend when immersed in a liquid, as in the convincingly visual effect of the half-submerged disciple.

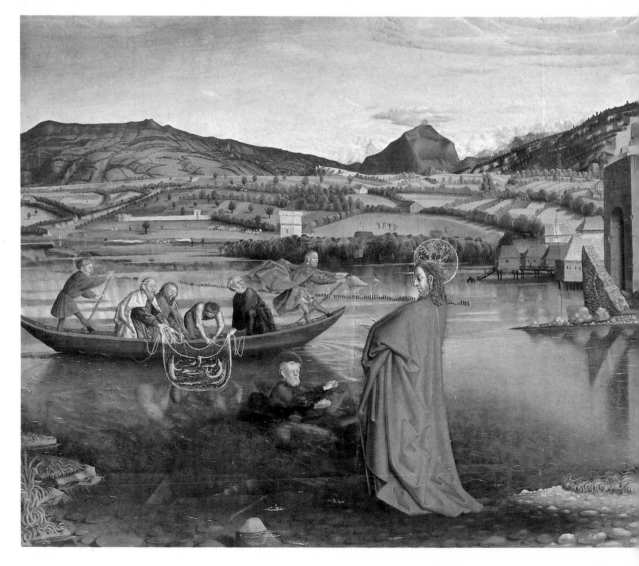

and the most detailed rendering of objects.

The actual world thus became the setting for religious scenes, bringing to vivid and immediate life the miraculous events taking place. Landscapes might be introduced by setting the religious scene in an enclosed garden or in the open countryside itself, though the commonest device was a painted window which offered a glimpse of the natural world outside. Such window vignettes became more and more important in 15th century Flemish paintings, with long roads winding between green meadows into the distance, and the various seasons accurately depicted. But it was the German-Swiss artist Konrad Witz (1400–47) who painted the first really identifiable landscape in European art. His only signed and dated work, *Christ Walking on the Water* (1444), is set in a landscape which is not just a generalized scene but recognizable as a particular point on Lake Geneva, with its shores bathed in the light of the summer sun. It is thought that the artist made preliminary sketches on the spot, since the lake, the Petit-Salève and the city of Geneva are all shown with realism and accuracy. The fields and meadows on the shore of the lake are criss-crossed by tree-lined roads and bushy hedges, interspersed with buildings, and all set against the background of hills. The artist's naturalistic observation includes accurate details like the air-bubbles rising from the green depths

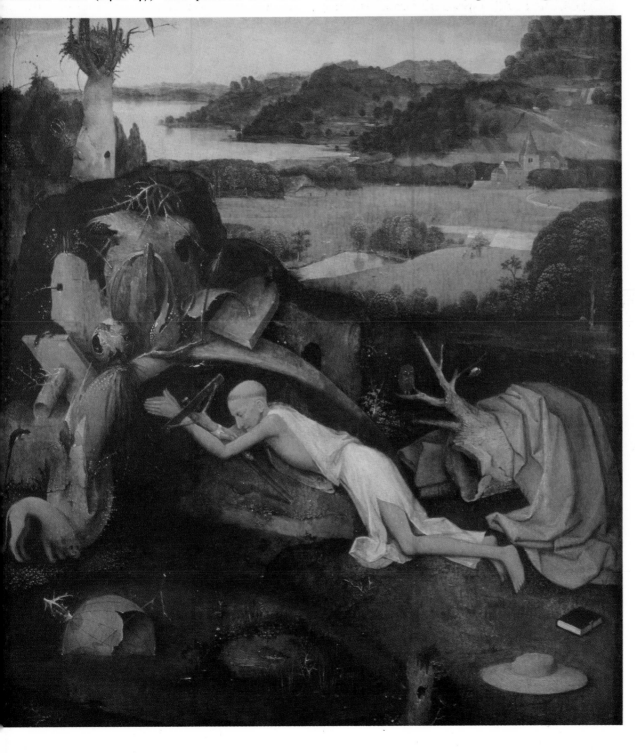

Hieronymus Bosch (*c.*1450–1516), *St Jerome in Prayer,* Museum voor Schone Kunsten, Ghent. Bosch's pen-and-ink sketches show him catching the essence of a landscape with a few bold strokes, though these often become filled with demonic presences or the settings for grotesque fantasies. Here, however, the Devil's temptations and snares of the senses are grouped immediately around the saint, who is absorbed in prayer, oblivious of them. And everywhere in this foreground there luxuriates a sinister vegetation. Yet the vast panoramic landscape in the background is untroubled by human vice. And it is the poetic serenity of such backgrounds that makes Bosch, despite his fantastic imagination, an important pioneer of landscape painting.

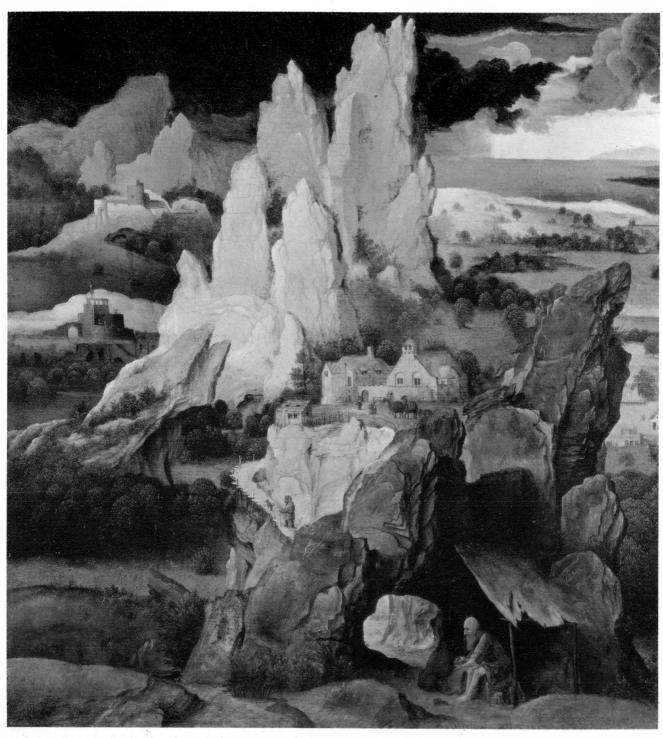

*Above* Patinir (attributed to), *St Jerome in a Rocky Landscape*. National Gallery, London.
There are only four signed works by Patinir, all landscapes in which small figures illustrate a religious theme. Other similar landscapes are attributed to him on stylistic grounds, as with this characteristically fantastic mountain setting with its strange, contorted rocks. It is a landscape of the imagination, since Patinir could never actually have seen such fantastic crags. But much of his river and rock imagery, in which curving rivers melt into the distant horizon after winding through a rocky foreground, was probably inspired by the scenery along his native river Meuse.

*Right* Pieter Bruegel the Elder (1525–69), *The Magpie on the Gallows*, 1568. Hessisches Landes-museum, Darmstadt. Bruegel's central theme of man's inhumanity to man is shown by the indifferent way in which the peasants heedlessly dance near the gallows. But this human activity on the wooded hillside is completely dwarfed by a vast panoramic landscape of river valley and mountains receding into the distance. The whole scene has a strong sense of atmospheric space in a real natural world, with a feeling that only birds like the independent and adaptable magpie really have the freedom of these immense airy spaces. His first biographer wrote that 'on his journeys Bruegel did so many views from nature that it was said of him that, when he travelled through the Alps, he had swallowed all the mountains and rocks, and spat them out again . . . on to his canvases.'

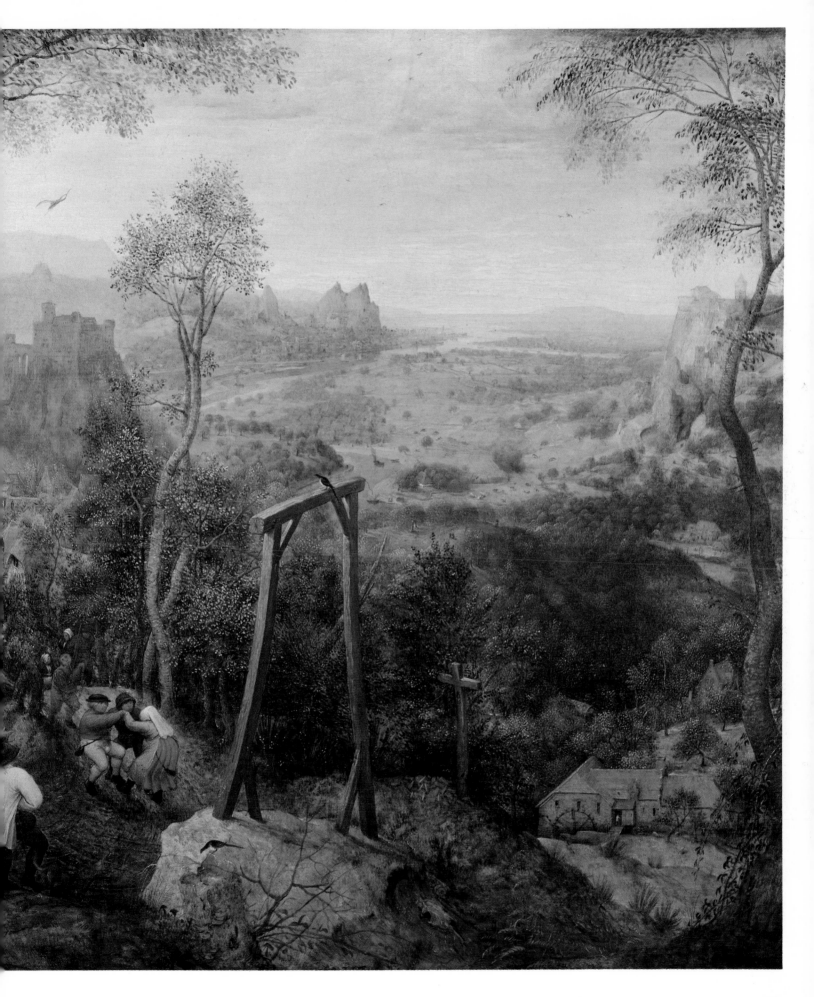

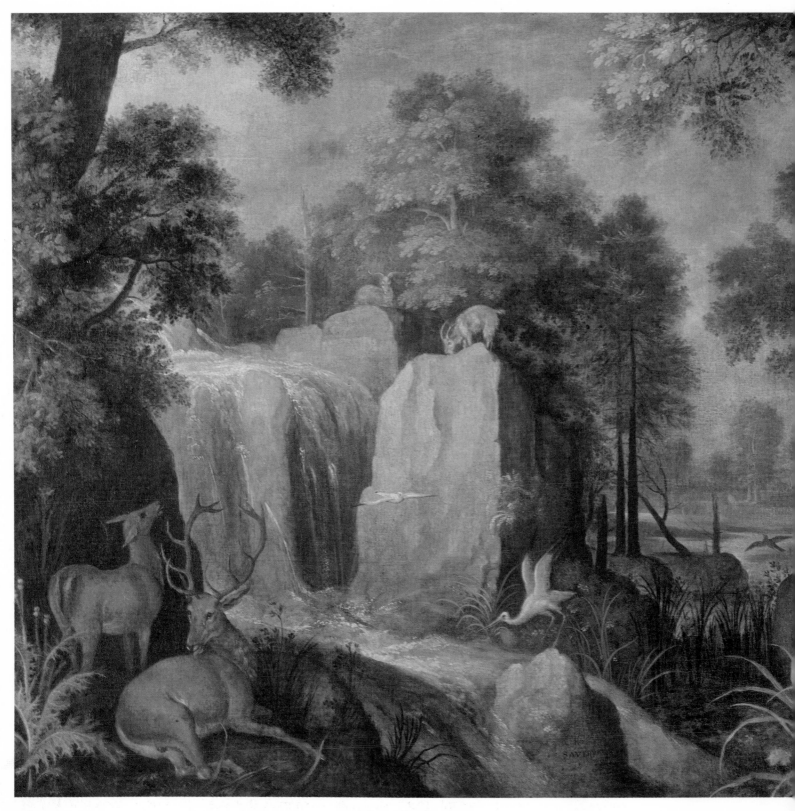

Roelandt Savery (1576–1639), *Rocky Landscape*. Museum of Fine Arts, Budapest. Savery actually sketched in the Alps, and this rocky landscape shows the way he was moved by this majestic world. Yet this is not an actual scene but a carefully arranged composition, with the sheer rocks and cascading mountain stream framed by huge trees. The animals which often crowd Savery's landscapes show the objectivity of his observation, for he was one of the first to make studies of animals directly from life, and his paintings of the Dodo, are our best evidence for what it looked like.

of the water and the gentle eddies round the boat; he also captures the way objects seem to bend when immersed in water, as in the marvellously convincing visual effect of the half-submerged disciple.

The 15th and 16th centuries were times of acute spiritual crisis which culminated in the Reformation and the growth of scientific speculation, and in the Counter-Reformation attempt to check both through the Inquisition – all of which went to make this a time of ferocious ideological conflict. In art, the darker and more disturbing sides of nature and human nature were represented above all in the grotesque world of fantastic images conjured up by the highly individual imagination of Hieronymus Bosch (*c*.1450–1516). This grotesque world has had a powerful appeal for our own century of psycho-analysis and surrealism, shaken in its turn by wars, revolutions and atrocities which seem to confirm Bosch's relentlessly savage portrayal of man's stupidity and greed. But his fantasies of the subconscious are so convincing because he sets them in such marvellously real landscapes. He was both extending and in a way reversing the naturalistic tradition, in which the landscape of fact had gradually become dominant over the religious or miraculous subjects. Bosch paints man as he is on the inside, not merely on the out-side, and his landscapes serve to enhance the reality of surrealistic images more fantastic than any created by his predecessors. Yet his work paved the way for the still greater dominance of the natural world; for in his later paintings the demoniacal happenings in the foreground become simplified, giving greater prominence to the serenely poetic landscape background.

This process of emancipating the landscape from the foreground events was carried further by Patinir, whose views of winding river estuaries are similar to those in several Bosch paintings including *St John on Patmos* or *St Jerome in Prayer*. But much of Patinir's river and rock imagery may also have been inspired by his own observation of the scenery along his native River Meuse, which is rich in unusual and striking rock formations. He specialized in landscape to such an extent that in at least one of his paintings, *The Temptation of St Anthony*, the figures are known to have been painted not by him but by Quentin Massys; while Patinir in turn did landscape backgrounds for figure paintings by other artists.

The growth of landscape painting was encouraged by the religious conflicts of the Reformation period, which meant there was less demand for religious paintings, especially as many Protestants regarded them as Popish idolatry. Such changes in attitudes and patronage encouraged many Flemish artists to specialize in the imitation of nature for which they had long been famous. This produced a great flowering of Flemish landscape painting during the 16th century, of which the landscapes of Pieter Bruegel the Elder (*c*.1525–69) are outstanding for their power and originality. In Bruegel's work, man's inhumanity to man is constantly contrasted with the eternal beauties of nature. The transitoriness and insignificance of human existence is perfectly caught in paintings like *The Fall of Icarus*, on one side of which Icarus plunges into the sea totally unnoticed, while elsewhere life goes on undisturbed; a farmer is intent on his ploughing, a shepherd is looking up into another part of the sky, and the whole scene is bathed in an atmosphere of rustic peace. Bruegel has always been popular for the robust humour and caricature of his peasant scenes, in which he offers a vision of man at the mercy of every sort of folly. But his direct observation of human nature was only one part of his direct observation of nature itself. In his series of landscapes that portray the changing characteristics of the seasons he catches the atmosphere of every sort of weather, with nature revealed in all her changing relationship to humanity, harsh and yet not inhospitable to the hunters in the winter snow, and richly bountiful for the haymakers.

The division of the Habsburg lands after the abdication of the Emperor Charles V in 1556 brought the Low Countries under Spanish rule. The Spanish attempt to impose the Counter-Reformation by means of the Inquisition led to a revolt against Spanish domination in 1568. This was to have a decisive effect on landscape painting, since the Protestant northern provinces managed to break away and maintain an independence which made possible the development of Dutch art in the 17th century. The southern provinces remained Catholic under Spanish occupation, but many Flemish landscape painters settled in Holland, and became important links in the development of landscape there. Gillis van Coninxloo was especially important. He first moved to Frankenthal in Germany, where he and other Protestant refugees formed one of the earliest artists' colonies, specializing in woodland scenes. Coninxloo's few surviving authenticated pictures reveal his accurate observation of the magnificent primeval forests, and of the effects of light shining through vegetation – effects which were to influence Rubens in the south, as well as two of Coninxloo's pupils who were to become major Dutch landscape painters – Hercules Seghers and Esaias van de Velde.

The fact that nature was being painted so realistically became important in natural history, though for a melancholy reason: the voyages of discovery that explored the world also marked the beginning of the mass extermination of animals that has been such a feature of the last 400 years. The first creature whose extinction became such a matter of public awareness that it gave rise to the proverbial saying 'as dead as the dodo' was a curious, ungainly, flightless bird bigger than a turkey. The dodo was discovered on the island of Mauritius in 1598 and had been totally wiped out by 1693, less than 100 years later. Not even a stuffed specimen survives, only a few bits such as a head and a foot. So we owe our detailed knowledge of this curious bird to the

Albrecht Dürer (1471–1528), *Alpine Landscape*, 1495. Watercolour. Ashmolean Museum, Oxford. This completely natural and delightfully spontaneous impression of the Alpine scenery is one of the watercolour studies which reflect Dürer's delight in the mountains which he passed through on his first Italian journey. Just as in the 18th century the Alpine scenes painted by English watercolourists played an important part in the rise of British landscape painting, so Dürer's journeys through the Alps seem to have freed him from the conventional limitations of art. But though nowadays they are recognized as works of art in their own right, he merely regarded these watercolours painted on the spot as sketches, some of which he later used as landscape backgrounds in oil paintings.

artists who painted it, above all to the Flemish painter Roelandt Savery (1576–1639). His employment by the French king and the German emperor enabled him to travel widely, and while in the service of the Emperor Rudolf II he was sent on a journey through the Alps and the Tyrol, drawing and painting wooded, mountainous scenes. He often filled his landscapes with animals, which he painted direct from life in the Prague menagerie of Rudolf II. The many imported animals and birds there included the second dodo to reach Europe; Savery made eight pictures of it, and since his rendering of animals which still exist is very accurate, we can be fairly sure that the same is true of the earlier group of these drawings and paintings, made direct from the living bird.

That the rise of landscape painting went along with the serious scientific study of nature, and that throughout the history of this rise the artist was an important factor in stimulating an awareness of nature in other men, is nowhere better seen than in the work of Albrecht Dürer (1471–1528). Like Leonardo da Vinci he was a true Renaissance man with wide interests. And though in his paintings and engravings Dürer was a master of the fantastic and the visionary in the Gothic religious tradition, his drawings and watercolour studies show the marvellous exactitude of his direct observation from nature. His flowers are not heraldic or allegorical, but actual flowers of the field picked up in a large piece of

turf and recorded in every tiny detail. Simila powers of observation are shown in his anima studies direct from life, such as the famous water colour of a hare. It is typical of Dürer that durin his tour of the Low Countries in 1521 he shoul have contracted fever through going into som swamps in the hope of seeing a dead whale. H was friendly with the contemporary Flemis artists, and owned a picture by Patinir, whos portrait he drew at Patinir's second marriage. Bu it was even earlier, when he set out on his firs visit to Italy in the autumn of 1494, that he bega that incredible series of topographical water colour landscapes which still seem so moder The beauty and magnificence of the Tyrolea Alps seem to have freed him from the conven tional limitations of art. His views of the natur scenery, and his panoramic image of the city o Innsbrück, which is the first true portrait of town, show his marvellous ability to see freshl and catch what he sees in what has been called th first 'traveller's sketchbook' in the history o European art.

Such factually observed landscapes reflect th insatiable curiosity about the natural world whic Dürer shared with other men of the Renaissanc But the Germans have tended to combine exac observation of nature with a lyrical and almos mystical attitude towards it which in some way resembles that of the Chinese. This romanti feeling for the German forests is seen in th paintings of Lucas Cranach the Elder (1472

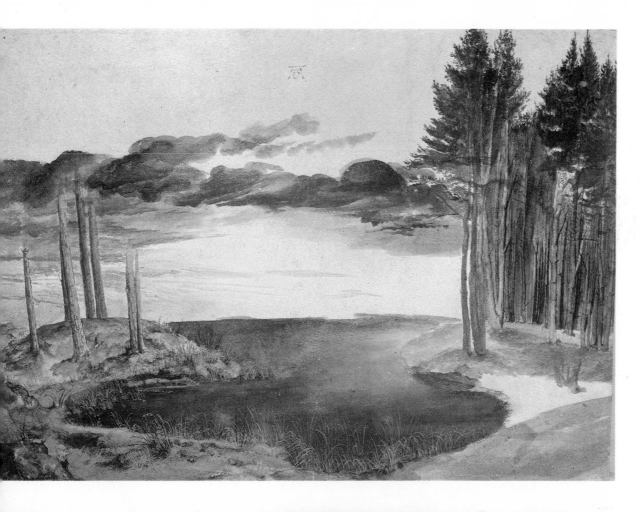

Dürer, *Sunset in the Forest* (or *Pond in a Wood*). British Museum, London. Dürer's watercolour sketches show the marvellous exactitude of his direct observation from nature, including his faithful copying of every tiny detail of the variety of plants picked up in a large piece of turf. Yet his innate romanticism often led him to choose picturesque or unusual views. And in this painting of a pond in a wood at sunset the drastic simplification and intense colouring transform this scene from nature into a poetic image of solitude and silence.

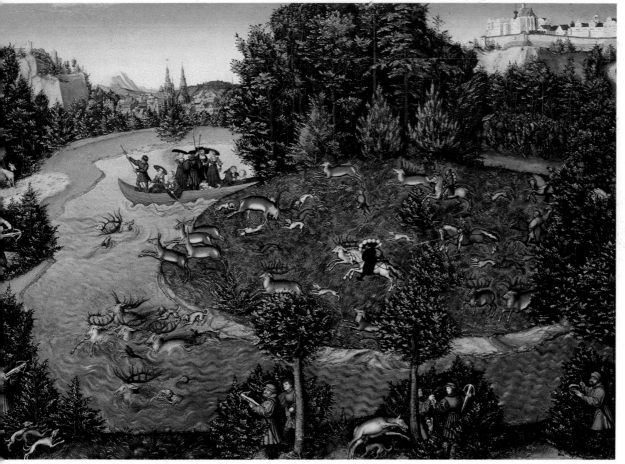

Lucas Cranach (1472–1553), *The Stag Hunt of the Elector Frederick the Wise and Emperor Maximilian*, 1529. Kunsthistorisches Museum, Vienna. Cranach himself frequently accompanied such hunting parties, and made vivid watercolour sketches of the dead animals. Here he displays to the full his gifts as a painter of animals in the pursuit of the stags along a curve of the river. But despite the dramatic activity, it is the poetic forest landscape which is dominant – leafy woodland and long grass cut by the arc of the river, while towards the horizon the landscape melts away among the towers of a distant town beneath a mountain. Cranach's landscapes epitomize the German romantic dream, the northern world of pine forests, steep crags and fairy-tale castles.

Matthias Grünewald (*c*.1475–1528), *The Two Hermits* – outer wing of the Isenheim Altar, Colmar Museum, Colmar. In contrast to Cranach's romantic world of northern pine forests, the landscapes in Grünewald's religious pictures are internal landscapes of the mind, aimed not at representing real scenes but expressing the emotion the artist wanted to convey, often centring on the cruel and violent forces of the human subconscious which lead to such acts as crucifixions. In this scene the wilderness to which St Paul the Hermit has retreated is an image of utter desolation. There is a feeling of primeval slime about the dead trees, with their branches eerily festooned with sinister fringes of hanging moss. Everything combines to give an overwhelming emotional effect to the atmosphere of decay.

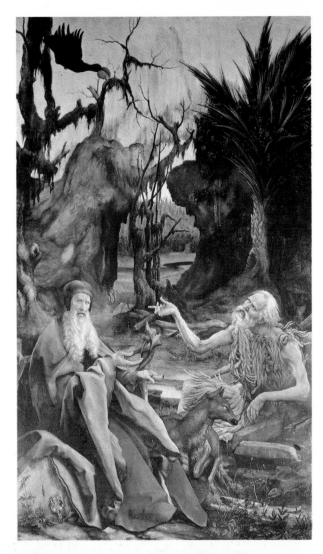

Albrecht Altdorfer (*c*.1480–1538), *Landscape with a Footbridge*. National Gallery, London. Since Dürer did not follow up his brilliant watercolour sketches to practise landscape painting as an independent art form, it was left to Altdorfer to paint the first pure landscapes in European art. On his journeys along the Danube he made beautiful drawings of its romantic scenery, which became the basis of his later paintings. Here the moss-covered ruined building and rickety footbridge suggest nature reclaiming this valley, in which the stream foams at the foot of the rocks. Though the spire of the church in the distance hints at a village nestling below the mountain, it is the shaggy, tangled wilderness of the trees and bushes which is dominant.

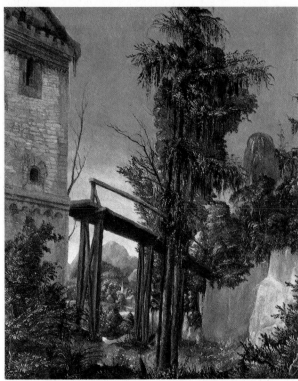

1553), whose landscapes are no longer just back cloths painted minutely in the Flemish manner with an almost botanical correctness of detail. Instead the figures and animals are fully integrated into the landscape, not just set decoratively against it. Above all Cranach achieves a pervasive poetic mood, an atmosphere which envelops and unifies the whole scene into a single romantic harmony. This is the style of the Danube school, so called because its chief subject was the romantic scenery of the Upper Danube, with its picturesque rocky outcrops, towering crags surmounted by castles, and deeply wooded valleys. Cranach's landscapes are essentially northern, with rugged pines ruffled by the wind, set against distant vistas of rocky Alpine crags and peaceful valleys.

Nature as shown in art always reflects the artist's own mind. There is no such thing as a detached observer, even in science, where one of the discoveries of quantum physics has been that we can never get rid of the human element; so that Heisenberg calls science 'part of the interplay between man and nature'. Landscape painting is always an interplay between each artist and nature, but there are also differences of temperament based on geography: northern artists tend to use nature to express their own emotions, while in the more classical, rational art of the south the intellect has been dominant, prompting an artist like Poussin to carefully re-arrange the natural world by removing all its 'imperfections' and imposing an idealized order on it. By contrast, the fantastic landscapes of German painters such as Grünewald and Altdorfer show that these are expressionist artists using the natural world to project their own emotional intensity. Grünewald is one of the great expressionist artists, yet we know very little about him, not even his real name and date of birth. He died in 1528, the same year as Dürer; but unlike Dürer, who was enough of a Renaissance man to regard himself as an artistic innovator, writing books to set out his views and keeping records of his travels, all we have from Grünewald is his works. However, these speak very powerfully for themselves – above all the numerous wings of the great altar painted for the Alsatian village of Isenheim. Though the scenes are all religious, landscape backgrounds play an important part in several of them. And just as Grünewald's crucifixions convey an agonizing impression of a human being dying in pain and distress, so his landscapes add to the intensity of the spiritual message, by creating a fantastically macabre setting in which St Anthony is assailed by monstrously ugly demons, or the most desolate of all wildernesses for the meeting of two saintly hermits.

It was Albrecht Altdorfer (*c*.1480–1538) whose emotional response to nature led him to paint the first pure landscape paintings as an end in themselves, without any figures at all. Dürer had already done this in his watercolours, but they were only intended as sketches, and it was

revolutionary change to make landscape the sole subject of a painting. Altdorfer is known to have made two trips along the Danube, in about 1503–5 and again in 1511, going into the woods and mountains to make watercolour sketches of the magnificent Alpine scenery, with its weathered rocks and shaggy larch trees. He had a feeling for the poetry of landscape which was shared by another important member of the Danube school, Wolf Huber (c.1490–1553), the major part of whose surviving mature work consists of beautiful drawings and watercolours of landscapes or trees. Gradually Altdorfer allowed his tangled woods and trees to dominate even in his oil paintings, where St George becomes a tiny figure on a white horse, almost lost in a magical fairy-tale forest whose surging foliage soars above him and threatens to engulf him completely. The real subject has become natural growth and the elemental forces of nature, which include the sunlight seeping through the green luxuriance of the foliage or reflecting back from it in a haze of broken gleams which adds to the feeling of enchantment. From this primeval forest with only a small intruding figure it was only a short step to having no figure at all. Getting rid of the narrative story-telling element leaves a painting of pure poetic mood, and so Altdorfer's landscapes become romantic pictures in which his lyrical expressionism arranges or distorts colours and shapes to reflect the artist's own emotions.

In 1548 the artist-historian Vasari observed that 'every cobbler had a German landscape in his house', since northern landscape painters found a ready market for their works in Italy. They were regarded as the specialists in this field, though in Italy too it was being given greater prominence, for example in the highly individual mythological fantasies of Piero di Cosimo (c.1462–c.1521). Piero's very personal and whimsical outlook included a special interest in primitive modes of life, from which he created a nostalgic dream-world illustrating man's first discovery of honey, of wine, or of fire (a marvellous landscape full of animals running away from the flames). But it was above all Leonardo da Vinci (1452–1519) who combined supreme mastery of the arts of drawing, painting and sculpture with an unusual curiosity about the working of the natural world. During the Renaissance, science was at last waking from its long medieval slumber as the book-learning of religious scholasticism gave way to the direct observation of nature that the Greeks had practised. And Leonardo possessed to such a very high degree that curiosity about the workings of the processes of movement and change in the natural world that is the foundation of modern science that his many contributions to subjects as diverse as geology, anatomy and engineering feature prominently in histories of science. Leonardo regarded it as the artist's task to reveal nature's mysteries and inner workings, and his restless questioning researches were aided by almost supernatural powers of sight, since in his studies of the flight of birds he was able to draw and describe movements which others could see only after the invention of slow-motion cinematography.

*Below* Leonardo da Vinci (1452–1519), *A Deluge.* Drawing in black chalk. Royal Library, Windsor Castle, England.
The movement of water was the most obsessive of all Leonardo's many interests, and one result was the famous series of Deluge drawings. In these his studies of floods and troubled imaginings about the apocalyptic events the Christian world predicted for the year 1500 combined to depict cataclysmic storms in which the savage forces of nature are totally beyond the control of puny man. These drawings are almost unique in European art, resembling Chinese or Japanese paintings in their powerfully dynamic convolutions. Here the deluge is accompanied by a thunderstorm, with great coils of rain plunging down on to trees lit by lightning playing in the sky.

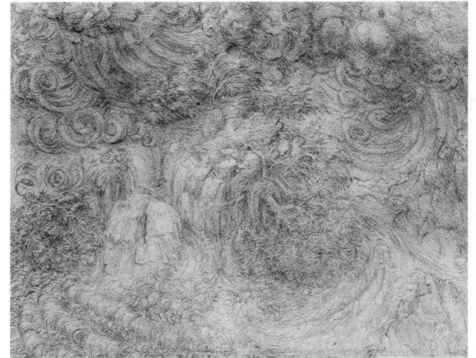

*Left* Altdorfer, *Danube Landscape near Regensburg.* Alte Pinakothek, Munich. Though Altdorfer's paintings capture the essence of the real Danube scenery, they go beyond mere topographical accuracy to a lyrical expressionism which establishes a mood by heightening colours and distorting shapes, like those of the clouds above the glow of the sun setting over the mountain – a scene whose impact is increased by framing it between trees.

In Leonardo's later years, after his return to Milan in 1508, he made many journeys to study the Alpine scenery that lies within a day or so's ride from the city, making notes and sketches of landscape, geology, botany, and the modification of colours by atmosphere. The way in which his scientific researches became integrated into his artistic imagination is apparent in his Deluge drawings. It was probably on a trip into the Alps from Milan that he witnessed one of those colossal deluges that occur every ten or twenty years, and even today are very destructive. In recording them, Leonardo combines two of his obsessions: his sense of the impotence of man when confronted with the forces of nature, and his long-standing interest in the movement of water. Swirling water satisfied the same sense of form which he expressed in his drawings of hair or leaves, so that the hair of Leda in his *Leda and the Swan* is full of a restless energy which is just as mysteriously organic as the eddies and bubbles he recorded directly in his studies of water. For swirling water was particularly interesting to him since it made lines of force visible. Leonardo's sense of form and his scientific curiosity were very closely linked: he loved to draw forms, and while drawing them he asked himself why they were their particular shape and what laws determined their growth. His interest in fantastic rocks began when he used them as conventional forms, to provide the mysterious landscape backgrounds of the *Virgin of the Rocks*, and culminated in his asking questions about the character and origins of rocks which were only answered 300 years later. For geology, more than any other science, was hampered by the authority of the Biblical accounts of the Creation and the Flood, but Leonardo was well ahead of his time in answering such questions as what fossils are and how seashells and other fossilized marine animals can be found high up in mountains many miles inland; other people, if they accepted them as marine at all, explained away these ancient scallops and oysters as the discarded remnants of meals eaten by pilgrims during their return journey from Jerusalem.

Leonardo's passionate enthusiasm for anatomy was shared by other Renaissance artists, such as his slightly older contemporaries the brothers Pollaiuolo. This was part of an emerging Renaissance concern for the lively and vital representation of the human body in action – an interest above all in musculature, in the body as a machine. But it is characteristic of Leonardo that his later anatomical studies show him moving from the purely mechanical aspect of the body to its inner workings, its organic nature, and its development, as shown in his embryological studies. He wanted to know how things worked at the deepest level, not just how they appeared to work. The whole movement of Leonardo's mind was from mechanism to organism, to a realization that man, plants and the earth itself are in a process of continual change. His drawings of the movement of water are studies of that continuous

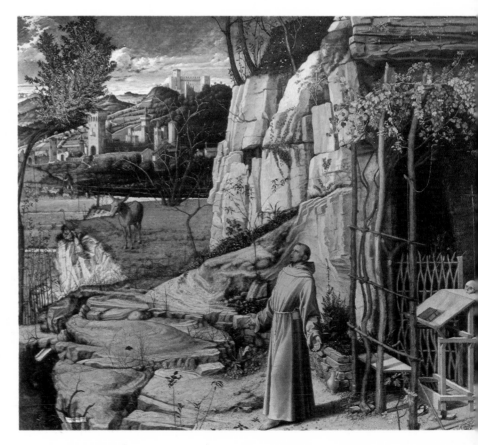

energy which is central to all this change, and in the astonishing Deluge drawings he expressed his vision of a world overwhelmed by floods, a reflection of man's insignificance when confronted with the forces of nature.

Leonardo's special interest in nature was exceptional, and it was really the 16th century Venetian painters who made atmospheric landscape backgrounds their own. Giovanni Bellini, Giorgione and Titian used landscapes to create ideal Arcadian settings and suggest a mood such

*Above* Giovanni Bellini (*c.*1430–1516), *St Francis in the Wilderness*. Frick Collection, New York. The saint steps out of his grotto into a countryside full of lovingly painted natural details, but unified by the light of the sun, to which St Francis lifts his eyes in that ecstasy he expressed in his *Hymn to the Sun*. This early

landmark in Bellini's development of landscape is full of air and light, which in later paintings progressively becomes warmer, with a golden glow in the atmosphere and a lyric mood that was to be fully developed by Giorgione.

*Left* Leonardo, *View of the Adda at the Tre Corni*. Pen drawing on yellowish paper. Royal Library, Windsor Castle, England. While Leonardo was living in Milan he travelled into the countryside to make landscape studies. One of the places he regularly stayed in was Vaprio d'Adda, a small town about 20 miles east of Milan on the steep left bank of the river Adda. This was an ideal place for Leonardo, who was not only deeply interested in the flow of water but was always drawing up ambitious plans for canals and hydraulic schemes. For as the drawing shows, where the river runs beneath the mountain known as the Tre Corni, the three peaks, it breaks into turbulent rapids. To avoid these a canal had been built along the side of the river, separated only by a narrow bank. A barge can be seen moving calmly down the canal, while just across the bank the raging swirl of the rapids is drawn with all Leonardo's delight in turbulent water movement.

*Right* Giorgione (1477?–1510), *The Tempest*. Accademia, Venice. In this enigmatic masterpiece the figures remain large and important enough to have sent many scholars off on a not particularly fruitful quest for its 'meaning' or story. For whatever the subject, the really important thing about this pastoral is not its story but its poetic or musical mood, which unifies the landscape into an evocation of the heat and tension of a summer thunderstorm, with the sky torn by a sudden flash of lightning, and all nature, with its perpetual growth and decay, from the young baby to the columns of the ruined building, bathed in a tremulous golden glow.

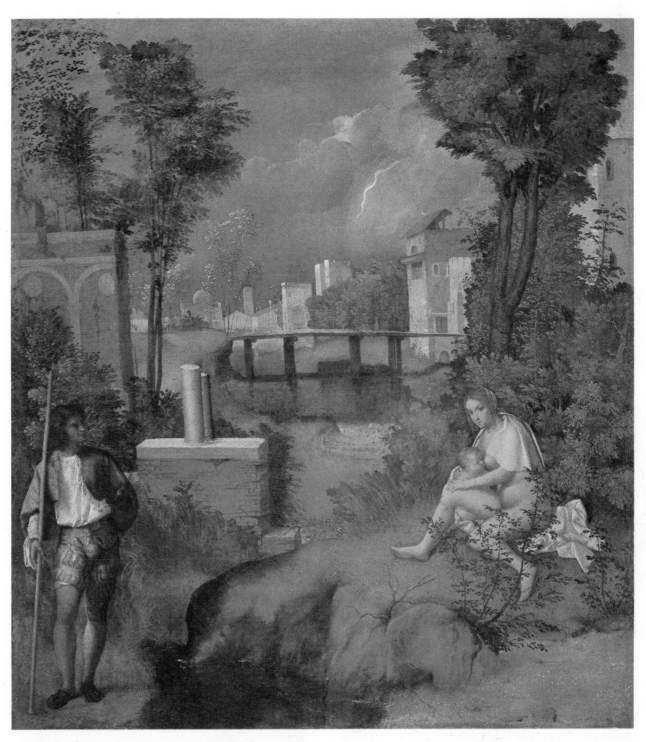

as poetic melancholy. As in the north, these landscape backgrounds gradually played a more and more important role, though narrative incidents and figures were more persistent in Italy. The emergence of landscape painting was closely bound up not only with changing attitudes to nature, but with changing attitudes towards the role of narrative in painting. In northern Europe the story-telling element grew very much less important in Patinir and effectively vanished altogether in Altdorfer. Landscape is essentially a romantic art because it replaces story-telling with a poetic feeling closer to the emotional impact of music.

Venetian painting developed a sensuality,

warmth and colour, and a use of light to unify the picture, which all helped to create the poetic mood of the landscape background. It has also been suggested that the atmosphere of the Venetian lagoons, which seems to blur the sharp outlines of objects and to blend their colours in a radiant light, may have taught the painters of this city to use colour in a more deliberate and observant way than previous Italian painters. Certainly they became renowned for the mellowness and richness of their colours, and when Dürer visited Venice he watched the aged Giovanni Bellini at work, and envied him his power to render the glow and serenity of nature. Bellini (*c*.1430–1516) had started by painting landscape backgrounds

37

full of light and air, and during his long career had gradually intensified the golden glow of the atmosphere to create a more and more dreamlike mood.

But it was Giovanni Bellini's pupil Giorgione (1477?–1510) who further developed the lyric element to create the pastoral 'landscape of mood' which would eventually lead to the ideal landscapes of Claude. The prevalent mood of Giorgione's paintings is that of pastoral poetry, of the Arcadian myth of the golden age of innocent country life, in which narrative has become relatively unimportant and the appeal is primarily to the lyrical and musical side of art which especially appealed to the Venetians. In his *Fête Champêtre* in the Louvre, contact with nature becomes openly sensual; the golden light of the setting sun shines on a group of young people on an open air picnic, the girls naked, the whole scene caught in an expectant pause as they prepare to play their musical instruments. Giorgione uses colour and light to unify his landscapes into a single atmospheric mood, and though he includes figures, they are sometimes so enigmatic that scholars have been unable to agree about the subject. This is particularly true of the famous

*Tempest*, where the two figures, the woman suck-ing a child and the soldier, seem lost in their own thoughts, paying no attention to each other. The mood is created by the heat and tension of a thunderstorm, with lightning flashing across the sky. Yet whereas everyone can accept that in Altdorfer the landscape and mood are the true subject, here the enigmatic figures remain important enough to create a sense of haunted mystery which has led a whole series of scholars to try in vain to solve the puzzle of the painting's 'meaning'.

Giorgione was one of those tragic artists,

like Keats and Schubert, who died very young at the peak of their creativity. When Giorgione died in an epidemic of plague in 1510 he was at most 33 years old. But the Giorgionesque poetic mood that he had created was continued in the work of many other Venetian artists, above all in Titian (*c*.1487–1576), who is thought to have completed several of Giorgione's unfinished pictures, including the *Sleeping Venus*, now in Dresden. The landscape background for this delightfully pagan nude is generally thought to be by Titian, who used the same landscape for *Noli Me Tangere* (National Gallery, London), showing Mary Magdalen's encounter with Christ in the garden after the Resurrection. Despite the fact that the landscape determines the mood of the whole picture, it has been used for both a pagan and a religious subject. In his youth Titian was decisively influenced by Giorgione, and his early works include several in the Giorgionesque idyllic vein, above all *Sacred and Profane Love*, an enigmatic idyll with its twin Venuses, one naked and one clothed, with contrasted landscapes behind them – a serenely beautiful painting which, however, has a different quality from the more deeply haunted mystery of Giorgione. Nearly every summer Titian returned to his birthplace, Cadore, in the valley of the River Piave, with which he retained strong links; and the hills, woods and castles of his native countryside feature constantly in his landscape backgrounds. As he grew older he gave more and more attention to the play of light, his style growing broader and more impressionistic. But despite the beauty and interest of Titian's landscapes, the true heir to the poetry of Giorgione and his landscapes of mood was to be a northerner, Claude, whose ideal landscapes were to develop in the next century from a fusion of the southern and northern traditions.

*Above and detail opposite*
Giorgione, *Landscape at Sunset*. National Gallery, London.
Giorgione further developed Venetian sensuality and light into idyllic pastorals in which, as here, the story involving the small figures is obscure. So the principal subject becomes the poetic mood of a rocky landscape at sunset, with a mysterious lake from which some strange creature is emerging.

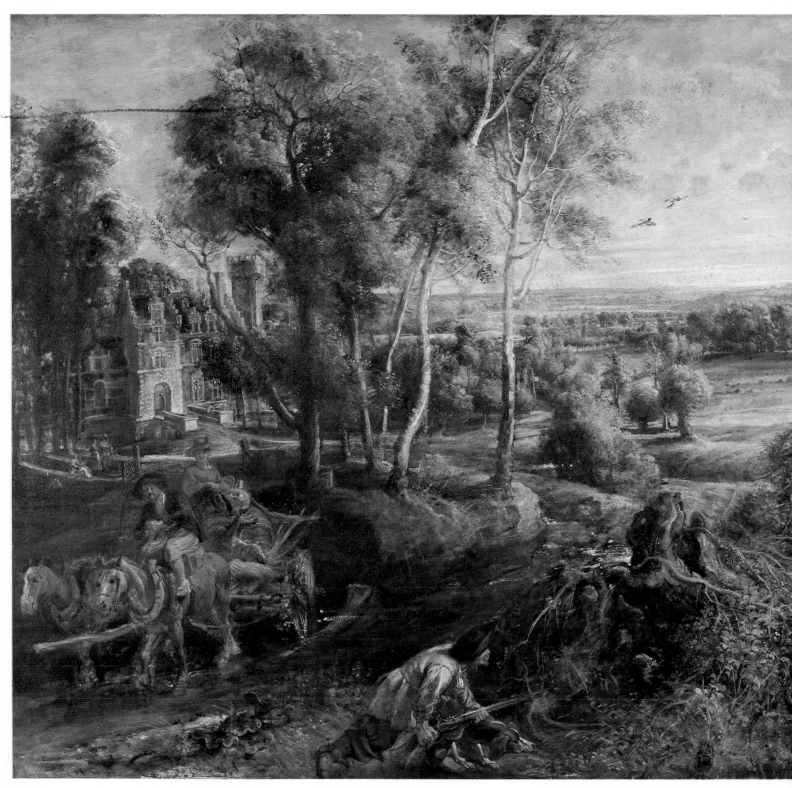

Peter Paul Rubens (1577–1640), *Autumn: the Château de Steen*. National Gallery, London. Rubens' landscapes are the product of the autumn of his own life, when he retired to this moated, turreted château and painted his own country-side. Though this is a panoramic view, the tangled undergrowth in the foreground reflects his pleasure in the intimate details of nature. And the cloud-flecked sky with the sun low on the horizon gives a wonderfully atmospheric effect to this mellow autumnal picture.

# Chapter Three
# The Ideal and the Romantic Picturesque

Adam Elsheimer (1578–1610), *Flight into Egypt*. Alte Pinakothek, Munich. There was a long northern tradition of interest in effects of light, such as moonlit scenes further lit up by fires. And Elsheimer is noted for the effective contrast he makes between different sources of light in the same picture. Here the scene is not only lit by moonlight but also by firelight and torchlight. Such effects of light influenced Rembrandt, whose own *Flight into Egypt* may well have been inspired by this painting; and Rubens, whose *Moonlight Landscape* also began as a flight into Egypt, though he then painted out the figures and made it into a pure landscape, one of the most poetic in all art (in a private collection).

The 17th century saw a radical change in the emphasis on landscapes in art, as pure landscape increased in importance. In Holland northern realism developed into a naturalistic vision which would later evoke a shock of recognition from the British Romantic poets and painters. But this Dutch naturalism took a long time to be fully appreciated in other countries, where the Dutch painters were often accused of following nature too slavishly, instead of selecting and idealizing her scenes as the painters of picturesque landscapes in Italy were doing. By about 1640 both the ideal landscapes of Claude and the more wildly romantic paintings of Salvator Rosa were on their way to becoming the dominant fashion; and they were to remain so for about 150 years, exercising a profound influence on the development of landscape in countries such as Britain.

These picturesque landscapes emerged out of a cross-fertilization of the two distinct traditions of landscape in the European Renaissance art of the 15th and 16th centuries. The northern, expressionistic tradition blended detailed observation of nature with fantasy, projecting the artist's emotions on to the dark northern woods. The southern tradition was the product of the lighter, sunnier climate of an idealized classical Italy. But there was a continual movement of Flemish and German artists to Italy, and the resultant blending of north and south in their work gave rise to the new ideal landscape of the 17th century.

One of the key figures in this cross-fertilization was the German landscape artist Adam Elsheimer (1578–1610). In 1600 at the age of 22 he settled in Rome, where he spent the last ten years of his brief life. This life was a complete contrast to that of his much longer-lived friend Peter Paul Rubens (1577–1640), a successful court painter and diplomat who employed a whole studio of assistants to help him produce more than three thousand paintings. In a letter expressing his grief at Elsheimer's death, Rubens attributed Elsheimer's small output to 'his sin of sloth by which he has deprived the world of most beautiful things, caused himself much misery and finally, I believe, reduced himself to despair; whereas with his own hands he could have built

up a great fortune and made himself respected by all the world.' Other reports say that Elsheimer was afflicted with melancholia, and that this prevented him from working. In size too his paintings contrast with those of Rubens, the master of northern Baroque, whose pictures tend to be on a huge scale: all Elsheimer's paintings are small, painted on copper with minute attention to detail. Landscape painting is a poetic rather than a narrative art, and with Elsheimer it became specifically romantic, a deliberate creation of atmosphere and mood for its own sake. He had a lyrical temperament which gives his intense little works a charm that is enhanced in his nocturnal scenes by his understanding of the effects of light, which so appealed to Rembrandt and Rubens. Though small in size and quantity, Elsheimer's works exercised a huge influence on the development of 17th century landscape. As Kenneth Clark has said, 'Rubens, Rembrandt and Claude each took from him something decisive in their development, and what is more extraordinary, each took something different.'

One result of Elsheimer's influence was a movement away from paintings celebrating seasonal activities towards the rendering of specific light effects. Rubens, for instance, painted sunset landscapes, a moonlight landscape, and two rainbow landscapes, though at first he had accepted the view that landscape was for specialists, who would paint an elaborately developed background full of animals and plants, as Jan Bruegel had done for Rubens's *Adam and Eve*. Though landscape backgrounds play an important part in many of his magnificently flamboyant Baroque paintings, Rubens's pure landscapes were done sporadically, mainly for his own pleasure rather than for patrons. They include imaginary scenes with some classical legend as their theme, and 'gardens of love', elegant pastoral diversions which anticipate Watteau, who greatly admired them. But Rubens really developed into a pure landscape painter only late in life, after he had bought his country house, the Château de Steen, in 1635. Being a landowner not only proclaimed his social position, but allowed him time to wander around his own grounds, making countless drawings and studies for the sheer joy that he felt in nature, in all the ordinary but delightful aspects of rural domesticity which surrounded him – fallen trees, blackberry bushes, wattle fences, a horse and cart. Here Rubens communicates a particularly intimate feeling, for his subject is not just landscape in general but a particular, personally relevant area, the land around his home. The Belgian countryside round the Château de Steen, which still exists, is actually flatter and less interesting than Rubens makes it, since he transforms it by his use of rhythms and undulations, and by his grasp of atmosphere. No one has caught better than Rubens the poetry of landscape, the fact that it involves not just topographical accuracy but the projection of a mood. This was a vision of nature to which Constable responded eagerly: 'In no other branch of art is Rubens greater than in

Elsheimer, *Tobias and the Angel*. National Gallery, London.
Though Elsheimer's works have titles and themes from the Bible or from Ovid, it is the landscape which plays the principal part. Here the light diminishes as the trees grow thicker around the dark lake, so that the spectator is drawn into the mysterious depths of an intensely poetic, tranquil landscape which anticipates Claude.

landscape; the freshness and dewy light, the joyous and animated character which he has imparted to it . . . the departing shower . . . the exhilaration of the returning sun . . . impressing on the level monotonous scenery of Flanders all the richness which belongs to its noblest features.' And when Rubens turned to the moonlit night scenes which have so often stirred the imagination of artists, his projection of a serene reposeful mood could produce a painting of magical poetic beauty.

Many other northern artists contributed to the fusion of northern and southern traditions; that was to create the new synthesis of ideal classical landscape. For example, the Flemish painter Paul Bril (1554–1626), who spent most of his life painting landscapes in Italy. But it was a Frenchman from Lorraine, Claude (1600–82), who brought this fusion to full fruition. Elsheimer's landscape of mood created by poetic lighting effects was developed by Claude in a completely novel way. For whereas the German artist had painted *night* scenes, Claude changed the tradition fundamentally by bringing it into the *daylight*, looking into the sun, so that the whole countryside was transformed with a blaze of golden light. One of the sources of Claude's continuing appeal is the spacious feeling of air, light and golden sunshine which he derived from his direct study of nature. But equally important was their classical order and form, through which he projected a dreamlike feeling of contemplation as the eye is drawn into the depths of his landscapes, into vast, light-laden distances. The very nature of light itself was a highly controversial subject during the 17th century, and light was approached in a very different way by the practical Dutch, playing an important part in the rise of their natural vision of landscape. But for Claude it remained essentially a mysterious natural force, transforming everything on which it shone.

An enormous amount of preparation went into Claude's finished landscapes, an essential element being the sketches which he made direct from nature in the countryside around Rome. These sketches still look incredibly modern, since his drawings are unequalled for their subtle observation of trees, banks, rocks and effects of light. Claude's earliest biographer, his friend the German painter Joachim Sandrart, tells us that he went out before dawn to draw direct from nature, often lingering until sunset, eagerly observing 'the changing phases of dawn and the rising and setting sun', the long shadows of early morning and evening, and even the effects of moonlight. Claude's paintings are therefore based on a study of nature as intimate as that of Constable or Monet, and they all convey his reaction to one particular type of scenery: the countryside around Rome, with all its rich classical associations. But the observation of nature was not for Claude an end in itself, and when he came to build up his paintings in the studio, all this careful observation of natural fact was subordinated to a poetic conception of landscape which continues the idyllic, pastoral mood created by Giorgione. These landscapes are often described as Virgilian, because their pastoral Arcadian mood resembles that of Virgil's *Georgics*: the sense of an idyllic life in a golden age, of an ideal ordered world apparently static and stable, of perfect harmony between man and nature, which is mastered, civilized and arranged into the planned paradise of a formal garden. It was above all Claude who, by creating this dreamlike vision, opened men's eyes to the sublime beauty of nature. During the century after his death travellers would judge real scenery according to the 'picturesque' standards he had established, admiring a view only if it was worthy to be the subject of a picture by Claude. And in the 18th century rich English connoisseurs not only began to discover the beauties of picturesque scenery in their own country, and so encourage the growth of a British school of landscape painting, but they even modelled their gardens and estates on Claude's dreams of ideal beauty.

Claude went much further than Giorgione in reducing his figures to a very small size, although he never painted pure landscapes without some human presence. Usually Claude's figures represent the characters in some classical myth, and since they play such a minor role it might seem that they are unimportant, merely providing the paintings with their titles. Yet they certainly meant a lot to Claude himself, and in his later years he tended to choose these mythical incidents more and more carefully for their appropriateness to the mood which he wanted to convey. That mood was the sort of bitter-sweet nostalgia that Virgil called *lachrymae rerum*, the mood of poetic sadness which scenes of natural beauty evoke by suggesting the transitory nature of life and the almost complete disappearance of many centuries of human history. Claude lived in Rome, then a small and picturesquely beautiful city dominated by the ruins of its classical past, which had left its imprint on the surrounding country, and which had been made the more vivid by the special interest the Renaissance had taken in its achievement. These factors had an enormous impact on the other great French painter of ideal landscape, Nicolas Poussin, whose career also brought him to Rome. Poussin and Claude were temperamental opposites such as often appear as contemporaries in the history of the arts (Brahms and Wagner, Constable and Turner, Reynolds and Gainsborough). Poussin, with his passion for Stoic philosophy, was deeply interested in the whole question of the relation between man and nature, whereas Claude's reaction to nature and light was more romantic. One French critic has summed up the difference by saying 'Poussin is a brain, Claude is an eye.'

Yet for Claude the Roman countryside was not just what he could see, but the whole web of its past and the legends which had grown up around it, such as the story of Aeneas sailing

*Right* Rubens, *Landscape with a Sunset*, after 1635. National Gallery, London. Rubens' sunset landscapes are marvellously atmospheric idylls in which the northern sky is characteristically lit up by the golden glow of the setting sun. This is a landscape of repose in which a shallow stream meanders through the gentle countryside, its few trees reflected in the water, while a shepherd pipes to his flock of sheep whose bodies catch the last rays of the setting sun, all helping to create the peculiar magic of this special time of day.

*Left* Claude (1600–82),
*Trees and Banks*. Chalk
and brown wash. British
Museum, London.
A sketch direct from
nature in which the forms
are caught rapidly in
washes of colour, without
any strengthening outlines
but through light and
shadow, to give the very
essence of a sandbank
crowned by trees. Such
drawings show the
immediacy of Claude's
direct response to nature,
and the minute study that
he made of the actual
details of natural forms.
His sketches have indeed
been compared in their
sense of light and
responsiveness to visual
detail with the work of the
impressionists. But for
Claude such sketches were
not ends in themselves,
since he was interested not
merely in sense perceptions
but in the imagination,
which imposes order on
the visible world.

*Left and detail opposite*
Claude, *Landscape with
Hagar and the Angel.*
National Gallery, London.
Only a small painting, yet
the whole composition is
arranged to draw the eye
in and give a feeling of
infinite distance, a sense
of huge lonely spaces in
which man is dwarfed. The
biblical subject is the story
of how Hagar, maid to
Abraham's wife Sarah,
flees into the wilderness
on discovering she is
pregnant by Abraham, but
is persuaded to return
home by an angel. But the
mood is one of pastoral
enchantment, of a world
bathed in air, light and
golden sunshine. The
painting was copied by
Constable who according
to his first biographer,

C. R. Leslie, 'looked back
on the first sight of this
exquisite work as an
important epoch in his
life'.

*Below* Claude, *Pastoral
Landscape with Cephalus
and Procris,* 1645.
National Gallery, London.
A serene countryside at
evening, with the setting
sun casting long shadows
as the cattle splash
homewards through the
ford, and their herdsman
sits negligently on a tree
trunk in the stream. The
eye is led by contrasts of
light and shade to a
horizon where distant hills
are bathed in the golden
glow of the setting sun.
But Claude is aware of the
fragility of his nostalgic
vision of a golden age of

serene beauty. For time
and change are about to
erupt into this timeless
world, as the goddess
Diana reconciles the
faithless Cephalus to his
wife, and makes a present
of the unerring spear with
which that keen huntsman
will finally kill Procris.

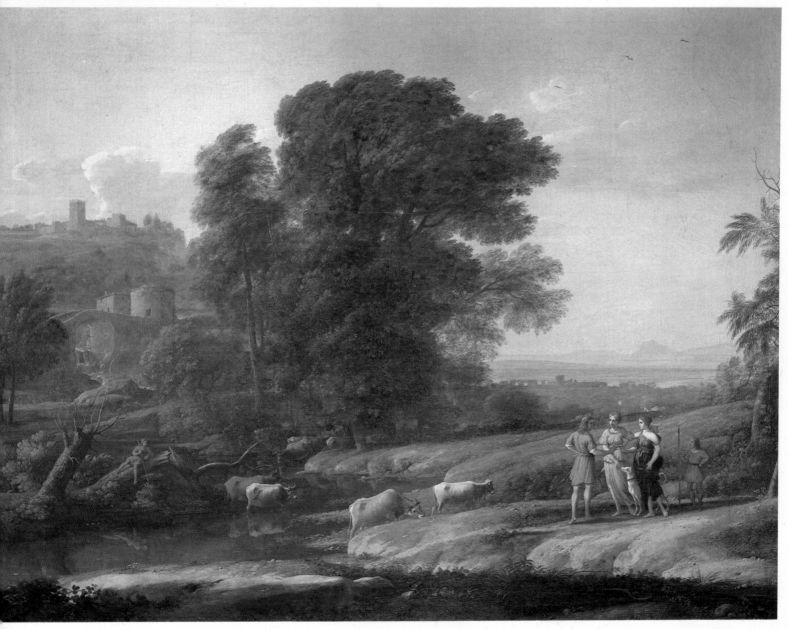

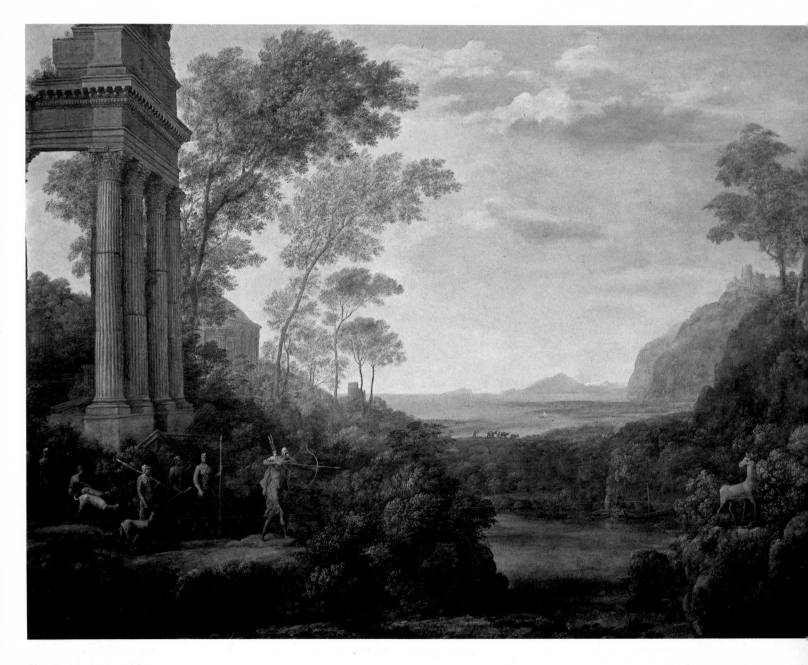

Claude, *Landscape with Ascanius shooting the Stag of Silvia*, 1682. Ashmolean Museum, Oxford.
The Roman Campagna where Claude painted is full of classical memories, and the countryside was for him not just what he could see, but the whole web of its past and the legends which had grown up around it, including the story of Aeneas sailing up the Tiber to found Rome. His very last painting is a seemingly quiet pastoral landscape, but shown at a typical moment of tension. For the trees behind Aeneas' son Ascanius bend in an ominous wind as he fires the fateful shot which will lead to war with the local tribes.

up the Tiber to found the city of Rome. And in a way the figures in Claude's paintings have a similar function to the ruins that were to play such a prominent part in the 18th century Roman landscapes of Panini, Piranesi and Hubert Robert: they indicate the inevitability of change over time. Claude's choice of these stories, myths and legends shows his constant awareness of the fragility of his Apollonian dream, and of the Dionysiac human passions which can disrupt this man-made classical order. The threat of violence is often just below the calm surfaces of these pictures, though this element of Claude's vision tends to be lost on a modern audience unfamiliar with Ovid and Virgil. For Claude often chooses a moment in the story which, though not very dramatic in itself, is pregnant with future consequences. Thus in *Cephalus and Procris*, at first sight a tranquil painting of cattle fording a stream, the small figures include the goddess Diana giving Cephalus the spear with which he is later

to kill Procris by mistake. Claude loved the poetry of Virgil, and in the last years of his life he painted a series of six canvases based on the story of Aeneas. Yet even though the *Aeneid* was a popular source for artists, the scenes chosen by Claude had not been used before. They were carefully chosen by him as critical moments of tension illustrating such incidents as Dido and Aeneas setting out for the fateful hunt during which they are to be overwhelmed by the storm of love; Ascanius shooting the sacred stag of Silvia, an action which leads to the storm of war; and Aeneas landing at the spot on which Rome is later to rise and conquer the world.

This awareness of the fragility of the Apollonian dream of order and of an innocent golden age is even more strongly present in the work of Nicolas Poussin (1594–1665). Like Claude he spent his whole working life in Rome, but in most other respects he was a complete contrast. Claude belongs to the long line of

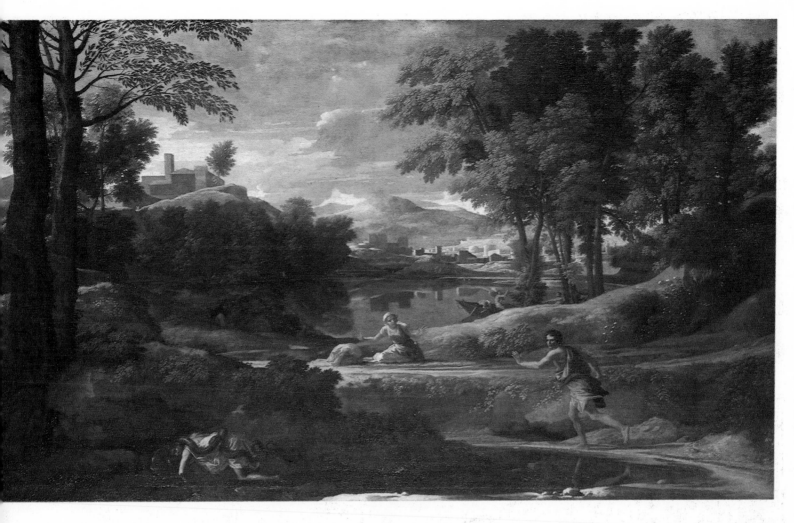

turalist landscape painters from the north ho worked in Rome; Poussin, though he was rn in Normandy and spent his youth in Paris, rried on the tradition of the Italian High enaissance. Whereas Claude's landscapes con- n very small figures, in Poussin's paintings the ures are usually dominant, so that the land- apes are only backgrounds. And where Claude's dscapes are poetic and evocative, receding to a stant horizon, Poussin's are closed and ration- y ordered.

Poussin was one of those rare artists who inted primarily to express his ideas, which rang from a deep interest in classical history d philosophy, and especially Stoic philosophy. s early works are small poetical paintings with bjects drawn from classical mythology, many of em – for example the death of Adonis – dealing th the cyclical processes of nature, with death in nter and rebirth in spring. When Poussin turned to these themes in later life it was with almost pantheistic feeling, with nature even re powerful and man by comparison insignifi- nt. Anthony Blunt, in his major study of ussin, has argued that his paintings are not so ch pictures of myths as of 'the origins of yths in the primitive feelings of man about ture'. Inevitably, therefore, they are about ange, since this is the great reality of nature. e of Poussin's most famous paintings is a

sunny southern landscape in which a group of young people are gathered round a tomb, reading its inscription: *Et in Arcadia ego*. Death is present even in the idealized land of Arcadia, for it is the inevitable consequence of life. This realization that the reality of biological life is constant change is the basis of Taoism and therefore of Chinese landscape, and was also present in Greek philo- sophy in Heraclitus. It was indeed still present in the later Greco-Roman philosophy of Stoicism, though since that stressed the rationality of the universe, holding that nature was strictly gover- ned by unbreakable natural laws, change was presented here as divine providence arranging the course of history so that the world moved towards its destined goal – an idea essentially similar to the Christian view of history as the working out of a divine plan. Poussin certainly believed that the universe was governed by unbreakable natural laws, with a God who was essentially a mathematician and whose world was one of order, law and exact measurement. Poussin's landscapes are so organized that it almost seems that he wants to impose a static pattern of order on them which will deny the reality of change and trans- ience and death. Poussin tried to give landscape an appearance of order and permanence, 'fleeing confusion', as the artist himself expressed it, to create a calm world of ideal, timeless beauty. Out of the chaos of nature itself he builds a care-

Nicholas Poussin (1594–1665), *Landscape with a Man killed by a Snake*, probably 1648. National Gallery, London. This is a landscape of mood, expressing a human emotion which is made even more explicit in the subtitle it soon acquired: 'The Effects of Terror'. The scene recreates an actual incident in the snake-infested country south of Rome, but contemporary writers saw it as a general study of fear – of human reaction to the evil, destructive force in nature. In every garden of Eden there is a snake, the dream of 'order' is always disrupted. Yet although the landscape is based on an actual location, Poussin has idealized it, creating a carefully ordered scene out of the chaos and flux of nature.

Gaspard Dughet, called Gaspard Poussin (1615–75), *A Road near Albano*. National Gallery, London.

Gaspard was Poussin's pupil and brother-in-law, and took his name. But to Poussin's Apollonian dream of imposing an idealized static order on the reality of change and transience in nature, Gaspard added something of the romanticism of Claude, and his own particular gift for straightforward naturalism. The resulting blend made his work immensely popular, and in the 18th century he became an important influence on the supporters of the 'picturesque', those aspects of nature whose beauty had been revealed by painters.

fully ordered scene, an idealization of nature, based on the belief that nature's 'imperfections' do not merit inclusion in a work of art. Nature does not in itself contain ideal beauty because of the 'ugliness' and 'deformities' that are to be found in the real world. So a slavish imitation of nature will not produce great works of art. For that, nature must be 'improved'.

The importance of Salvator Rosa (1615–73) is that he rejected the idea that the natural world needed to be improved, and experienced a mood of awe in the presence of wild, savage nature. Instead of pursuing ideal beauty, he positively gloried in the 'imperfections' of nature. If Claude's symbols of serenity and idyllic peace are the archetypes of the classical picturesque, there was also a more romantic picturesque deriving from Salvator, who was largely responsible for the common identification of the picturesque with the wild and the savage. He too used landscape to suggest a mood – not the serene tranquillity of a golden age of innocence, but a sense of the might and vastness of nature, of the wild and untamable quality of great rocks with waterfalls

thundering over them, dwarfing men who a[p]proach them.

This contrast between Claude's quiet pasto[ral] beauty and the wild, rugged, bandit-haunt[ed] scenes that Salvator Rosa loved to paint, refle[ct] great differences of character and temperamen[t]. Neither artist was at ease in society. The gent[le] Claude withdrew to become a romantic dreame[r] introducing the contemplative spirit into lan[d]scape painting. Salvator Rosa, from the turbule[nt] city of Naples, was a rebel against society, [an] aggressive exhibitionist, a sort of Byron of t[he] 17th century, a melodramatic personality w[ho] gathered many legends about him. What he d[id] have in common with his age was the full-bloo[ded] theatricality of the Baroque. Poet, actor a[nd] musician as well as painter, he longed to excel [in] all things. Though he was psychologically a reb[el] stories claiming that he actually lived with t[he] bandits whom he loved to portray in the wild a[nd] rugged landscapes of southern Italy are probab[ly] inventions. Even his violence was probably mo[re] intellectual than physical. But he expressed t[his] violence in pictures of topographical and son[...]

Salvator Rosa (1615–73), *Grotto with Waterfall*, c.1640. Palazzo Pitti, Florence.

The contrast between Claude's ideal, tranquil pastoral landscapes and the wild, rugged scenes that Salvator Rosa preferred reflect great differences of character and temperament as well as of aim. Salvator too used landscape to suggest a mood, but in his case it was a sense of the might and vastness of nature, the thrill of the wild and untameable. This is a good example of his choice not of calm or idyllic scenes, but of fierce spectacular examples of savage nature. The figures are physically and spiritually dwarfed by the natural grotto and the mighty waterfall dashing down the rocks.

Rosa, *Landscape with a Bridge*, Galleria Palatina, Palazzo Pitti, Florence.
A line of horsemen crosses a precarious, partly broken bridge in fantastic scenery. While the landscapes of Claude and Poussin are idealizations of the gentle rolling countryside of the Roman Campagna, Rosa's landscapes are based on a different type of scenery, the wilder mountainous regions of the Apennines and Calabria. These had become refuges of bandits, some of whom appear in Rosa's paintings. They make scenes in which geographical wildness is matched with human wildness, helping to create the legend of the romantic, 'bandit' Rosa.

times also of human wildness, with picturesque crags and ruins, hermits and gypsy encampments, and also paintings of witches which reflect the 17th century fascination with the occult.

Spanish-ruled Naples at the time of the Masaniello rising (1647) was certainly a violent place, even if the gangster-like activities of some of its artists have been exaggerated. The Spaniard Jusepe de Ribera, for example, is credited with driving away his rival Guido Reni, who fled from the city after the murder of one of his assistants; he is also supposed to have persecuted the harmless Domenichino, one of the pioneers of the classical ideal landscape, sending him threatening letters, mixing dirt in his colours, and finally causing his death in 1641, either by grief or poison. Salvator Rosa may have worked for a time with Ribera, but the romantic story that he took part in the 1647 uprising is as apocryphal as most of the legends about him: he had long since left his native city to work in Rome.

Before leaving Naples as a young man, Salvator Rosa seems to have made oil sketches from nature which became the basis of his coast scenes. Claude too is reported to have made such oil sketches, though none have survived by either artist, since they were never intended as finished work. Salvator hoped to be successful as a history painter, an ambition which many later landscapists were to share. Like Poussin he adopted the then fashionable doctrine of Stoicism, and though it was not in his character to practise the renunciation of worldly ambition and material goods, he chose such subjects from the lives of the Greek philosophers for his paintings. One of these shows the Cynic philosopher Diogenes making his supreme renunciation: having reduced his possessions to a coarse cloak, a staff and a drinking bowl, he sees a peasant boy drinking water from a stream by cupping his hands, and throws away his bowl. Such scenes were no doubt implicitly critical of the corrupt city life of

Salvator Rosa, *Landscape with Hermit*. Walker Art Gallery, Liverpool. In a surviving letter Salvator Rosa describes a journey he made from Ancona to Rome via Assisi as 'beyond all description curious and picturesque, much more so than is the route from here to Florence'. And he goes on to express his love of wild mountain scenery, and of the solitary hermitages in the mountains, which profoundly impressed him. This is one of several paintings of such hermits in which he uses landscape to inspire a mood of religious fear and exaltation, with massive tree-covered rocks and stormy skies looming over the tiny isolated figure of the hermit.

Salvator Rosa's day, though they were valued and praised primarily as landscapes. To Salvator this too seemed a form of persecution, and he was one of the first artists to try to break the stranglehold of patronage and sell his works by exhibiting them. Yet it was as a landscape painter that Salvator Rosa made his significant contribution to art, and to later attitudes towards nature, on which his influence was profound. His character led him to respond to a different kind of countryside and scenery from other landscape painters in Italy. These, like Claude, mostly worked in the Roman Campagna, with its open plains, gentle hills and ancient ruins; whereas Rosa was attracted to the rugged, barren, mountainous regions of the Apennines, and to the rocky coasts. Claude and

Salvator Rosa exemplify the twin poles of Romanticism: nostalgia for an idyllic past, and a feeling for the wild, grand and terrifying aspects of nature, later to be characterized as 'the sublime'. As the taste for mountains, waterfalls, lightning and storms at sea grew during the Age of Reason, Salvator Rosa's paintings helped to popularize the sort of wild, dramatic scenery to which the Grand Tourists had been introduced in crossing the Alps. Horace Walpole described his journey over the Alps in 1739 in terms of 'Precipices, mountains, torrents, wolves, rumblings – Salvator Rosa'. And so, like Claude, he became a special cult with the English, and helped to influence the rise of British landscape painting in the 18th century.

# Chapter Four
# The Natural Vision of the Dutch

Rembrandt (1606–1669), *The Stone Bridge*, 1637 or 1638. Rijksmuseum, Amsterdam. Rembrandt's expressive intensity often owes much to his masterly use of light, and his interest in effects of light is already seen in his early pictures painted in his home town of Leyden. While he was living in Amsterdam he made a passionate study of landscape on walks just outside the city, mostly in drawings and etchings, but with an occasional painting, like this little landscape with a stone bridge. Seen in the late afternoon as the sun sets and storm clouds gather, it is dramatically characterized by the intense contrast between the lively glare of the sun and the menace of the dark clouds.

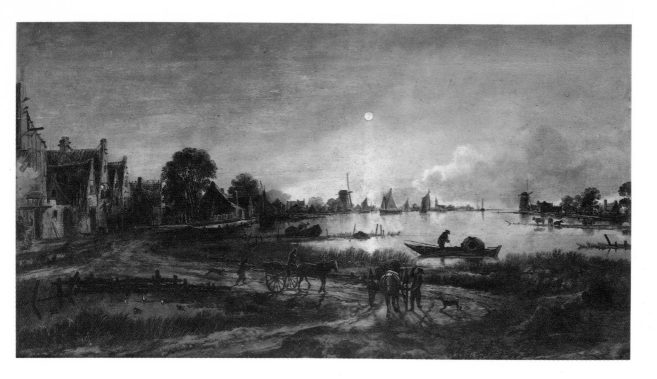

Aert van der Neer (1603–1677), *River by Moonlight*. Rijksmuseum, Amsterdam.
The nature of light became one of the central scientific problems of the 17th century, particularly in Holland. But interest in light had long been a speciality of northern painters, and many other Dutch artists besides Rembrandt were fascinated by its effect. The Amsterdam painter Aert van der Neer is famous for his twilight scenes, or for nocturnal scenes in which moonlight transforms the flat Dutch landscape, giving it a mysterious fascination.

One of the most surprising things about the Renaissance and Reformation is just how little basic philosophical or religious beliefs were changed, despite the intensity of ideological conflicts. It was the 17th century that witnessed what has been called the Great Intellectual Revolution, during which fundamental assumptions about the nature of man and of the natural world were overturned. This scientific revolution proceeded furthest in England, where Newton's work seemed to have laid bare the very heart of nature. Pope summed it up in his famous lines

Nature and Nature's laws lay hid in night:
God said, 'Let Newton be!' and all was light.

But in art it was the Dutch painters who held up a mirror to nature and produced thoroughly naturalistic landscapes. The passion for accurate observation which played a large part in this was reflected in science itself, for the study of light was a Dutch speciality. The Dutch mathematician Christian Huygens (1629–95) proposed the wave theory of light to account for its behaviour; the philosopher Spinoza earned his living as one of the Dutch lens-grinders who were creating telescopes which could penetrate further into space; and the microscope, as van Leeuwenhoek discovered, could reveal a whole new world in a drop of water.

Another factor in the growth of Dutch landscape was the sense of national pride that followed victory in the long struggle for independence. The victory was only partial, since the Flemish provinces of the south remained Spanish and Catholic, and this led to a stylistic polarization of painting in the Low Countries. Rubens, from the Catholic south, became the greatest master of northern Baroque art, while the Protestant Dutch developed a naturalistic art which in effect comprised a portrait of their country in all its aspects

– people, cities and scenery. The northern belief that painters should take their subjects from the natural world already had a long history, and the realistic Flemish tradition of landscape was brought north by the emigration following the fall of Antwerp to the Spaniards in 1585. But the society in which Dutch artists had to sell their work was very different to previous societies dominated by kings, princes and churchmen. The Netherlands was a hard-headed mercantile society in which classical and religious myths were giving way to modern secular images, and prosperous middle-class merchants wanted clearly recognizable, unidealized views of their own country. But if Dutch landscape painting was to be more than a merely factual account of topography, its practitioners had to develop a style which could create mood and poetic atmosphere.

This might have seemed difficult in such a flat land, yet it was the very flatness which became a key element in Dutch landscape. Dutch artists were the first to discover the beauty of the sky, which Constable was later to call 'the chief organ of sentiment'. They made a virtue out of the flatness of the land by emphasizing the majesty of Holland's vast cloudy skies and distant horizons. The Flemish landscape painters, even Bruegel, had kept a high, panoramic viewpoint, instead of making use of the basic fact that these were the Low Countries, so that especially in the northern provinces, it was difficult to find a high vantage point from which to paint a long view. And so it was left to the Dutch to discover that a satisfying picture could be made out of the unpretentious natural beauty of an ordinary scene.

One of the pioneers in this was Jan van Goyen (1596–1656), whose sea and river views show a steady development away from the artificially picturesque style he inherited from his teachers.

*Right* Jan van Goyen (1596–1656), *View on the Meuse, Dordrecht*. Rijksmuseum, Amsterdam. The low-lying land at the river's mouth means that the windmills and Dordrecht's Great Church with its unfinished tower are low on the horizon, with the picture dominated by the sky which floods the whole scene with a glow of golden light. As van Goyen's art freed itself from the incidental narrative interest of human details in a landscape to concentrate on space, light and atmosphere, so he also freed himself from spots of bright local colour to put the emphasis on Holland's sweeping skies, painted in low-key tonalities like the brown and gold of this richly luminous river scene.

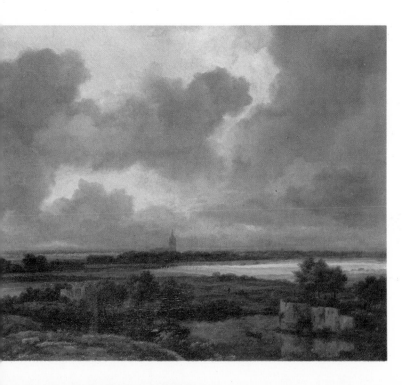

*Left* Jacob van Ruisdael (1628–82), *An Extensive Landscape with a Ruined Castle and a Village Church*, (c.1665–70). National Gallery, London. A panoramic view where the flatness of the countryside, broken only by the church tower, emphasizes the excitement of the cloudy sky on a windswept day. Dutch artists were the first to discover the beauty of cloud-filled skies, which play such a prominent and poetic part in Ruisdael's romantic scenes. As Constable observed, 'Ruisdael delighted in, and has made delightful to our eyes, those solemn days, peculiar to his country and to ours, when without storm, large rolling clouds scarcely permit a ray of sunlight to break the shades of the forest. By these effects he enveloped the most ordinary scenes in grandeur.'

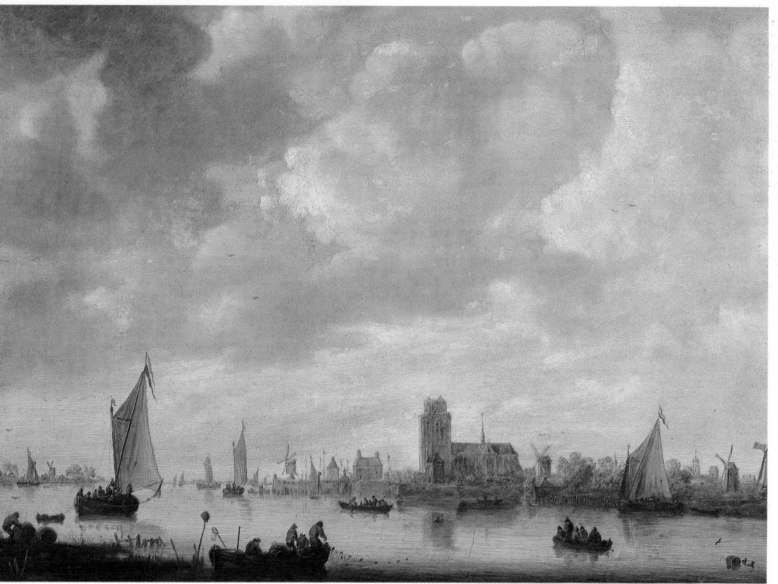

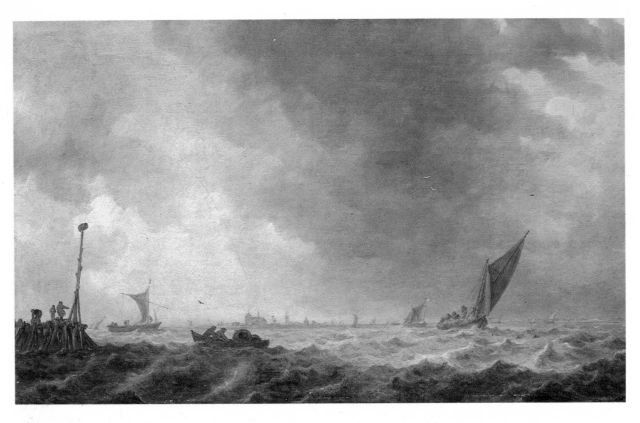

*Left* Jan van Goyen, *Seascape with a Jetty and a Distant View of the Town of Veere*, 1639. Castle Museum, Norwich.
The sky increasingly comes to dominate van Goyen's paintings, and here the town is reduced to an outline on the distant horizon, so that the picture becomes primarily an elemental one of rough sea and clouded sky. The vast sky with its scudding clouds conveys a tremendous sense of airiness. But the water is also faithfully portrayed, since these are no mere stylized waves, but give a real feeling of the choppy sea at the mouth of a Dutch estuary.

*Right above* Rembrandt (1606–69), *Landscape with a Coach*, 1640–5. Wallace Collection, London.
In contrast to Rembrandt' closely observed realistic drawings of scenery, his few landscape paintings (just over a dozen are known) are intense dramas of light and shade, having a deeply searching quality into the infinite universe and man's part in it which parallels the introspection of his self-portraits. The poetic atmosphere is enhanced by his choice of times when the elements appeared threatening or sublime, as in this brooding painting, which evokes an eerie world of twilight mystery.

*Right below* Rembrandt, *Three Trees*, 1643. Etching. Metropolitan Museum of Art, New York.
In his landscape drawings and etchings Rembrandt always shows a steady, objective grasp of the natural world, yet with an ability to endow it with intense emotional overtones that make works like this small masterpiece of poetic mood. Behind the three trees which dominate the foreground, a whole vast panorama of endless space opens up, full of sunlight and the movement of wind and clouds. The small human figures at the extreme left emphasize by contrast the vastness and overwhelming power of nature.

Gradually his art freed itself from concern with the incidental narrative interest of boats, figures and buildings, and became centred on space, light and atmosphere. But the topographical basis of van Goyen's art was crucial, for as soon as he started to abandon the high, panoramic viewpoint of earlier compositions and paint the low, flat empty land, with its distant horizons easily lost to sight, what he was left with and began to capture was the quality of light and air in a scene, or the movement of clouds across the sky. And as he moved away from picturesque anecdote to poetic landscape, he developed a distinctive manner of his own, creating almost monochrome landscapes in browns and greys, with brilliant touches of red and blue that stand out and catch the eye.

Apart from some unfortunate speculations in land and in tulips, van Goyen had a relatively uneventful life. Most of his paintings seem to be based on drawings made as he travelled about the Dutch countryside, and he evidently used the same drawings again and again, since the same motifs recur repeatedly in his work. But his later paintings are increasingly dominated by the sky, which often comes to occupy four-fifths of the picture surface; in his seascapes, for example, there may be ships, but it is always nature rather than man that dominates. Increasingly van Goyen's interest was in light, which becomes as much as anything the real subject, with his paintings showing how light affects the colours of the landscape so that they become paler as they recede towards the horizon.

Van Goyen's influence was to be great, reaching right down to Turner, who was to repeat almost exactly the arrangement of clouds in one of the Dutch painter's pictures in his own seascape *Antwerp: van Goyen looking out for a Subject*. Yet oddly enough van Goyen's immediate pupils, Jan Steen and Nicholaes Berchem, failed to build on his discoveries.

For the triumph of Dutch naturalism was not quite the simple process it may seem in retrospect. Berchem and his chief rival, Jan Both, were the leading painters of Italianate landscapes, profoundly influenced by Claude and the nostalgic northern longing for the south, rearranging their memories of time spent in Italy into an evocation of an ideal countryside of blue mountain distances seen through a warm golden haze of light. Claude was born just four years after van Goyen, so they were of the same generation, though their work was so different. Both made studies in the countryside for paintings which took final shape only in the studio, so it would be wrong to think of van Goyen unquestioningly accepting the scene before him and painting it on the spot. But whereas Claude transformed his studies into a nostalgic vision of an ideal land of serene beauty, van Goyen transformed the ordinary scenery of the Netherlands into compositions revealing, as he omitted the anecdotal story-telling incidents, an increasingly Turneresque concern with the basic elements of space, light and atmosphere.

Rembrandt (1606–69) was not only the greatest of all Dutch painters, but also a great graphic artist, and he adopted different approaches to landscape in the two media. His art in any case veered between the two poles of Dutch literalness and Baroque theatricality, and while his painted landscapes are intense dramas of light and shade, it is his more topographical landscape drawings and etchings which demon-

strate his great powers of factual observation. It was in these drawings and etchings that he explored his own surroundings with a passionate intensity that anticipates Cézanne's absorption in his native Provence. Especially during the fifteen years between 1639 and 1654, from the time he moved into his new house on the Breestraat and himself became a property owner, Rembrandt drew obsessively during his walks outside the city. With something of the same introspective quality that enabled him to penetrate into the souls of his sitters in portraits, he produced drastically simplified visions of nature with a few strokes of the pen. In his landscape etchings, for example the well-known *Three Trees*, he conveys on a small scale the vastness and power of the elements which sweep over the rugged trees silhouetted against the skyline.

Landscape painting is essentially a romantic art, which frees itself from narrative and story-telling in order to concentrate on the poetic creation of atmosphere and mood. And the most romantic of the Dutch landscape painters

is Jacob van Ruisdael (*c.* 1628–82), who more than any previous artist made landscape a reflection of his own moods and feelings, and in the process brought out the full poetry of northern landscape as Claude had done for the ideal landscape of the south. As Constable said in his third lecture at the Royal Academy, 'The landscapes of Ruisdael present the greatest possible contrast to those of Claude, showing how powerfully, from the most opposite directions, genius may command our homage.' In Ruisdael's subjective approach to nature Romantic painters recognized a kindred spirit. A major factor in Ruisdael's poetry of landscape is his atmospheric language, his ever-changing skies suggest changes of mood and weather in the transient play of light and shade and the gathering clouds. This gives his paintings a great variety and range, from the heroic grandeur of a windmill rising dramatically against a stormy sky to the melancholy feeling of dissolution in his two famous paintings of the Jewish Cemetery at Ouderkerk near Amsterdam. The stormy, threatening sky above the cemetery, relieved only by the promise of the rainbow, conveys something of the sublimity of nature, and reinforces the melancholy feeling of the transitoriness of existence, suggested by the decaying tombs and the dead, lightning-blasted tree.

Ruisdael shows equal mastery of a wide range of landscapes – panoramic vistas of the low-lying countryside around his native town in his many views of Haarlem, marshy woodlands with ancient oaks, and also paintings of stormy seas. There was a whole school of Dutch marine painting whose development was closely linked with that of landscape painting as a whole, for the Dutch were as proud of the ships that had played a major part in liberating them from Spain, as they were of their native country, though many of the paintings they inspired were little more than matter-of-fact portraits of ships and sea battles, a genre which gained a new lease of life with the Anglo-Dutch struggle for overseas trade and possessions in the later 17th century. Yet many specialist sea painters were very talented, particularly Willem van de Velde the Younger, who with his father, also a sea painter, settled in England and helped to found the tradition of English marine painting which became important in the 18th century. All the same, there is a grandeur about Ruisdael's response to stormy seas that made Constable say that 'whenever he attempted marine subjects he is far beyond Van de Velde'.

Ruisdael spent the first half of his life in Haarlem, which is separated from the sea by a line of wooded dunes; there he painted many picturesque scenes exploring the effects of light and shade produced by the trees. Many of the views he painted around Haarlem can still be identified, as can later examples from his travels in Holland and Germany, where he first saw mountains. But although Ruisdael is above all the painter of his native Holland, the range of his landscapes is far

*Top* Van Ruisdael, *The Jewish Cemetery c.*1675. Detroit Institute of Arts. Ruisdael had a marvellous ability to express his feelings through landscape. Here the dead, lightning-blasted tree, the decaying monuments and ruined building, the threatening clouds relieved only by the promise of the rainbow, all help to create a melancholy feeling of constant change in nature and of the transitoriness of existence.

*Above* Van Ruisdael, *Stormy Sea c.* 1649. Stockholm. Ruisdael's temperament led him to a particular appreciation of the majesty of stormy weather. Constable said of a similar Ruisdael painting: 'The subject is the mouth of a river, without a single feature of grandeur in the scenery; but the stormy sky, the grouping of the vessels and the breaking of the sea, make the picture one of the most impressive ever painted.'

*Right* Van Ruisdael, *View of Haarlem*. Rijksmuseum Amsterdam. Ruisdael spent the first half of his life in Haarlem, a town separated from the sea by a range of wooded dunes. These gave rise to the many picturesque forest scenes of his early paintings, as well as panoramic views like this looking inland from the dunes, where his emphasis is on distance and space, dominated by a sky filled with storm clouds.

Van Ruisdael, *A Waterfall in a Rocky Landscape.* National Gallery, London. Ruisdael's later works became more and more romantic. This dramatic foaming waterfall amid rocks is not an observed landscape, but one of Ruisdael's memorably imaginative evocations of the rocky scenery of Scandinavia, which he knew only from the work of the slightly older Dutch artist Allart van Everdingen, who had spent four years there before returning to Holland to paint romantic mountain landscapes. Ruisdael uses the motifs of tall pine trees and great rocks over which tremendous torrents pour to create a wild scene in which the tiny figures on the bridge and the path are completely dwarfed, heightening the suggestion of the vastness and grandeur of nature.

wider than that offered by his immediate environment. The inspiration for his rocky hillsides and rushing waterfalls was not so much personal experience but the pine-forested mountain landscapes of Allart van Everdingen, a Dutch painter who had spent four years in Scandinavia and responded intensely to its dramatic scenery. Yet these wild scenes of great rocks over which torrents cascade, so different from the flat reality of Holland, obviously spoke deeply to Ruisdael's imagination; in his own works in this vein, he combined all his response to weather and atmosphere with these images of the vastness and grandeur of nature, creating some of his most bleakly memorable scenes.

No other Dutch landscape painter had Ruisdael's extraordinary ability to express his own feelings through their reflection in nature. But Aelbert Cuyp (1620–91) is justly famous for landscapes bathed in warm golden light, with the sky reflected in the water to achieve a complete unity of luminous atmosphere. Cuyp's special achievement was to impose the Italianate landscape style on to specifically and recognizably Dutch views. He started by painting landscapes with the same fidelity to nature as Jan van Goyen,

but then came under the influence of Jan Bot who had come back from Italy after discoverir there the golden light of the Campagna whic Claude had taught painters to see. In Cuyp hands the fusion of the two styles became visionary transformation of the Dutch countr side, suffusing with a mellow brilliance t watery coastal scenery around his native Do drecht, where the estuaries of the Maas and Rhi mingle together. These glowing effects of su

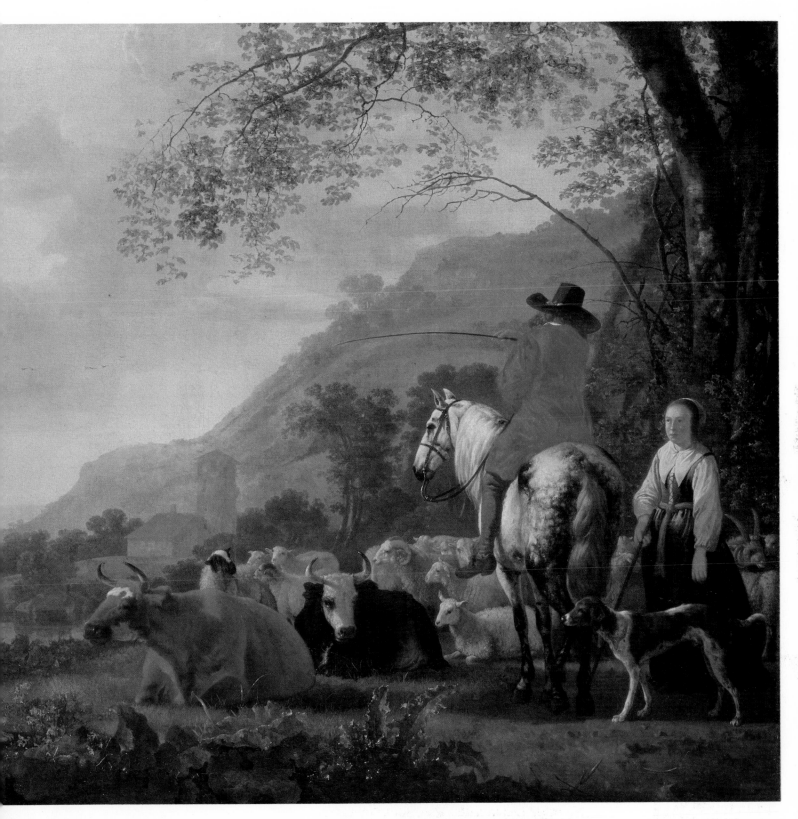

light in placid landscapes with cattle and horses made him especially popular with English collectors, who thought of him as 'the Dutch Claude', so that many of his best paintings found their way into British collections, where they were admired by Turner and Constable.

Cuyp seems to have painted little in the last decades of his life, and the same is true of Ruisdael's friend and pupil Meindert Hobbema (1638–1709), who survived into the 18th century but produced only a few paintings after taking a job as one of Amsterdam's winegaugers in 1668 – a minor post in the customs, testing the wine in casks. It has even been suggested that he was rather bored with his own paintings, for J. M. Nash argues that Hobbema's work typifies the central paradox of much 17th century Dutch painting in appearing very repetitive when seen in quantity, although every picture seems individually fresh:

Aelbert Cuyp (1620–1691), *A Hilly River Landscape with a Horseman talking to a Shepherdess*. National Gallery, London.
Cuyp's early works include two magnificent views of his native Dordrecht in a thunderstorm, with lightning rending the sky. But his typical scenes are *continued overleaf*

63

When Hobbema found a successful motif he would copy it and remake it with small variations. His formulas for building pictures were very limited: clumps of feathery trees, diverging perspectives, a shadow across a path, a cottage high-lighted by a shaft of sunlight. Yet almost every picture is, individually, as fresh and thoroughly carried through as if it were a totally novel conception.

Hobbema's landscapes, with their peaceful pools and woods and watermills, are essentially serene, and he too had a strong influence on English artists; John Crome, the best known artist of the Norwich school, is reported to have uttered as his last words, 'Oh Hobbema, my dear Hobbema, how I have loved you.' And with his last, or certainly one of his last, paintings, the famous *Avenue, Middelharnis* in London's National Gallery, Hobbema produced his masterpiece – a flat, empty landscape with an enormous expanse of sky against which a double row of tall, slender poplar trees stands out against the low horizon. There had been earlier paintings of such avenues of trees, including one by Cuyp, but the austere geometry of this one makes it a strikingly memorable image, and a fitting swan-song for the golden age of Dutch landscape painting. The conditions that had brought it into being were changing by Hobbema's day, and the fire of inspiration was dying out. Yet the Dutch had pioneered a new naturalistic vision, which would later be greeted with a shock of recognition by the English Romantic painters as they came to develop their own vision of nature. For the 17th century Dutch artists had discovered what it would take painters in other countries a century or more to realize: that anecdotal subjects and story-telling are not essential to painting, and that just as music without words can produce its own emotional impact, so can the sheer beauty of the natural world, freed from association with classical or religious myths.

*continued*
almost the opposite of Ruisdael, not storms but tranquil landscapes bathed in a warm glow of golden sunshine. The light in this wide river valley has the soft haziness of a perfect sunset. And in contrast to Ruisdael's emphasis on the grandeur of nature, figures play an important part in Cuyp's landscapes. Here the placid cows and sheep and playful dogs are all very much at home in a serene landscape which becomes the scene for a peaceful meeting of a lost horseman and a shepherdess.

Meindert Hobbema (1638–1709), *Road on a Dyke*, 1663. Sir Alfred Beit, Blessington, Ireland.

Though Hobbema was Ruisdael's friend and pupil he usually painted peaceful scenes, with little of the romantic quality of the stormy skies and gathering clouds of his master. Yet despite these differences, Ruisdael's influence on him was strong, and they often painted the same views, including many of the sandy woodlands in the neighbourhood of Haarlem. But Hobbema's woods and trees usually screen off the horizon, so that in place of Ruisdael's favourite dramatic cloud masses they have a sunnier, friendlier atmosphere, with more suggestion of space and light. This is a peaceful landscape that invites the viewer to stroll quietly through it.

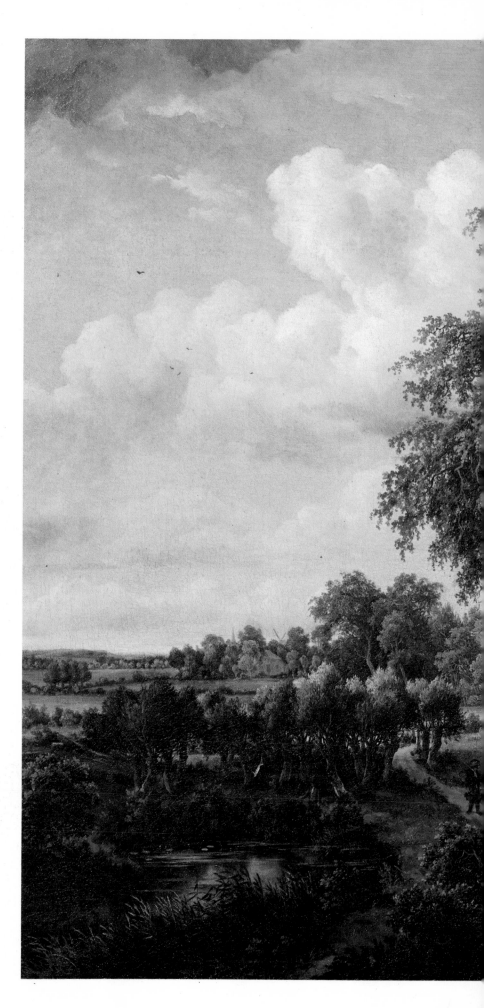

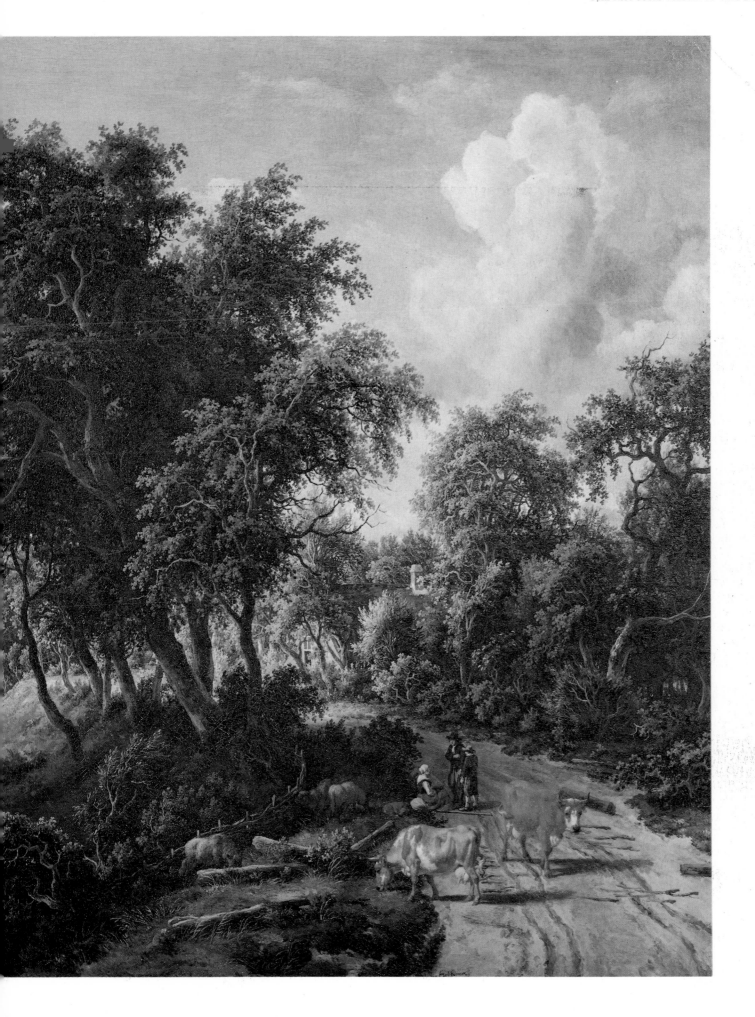

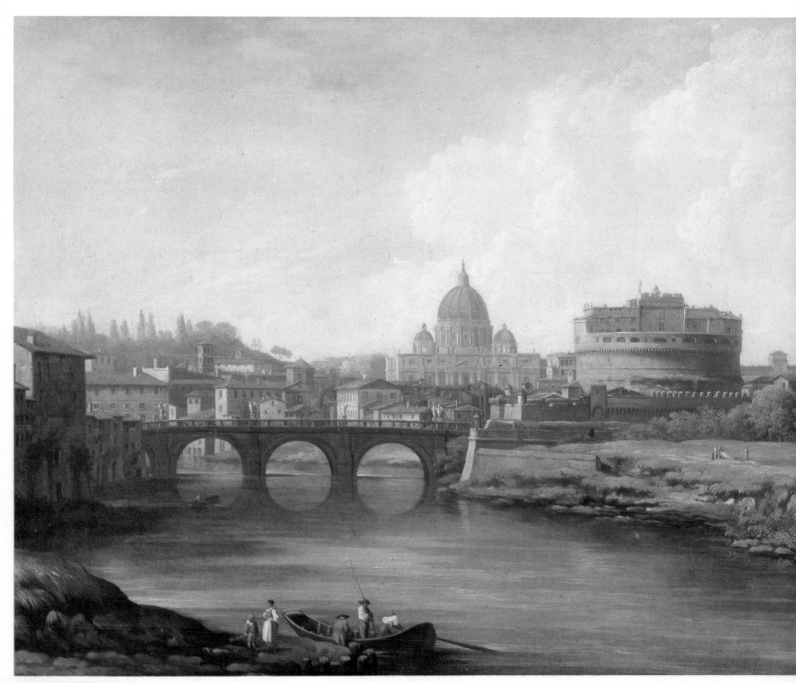

Gaspar van Wittel (known in Italy as Vanvitelli) (1653–1736), *View of Rome with Castel Sant'Angelo*. Rijksmuseum, Amsterdam. Much of Italian 18th-century landscape painting consisted of picturesque topographical views or *vedute*, especially of Rome or Venice, for sale as aristocratic souvenirs of the pre-photographic age to wealthy visitors who had come to those cities on the Grand Tour. Though the best-known of the painters of *vedute* were Italians like Canaletto, an important part in the invention of the genre was played by northern artists who worked in Rome, such as Gaspar van Wittel who was painting views of the city as early as 1681.

Wittel's work as a draughtsman on the plan to regulate the flow of the Tiber may have first inspired him to make accurate topographical drawings. This view of the Tiber shows that 18th-century Rome was still a picturesquely beautiful city, with open countryside stretching right up to the Castel Sant'Angelo.

# Chapter Five
# The Eighteenth Century in Italy and France

The 18th century is known as 'the age of reason' because the philosophers of the Enlightenment were heirs to the Galilean and Newtonian scientific revolution of the 17th century. They believed that science's achievements in the material world could be translated into philosophical terms: philosophy too, they hoped, would become a natural science, though their overoptimistic faith in reason was to be swept away at the end of the century by the French Revolution. The scientific revolution had centred on astronomy, because it was in the movements of the heavenly bodies that the laws of physics could most easily be observed. But in the 1750s the serious scientific study of natural history at last acquired its basic framework with the appearance of the two books by Linnaeus which have been adopted as the starting points for modern zoological and botanical classification.

In France Louis XIV founded a zoo and botanical garden which during the 18th century became a leading centre of natural science under the curatorship of the naturalist Buffon. His 44 volume *Histoire Naturelle* did much to popularize the subject, and he was only the first of a line of great French naturalists who included Lamarck and Cuvier. The official painter of royal hunting scenes, Alexandre Desportes (1661–1743), also painted the animals in this royal zoo, while the astonishingly unconventional landscapes in oils that he made as studies for the backgrounds in his hunting scenes are early examples of direct painting from nature.

During the 18th century a variety of fresh literary and pictorial sources contributed to the growth of a new sensibility which eventually led to close communion with and worship of nature –

an attitude that was at the heart of Romantic poetry and made landscape central to 19th century art. The 18th century was an age of collectors, and of explorers such as Captain Cook, who took naturalists and artists with them and brought back all sorts of extraordinary new animals and plants, and sketches of exotic new lands. One of these was Tahiti, visited by the French explorer Bougainville in 1767 and by Captain Cook in 1769. The idyllic life of the South Pacific islands helped to promote the myth of the Noble Savage and the return to nature and instinctive feelings preached by the Swiss writer Jean-Jacques Rousseau; reacting against the artificiality of contemporary society, Rousseau popularized the idea that man might live in harmony with nature without all the frustrations and discontents of civilization.

Such changing attitudes to nature had a profound influence on the development of landscape painting. French landscape painting is usually thought of in terms of Claude and Poussin and the ideal landscapes of the 17th century, or of 19th century developments from the Barbizon school to the Impressionists. But there was also a rich and diverse strain of landscape in 18th century French art. One important reason for this was the existence of the Prix de Rome, the scholarship awarded to young artists and composers which allowed them to study at the French Academy founded in Rome in 1666. The 'voyage d'Italie' became such an essential part of every artist's education that even those who failed to win the coveted prize usually contrived to get to Rome by some other means. Rome was still one of the most picturesquely beautiful places in the world, and it became customary for French

*Below* Alexandre Desportes (1661–1743), *A Field Bordered by Trees, with Cows Grazing and Pine-Trees in the Foreground.* Musée National, Compiègne.
The hunting field in 17th- and 18th-century France was still regarded as an important part of court ceremonial, and Desportes became official painter of the royal hunts. He used to go hunting carrying his brushes and palette in tin boxes, and a little sketchbook in which he made rapid oil sketches of the movements of animals, and also of landscapes, which he later used for backgrounds. These oil studies are early examples of direct landscape painting from nature, and his rapid sketching methods resulted in views which were for the time astonishingly informal and unconventional, though they were not intended for public exhibition.

*Opposite left* William Hodges (1744–97), *A Crater in the Pacific,* c.1775–7. Brighton Museum and Art Gallery, Brighton.
William Hodges was one of the artists who sailed on Cook's voyages of Pacific exploration, and made topographical landscapes of the new lands thus revealed, as well as paintings of their cultures. The Polynesian island worlds of Tahiti, Tonga, New Zealand and Hawaii that these voyages explored fascinated the European imagination, and their idyllic simplicity, which contrasted so strongly with the heavily authoritarian Baroque grandeur of the European courts, helped to encourage the idea of the Noble Savage and the return to the simple life.

rtists to follow the tradition of Claude and spend much of their time sketching in the surrounding ountryside. As a result, many artists made andscape drawings during their time in Rome, ven if their main interest later shifted to other enres.

Sketching out of doors directly from nature as also becoming the pastime of artists around aris itself, and the phrase 'after nature' began to ppear in the catalogue of the Salon, first applied o landscapes by Jean-Baptiste Oudry (1686–755). He specialized in animal and hunting cenes, succeeding Desportes as painter of the oyal hunt. But landscape always played a major art in his work, and his talent for it is particularly ell displayed in the drawings he did directly om nature, with their realistic depiction of the runks and foliage of trees and the effect of light alling through leaves. In 1761 the Abbé Gou-enot wrote of Oudry that 'on Sundays and holi-ays his greatest pleasure was to go to the Forest f St Germain or to Chantilly or to the Bois de ougeon in order to make studies of tree trunks, lants, woodland vistas, stormy skies, horizons.' he same writer describes the park and gardens f the Prince de Guise at Arcueil, whose pictur-squely neglected state attracted not only Oudry ut younger artists like Boucher and Natoire to ketch there: 'Everywhere one came across eople sketching, all anxious to ask advice from 1. Oudry, who in this picturesque pastime ppeared like a schoolmaster among his pupils.' French culture owes much of its exceptional chness and diversity to its blending of northern nd Mediterranean elements, so that the realistic rain in French landscape, derived from the ow Countries, was complemented by an Italian-

ate tendency to idealization. The 17th century Dutch concept of pure landscape only gradually found acceptance elsewhere. In 18th century France, as in the England of Sir Joshua Reynolds, landscape was regarded as inferior, since it did not represent the ennobling events or ideas which academic theorists valued, above all in history painting. Thus the Abbé Dubos, in his *Réflexions critique sur la poésie et la peinture* (1719), argued that landscape was suitable only as a setting for some human activity:

> The most beautiful landscape, even by Titian or the Carracci, is of no more interest to us than an actual tract of country, which may be either hideous or pleasant. Such a painting contains nothing which, as it were, speaks to us; and since we are not moved by it, we do not find it of any particular interest. Intelligent artists have always been so well aware of this truth that they have rarely painted landscapes without figures.

But the rigid categorization of painting into genres was tending to disappear, so that an artist such as Boucher could now produce a very wide range of works, from attractive landscapes to portraits, genre scenes and decorative paintings. And the complacently rigid values of the pre-vious age were suffering a general breakdown under the strains of a social transformation whose conflicting pressures and unresolved stresses would erupt at the end of the century in the French Revolution. The pompous Baroque splendour of 17th century Versailles and the Louvre which had expressed the aristocratic certainties of the age of Louis XIV became obsolete as artists found new patrons in the

*Below* Jean-Baptiste Oudry (1686–1755), *A Flight of Steps Among Trees in the Park at Arcueil.* Cabinet des Dessins, Louvre, Paris. The park and gardens at Arcueil had become picturesquely neglected. But their contrast of nature running wild within an ordered setting made them a favourite sketching place with Oudry, becoming as significant for the development of his landscape as the Villa d'Este at Tivoli was later for Fragonard and Hubert Robert.

*Below* Jean-Antoine Watteau (1684–1721), *Meeting for a Hunt*, 1720. Wallace Collection, London. One of Watteau's last pictures, this is a typical *fête galante*, a group of elegant people enjoying themselves. These are pastoral dreams rather than actual naturalistic landscapes, with their nostalgic mood conveying a melancholy sense of the transitoriness of pleasure and of life. Yet with their intimacy and informality, contrasting so strongly with the pomp and ceremony of Louis XIV's Versailles, they helped to crystallize the age's dream of a return to nature.

rising class of officials and financiers which had swollen into a numerous and pleasure-loving bourgeoisie. Because of the prolonged exclusion of this class from power and privilege – one of the underlying causes of the French Revolution – the Rococo art which appeared as a reaction against the pompous grand manner of Versailles was an essentially escapist phenomenon.

The paintings of Antoine Watteau (1684–1721) are perfect expressions of the Rococo pastoral dream, warm romantic landscapes in which elegant fancy-dress figures enjoy the pleasures of music, love, the chase or a picnic in the open air. This kind of picture, the *fête galante*, was virtually invented by Watteau, and at first sight seems to represent a series of enchanted moments; but they are moments whose transience is keenly felt, and which are therefore

tinged with sadness and nostalgia. The landscapes are vitally important in these paintings, yet it is more difficult to recognize any actual place in them than in even the ideal landscapes of Claude and Poussin. Yet in these imaginary landscapes Watteau helped to crystallize the age's dream of a return to nature – to the simple life from which, of course, the brutalities of work and poverty would be absent.

The Rococo spirit found its most typical exponent in the work of François Boucher (1703–70), an essentially decorative artist whose landscapes seem to represent that style at its most frothily artificial. Yet although Rococo now seems so thoroughly artificial, it was in its day the first of a series of naturalistic reactions against the excessive, Baroque splendour of Versailles – 'natural' reaction which would soon appear unnatural and be reacted against in its turn by

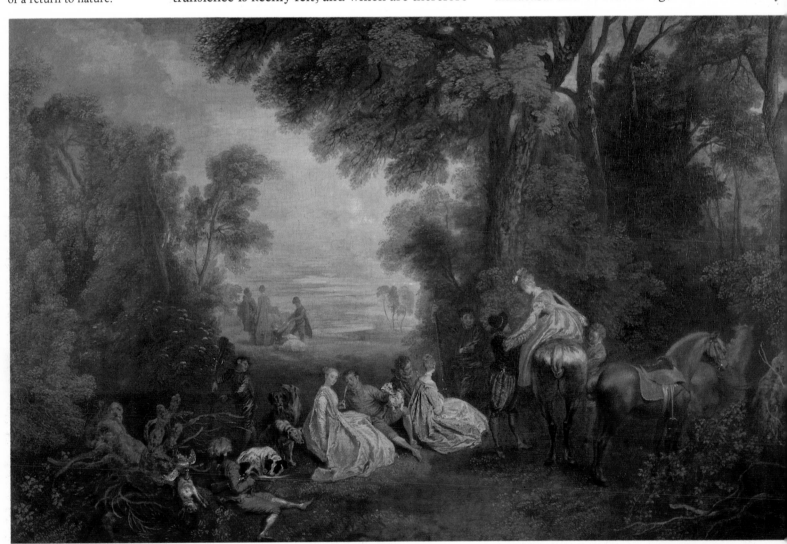

*Right* François Boucher (1703–70), *Landscape with Watermill*. National Gallery, London. Boucher's landscape drawings show that although he was perfectly able when he wished to achieve a sensitive realism and truth to nature, he was essentially a decorative artist. And his pastorals are the perfect expression of the wilful artificiality of rococo landscape, full of frivolously elegant Arcadian shepherds and shepherdesses treated in a spirit of light-hearted sensuousness. They represent a rural dream of tranquil nature full of picturesque waterwheels and mills, with dovecotes in the lofts, trees with frothy foaming foliage, and washerwomen and milkmaids who might be Marie Antoinette herself, playing at rural life.

new definition of the natural. Boucher himself admired the Dutch landscape painters, and made direct drawings from nature not only while he was in Rome but also later in the 1740s, in the park at Arcueil with the group of artists around Oudry. But in contrast to the sober realism of his chalk sketches direct from nature, his landscape paintings, done from memory, are conventionalized and decorative.

This is not the case with Jean-Honoré Fragonard (1732–1806). Although he is usually thought of as a typical painter of gallant and sentimental Rococo subjects, nature usually dominates the figures in his paintings, especially the more picturesque aspects of nature such as foaming masses of foliage and waterfalls. His extensive travels in Italy with the landscape painter Hubert Robert and their mutual patron the Abbé de Saint-Non were a decisive episode in

his career. The artists spent the summer of 1760 at the Villa d'Este at Tivoli, sketching from morning to dusk in the decaying splendour of the famous park, with its avenues of cypresses, its fountains and its statues. The styles of the two painters were at this time so alike that the drawings and paintings they made there are almost impossible to tell apart. In many of their pictures the countryside which Claude had loved so much is transformed into a romantic dreamland, a place for lovers to walk through. It was at Tivoli that Fragonard began to draw the huge trees with overhanging boughs which dominate his later French park scenes, and which sometimes seem so exaggerated. Yet, like several other parks at the time, the gardens of the Villa d'Este were in a state of considerable neglect, so that their overgrown trees and toppling statues were not simply a product of the romantic imagination. Both

*Next page* Jean-Honoré Fragonard (1732–1806), *The Waterfall at Tivoli,* c.1761–2. Louvre, Paris. This is one of several works which has been attributed to both Fragonard and Hubert Robert, whose styles when they were sketching and painting together amid the cypresses, fountains and statues of the neglected park at Tivoli were almost indistinguishable. In other paintings the washerwomen are shown stringing their lines from one statue to another – a marvellous image of classical antiquity in decay.

ragonard and Hubert Robert liked to paint
assical antiquity in decay, particularly in the
ape of crumbling statues, which were in daily
e by washerwomen, who in several paintings
ave strung out their lines from one statue to
other. But the group of Italianate landscapes
at Fragonard painted in the 1760s after his
turn from Italy are far from being his only
ontribution to the genre. In fact, although he is
often thought of in terms of light-hearted
oticism, Fragonard portrayed the full range of
ture's moods; and in his taste for brooding
ies and melancholy trees he moves close to the
utch masters whose works he could have seen
Paris.

Changing attitudes to nature were accom-
nied by changing attitudes towards the classical
st. Excavation of the buried cities of Pompeii
d Herculaneum in the mid-18th century
lped to promote a renewed interest in the
cient world, and in the second half of the
ntury this led to the emergence of Neo-
assical art, which reacted with high moral
riousness against the frivolity of the Rococo.
ome itself was a meeting place not only for
tists but for travellers coming from all over
urope to admire the glories of Italy's past
eatness. Such visitors on the Grand Tour often
ught paintings as souvenirs; and so the painting
views or *vedute* for wealthy international
avellers became an important part of 18th
ntury Italian art, both in Rome and in Venice.
ome was still a picturesquely beautiful city in
hich a romantic landscape stretched almost
to the centre, as may be seen in the topo-
aphical views of the Dutchman Gaspar van
'ittel. The ruins of the classical past became
art of this picturesque landscape, crumbling
mnants of a once powerful civilization over
hich nature was slowly triumphing. And so a
ne of painters arose who specialized in ruins.
he first was Giovanni Paolo Panini (1692–1765),
hose views of Rome proved enormously popular
ith tourists. View painting was connected with
age design both in its origins and in the early
reers of its practitioners. It is not therefore
rprising that Panini initiated an extension of
e ideal landscape into a new sort of ideal view,
e *capriccio*, in which he took buildings and
xtaposed them in fantastic ways to give
tensely theatrical effects. Giovanni Battista
iranesi (1720–78) also made a series of 137
chings of Roman views, which with those of
anini make up a detailed record of the city. In
ese views Piranesi communicates not only a
rong feeling for the poetry of ruins through his
tensely dramatic exploitation of the contrasts
f light and shade, but also an overpowering
nse of grandeur, achieved by exaggerating
roportions. This made the English connoisseur
nd Gothic novelist Horace Walpole speak of

the sublime dreams of Piranesi, who seems
to have conceived visions of Rome beyond
what it boasted even in the meridian of its
splendour. Savage as Salvator Rosa, fierce

as Michael Angelo, and exuberant as Rubens,
he has imagined scenes that would startle
geometry, and exhaust the Indies to realize.

Usually the romance of ruins suggests the theme
of nature versus man, of man the builder and time
the destroyer. But the titanic grandeur of some of
the remains of Imperial Rome could be so terrify-
ing and oppressive that they led Piranesi to a
rather different theme, that of oppressive prisons
in which man becomes a puny, trapped animal, an
absurdly small figure amidst huge stone stair-
cases and dark abysses filled with instruments of
torture.

More than any other artist, Hubert Robert
(1733–1808) became associated with the idea of
romantic ruins in a landscape – he was even
nicknamed Robert of the Ruins. His early
work done in Italy is very close in style to
that of his friend Fragonard. But Robert's
future path was decisively influenced by the

*Above* Fragonard, *The
Avenue*, wash drawing,
Petit Palais, Paris.
Fragonard's landscape
paintings, despite their
spontaneity, were the
result of many careful
preparatory drawings direct
from nature. This superb
drawing was probably
made in the garden of a
French country house soon
after his return from his
second Italian journey. It
was in the decaying
splendour of Tivoli that he
first drew the huge trees
with their overhanging
boughs which dominate
his later French park
scenes.

*Left* Fragonard, *The
Waterfall at Tivoli*, (see
previous page).

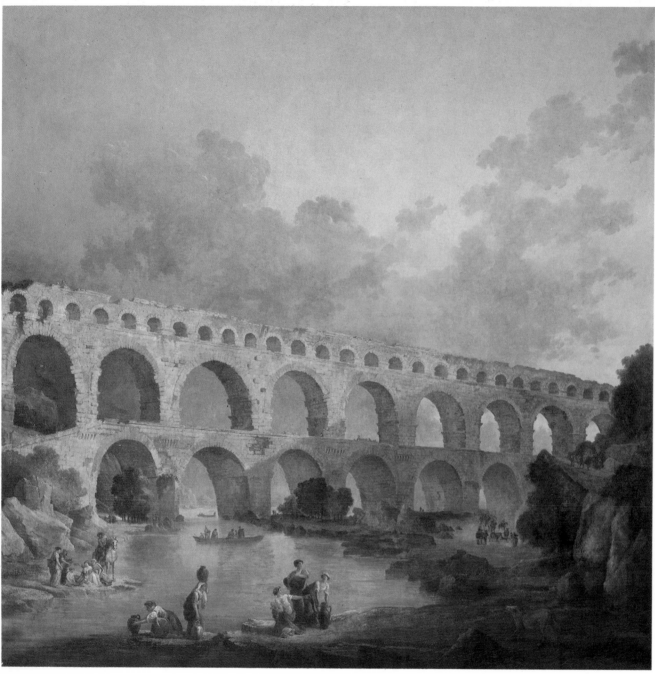

Hubert Robert (1733–1808), *Le Pont du Gard*, 1787. Louvre, Paris. Robert's feeling for nature combined with a feeling for the classical past which was itself to become part of Romanticism. In this painting, the landscape is not an idealized one like those of Claude, but a real topographical view with a well preserved Roman aqueduct. But it is still a painting of mood rather than of fact, and at the end of his life, after his imprisonment during the Revolution, Robert's pictures became filled with a brooding melancholy.

picturesque beauty of Rome and its surroundings, which were a revelation to him. During his eleven years there he made many studies of the Roman ruins and the decaying villas of Tivoli and Frascati. His paintings could therefore be seen as reflections on the passage of time and the decay to which even the greatest civilizations are subject. When first exhibited in Paris in the Salon of 1767, they attracted high praise from the philosopher Diderot, whose reviews of the biennial salons at the Louvre made him the founder of art criticism in France. But since Robert's paintings retained more than an echo of Rococo elegance, Diderot later reproached him for not having plumbed the full poetic depths of the pleasure of ruins and their philosophical implications: 'Everything dissolves, everything perishes, everything passes, only time goes on . . . How old the world is. I walk

between two eternities . . . What is my existence in comparison with this crumbling stone?'

The rediscovery of the joys of nature also stimulated a renewal of the art of landscape gardening, in which Hubert Robert took a leading part when he was put in charge of the planning of the royal gardens. Even the rigidly formal garden of Versailles were given picturesque elements, for example the 'Jardin Anglo-Chinois' at the Trianon, for which Robert designed a rocky grotto, the name derived from the characteristic French assumption that since both the English and the Chinese had irregular gardens the concept behind them must be identical. Yearning for the simple life and the feeling of the age that its vanities and luxury were meaningless led Marie Antoinette to discard etiquette in her private domain of the Petit Trianon, where she could

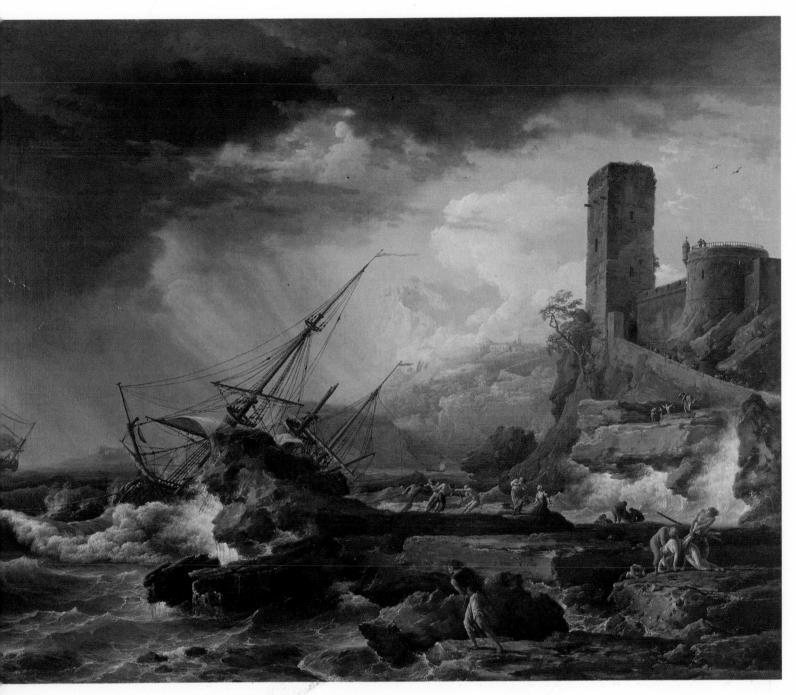

eep cows, play at being a milkmaid, and act in musical comedies. So powerful was the influence of Rousseau's descriptions of nature in his romantic novel *La nouvelle Héloïse* that his patron the Marquis de Girardin laid out his estate at Ermenonville on the 'natural' lines he thought the book suggested. There were picturesque gardens containing a hut on a rock and a lake island – which could be made still more picturesque, when Rousseau actually died on the estate in 1778, with his tomb, a sarcophagus surrounded by poplars.

All these currents of 18th century thought were preparing the way for the Romantic Movement. The pre-Romantic mood created a demand for picturesque paintings of seaports at sunset or by moonlight, for cascades, storms at sea, shipwrecks and other natural disasters. In pro-

viding such paintings, Claude-Joseph Vernet (1714–89) expressed this pre-Romantic feeling, the sensibility crystallized by Jean-Jacques Rousseau. At the age of 20 Vernet was sent to Rome to study, and on reaching Marseilles his first sight of the sea, the rocky shore and the ships in the harbour was a revelation which caused him to specialize in seascapes and landscapes. Settling in Rome, he painted harbour scenes at sunrise and sunset which show the influence of Claude. But he also began to catch something of Salvator Rosa's feeling for nature's savage splendour, becoming the first French painter to depict the violence of waterfalls and the grandeur of mountains. These give the delightful *frisson* characteristic of the sublime rather than the full Romantic feeling of inward response to nature's moods, and Vernet's waterfalls and coast scenes often

*Above* Claude-Joseph Vernet (1714–89), *Storm with Shipwreck*. Wallace Collection, London. Many of Vernet's paintings are in a pastoral, almost Claudian mood. But he came to share the pre-Romantic feeling, in representations of sublime nature indifferent to the plight of wretched human beings, such as dramatic shipwrecks. The story goes that on board ship in a real storm he had himself lashed to the mast to study the waves washing over the deck, exclaiming: 'Give me my brushes so that I may paint these superb effects before I die.'

*Right* Marco Ricci (1676–1730), *Landscape with Waterfall and Banditti*. Leeds City Art Gallery, Temple Newsam House, Leeds.
The picturesque tradition deriving from Salvator Rosa has here been softened into a Rococo version of the drama of nature, though the flickering brushwork helps to give a powerful feeling of energy to this cascading waterfall. The overhanging rocks and trees have been exaggerated and attenuated to create a sense of frenzied movement. Marco Ricci had at one time worked on stage scenery for the Italian Opera in London, and there is an element of theatrical, operatic exaggeration in his work. But despite this, he was important as a leader of the revival of landscape painting in 18th-century Venice.

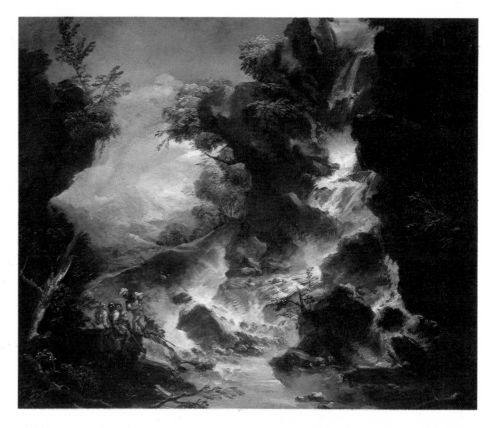

*Above* Antonio Canaletto (1697–1768), *The Night Festival at San Pietro di Castello*. On loan to Gemäldegalerie, Berlin-Dahlem, Berlin.
Canaletto painted Venice in all its aspects, not only its unique blend of architecture and sea, but all the bustling pageantry of boats on the canals, and the water pageants which

include a boatload of elegant admiring tourists. They even gained attention at the French court, when Madame de Pompadour, wanting to flatter Louis XV with a vision of his power at sea, persuaded the king to commission Vernet to paint a series of 'The Ports of France', 16 of which were completed. Vernet's patrons also included many of the British colony in Rome, with whom he had close contacts. He married the daughter of the Irish naval captain who commanded the papal squadron, and he encouraged the Welsh painter Richard Wilson to devote himself to landscape. Vernet was very much a professional artist and belonged to a dynasty of professional painters, the best known apart from himself being his grandson Horace Vernet, a popular painter of military and equestrian subjects in the Napoleonic period. Unlike Salvator Rosa, Vernet was very responsive to the demands of his patrons, and his notebooks record that they were increasingly for sublime subjects such as a 'tempest with a great mountain in the background obscured by the shadow of a cloud', 'a tempest of the most horrible description', and 'a sunset with singular effects of light and a rainbow in the background'. And so Vernet increasingly showed the power of nature to dominate and destroy man, yet a nature that reflected the moods of man and the drama of his existence. Unlike Salvator Rosa, whose landscapes may have bandits but no real action, Vernet depicts actual human tragedy in his dramatic shipwrecks near the shore watched by terrified onlookers or in scenes such as one in which a bridge is carried away by a swollen river and a coach hurled into the abyss. Vernet's art may fall short of the truth to nature and the

intimate communion with it that the Romantic artists were to achieve, but it is a good example of the picturesque phase. Anyone who could follow the tradition of Salvator Rosa, but tame and domesticate it as Vernet did, was assured of success, because the 18th century cult of the picturesque offered an escape from the extreme rationalism and extreme artificiality of contemporary society, so that the wildness of untamed nature was no longer a threat but an increasingly attractive refuge.

In Italy too the tradition of Salvator Rosa was continued in a picturesque transformation, notably in the melodramatic landscapes of the Genoese painter Alessandro Magnasco (1667–1749), storm-tossed, full of ruins and gloomy monasteries, and peopled with witches, beggars and mercenary soldiers of fortune. The loose and fragmented handling of the paint, which in other Italian painters had a largely decorative purpose, becomes in Magnasco a method of painting with febrile, dashing brushstrokes to create a feeling of frenzy and a vibrating mood of psychological intensity.

Magnasco's influence is evident on the Venetian Marco Ricci (1676–1730), who became one of the leaders in the revival of landscape painting in the city. Politically the Venetian state, which had once controlled an empire in the eastern Mediterranean, was now in the last stages of decline before it was suppressed altogether by Napoleon. Yet at a time when the stream of Italian painting seemed to have become too sluggish to be interesting, 18th century Venetian art had a final flowering which serves as a warning against any easy relation of artistic achieve-

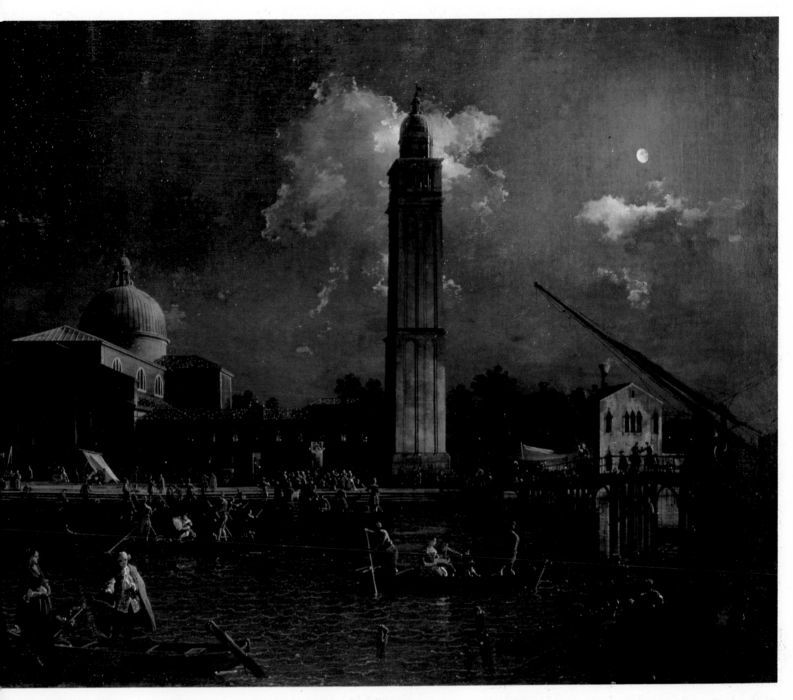

ccompanied the various
nnual ceremonies. But
ight scenes by him are
ery rare. This is one of a
air showing two of the
ur night festivals which
ok place every year. The
hurch across the canal is
an Pietro di Castello,
here the festival took
lace on the eve of St
eter's Day (29 June).

ment to social and political expansion. This
artistic revival included the purest Italian ex-
pression of the Rococo in the large scale decor-
ative art of Tiepolo. There was also a considerable
variety of landscape, including the strain of ideal
pastoral, brought from Rome by Francesco
Zuccarelli and developed at Venice into the pretty
Rococo dream landscapes of Giuseppe Zaïs.
Marco Ricci took over the melodramatic approach
of Magnasco, but tended to confine it more
strictly to the drama of nature, avoiding the
romantic figure subjects Magnasco had loved.
But he employed the same loose and fragmented
brushwork, dissolving the forms in a flickering
cascade across the surface to give a strong feeling
of energy and drama. And during the last ten
years of his life, perhaps following a journey to
Rome and the influence of the Roman ruin

painters, he became a master of the *capriccio*, an
imaginative arrangement of ruins in a landscape,
designed to create a romantic and often dream-
like effect.

Such fanciful inventions were produced side
by side with the topographical views or *vedute*
which Venetian artists like Antonio Canaletto
(1697–1768) and Francesco Guardi (1712–93)
painted for wealthy travellers visiting Venice on
the Grand Tour. This had become such an
indispensable part of the education of the English
gentleman that in the summer of 1785 alone,
40,000 Englishmen are reported to have made the
tour, moving on from the ruins of Rome to the
pageantry of the canals of Venice. Topographical
views acted as aristocratic tourist souvenirs of
the pre-photographic age. Canaletto's views of
Venice were so popular that his studio became

Canaletto, *View of Alnwick Castle, Northumberland.* Duke of Northumberland, Alnwick, Northumberland. By the 1730s Canaletto was working mainly for the English market, with the British Consul in Venice having the pick of his output and arranging sales to wealthy English visitors who came to the city on the Grand Tour and wanted souvenirs of its famous sights. It is hardly surprising that he should visit the country that had shown such appreciation of his art, and this is one of the many scenes commissioned from him by patrons in England. It is a highly unusual view for Canaletto, a great medieval castle in a rugged landscape, painted just before Robert Adam restored the building in the 1750s.

Francesco Guardi (1712–93), *Imaginary View of the Lagoon.* Museo di Castelvecchio, Verona. Though they painted many of the same Venetian subjects, Guardi's work is very different from the straightforward representation of Canaletto's views, which have little suggestion of mood. In contrast Guardi's paintings have a strong element of poetic fantasy, and this is an example of the landscape *poesia* which formed a large part of his output – imaginary scenes, looking out over the lagoon, full of such romantic imagery as ruins. Guardi's free-handling and atmospheric effects give an eerie, haunted feeling to his vision of the decaying city which was already sinking into the sea and had to be reinforced with sea walls – a poetic vision tinged with a mood of nostalgia for past greatness.

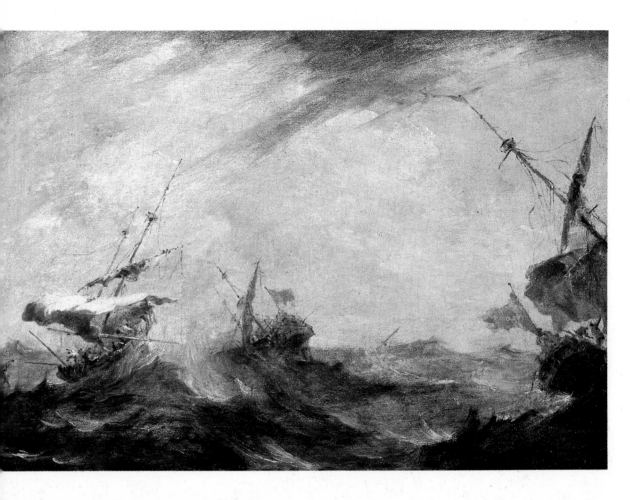

Guardi, *Storm at Sea*. Castello Sforzesco, Milan. It is almost inconceivable to think of a storm among Canaletto's placid paintings, though Venice was not of course immune from nature's wrath. But Guardi paints the raging sea with ships thrown into wild confusion as great waves batter against them. Though such a storm-picture is exceptional in his work, he regularly paid much more attention than Canaletto to weather, atmosphere and effects of light, so that his city is often an insubstantial shimmering fusion of land and sea, anticipating the discoveries of Constable and the Impressionists, and so not fully appreciated in his own day.

mething of a factory, with almost all the output ·ing abroad, above all to England. Between ˙46 and 1755 Canaletto himself visited England, e country which had shown such appreciation ˙ his art. In painting views of London and the ·untry houses of patrons he was tackling scenes ry different from the animated bustle of the ·goons and their special light, and his style lost me of its breadth and freedom, so that these ·glish works have often been thought cold in ·mparison. Canaletto is sometimes criticized for ˙ art which is almost too purely topographical, ·d his nephew and pupil Bellotto, who some-·nes used his uncle's name, was even more ·eral. Bellotto spent much of his time in northern ·urope, painting above all Dresden and War-·w; and since both of these beautiful cities were ·most totally destroyed in the Second World ˙ar, his views have acquired an extra post-·mous value and proved very helpful in the ·instaking reconstruction of both cities.

The Venice of the other leading view painter, ·ancesco Guardi, is more romantic and more ·ersonal than that of Canaletto. The two artists ·w the same places in very different ways, the ·ear, meticulous, almost photographic realism of ·analetto contrasting with the more impression-·ic atmosphere of Guardi's insubstantial city ·ashed by light and water. Guardi's style, with its ·iick, loose brushwork, is to a great extent the ·sult of grafting the picturesque manner of ·agnasco and Marco Ricci on to topographical

subjects, and it has the effect of making them look eerie and insubstantial. And whereas Canaletto concentrated on the canals with their crowded life, Guardi's natural subject was the lagoons, looking out to the islands and the sea, with a sense of space which is increased by his free handling and atmospheric effects. Much of his output consisted of a type of picture which he made his own, the landscape *poesia*, halfway between the traditional *capriccio* and the tone poems of Whistler, with imaginary scenes whose ruined towers and drooping fishing nets fuse with the blue-grey tones of the lagoons to create a poetic mood tinged with nostalgia. If Canaletto records the survival of Venetian pageantry, Guardi is the interpreter of Venetian decay. This was not merely political, for Venice, a city constructed on piles sunk into the shallow part of a lagoon, was already in danger of being destroyed as it sank steadily beneath sea level. In the 18th century the sand bars which separate the lagoon from the Adriatic Sea had had to be reinforced with sea walls. But Venice has continued to sink, with flooding becoming a more and more regular occurrence right down to our own day. However, political decay was swifter, and the once proud Venetian Republic was abolished by Napoleon only four years after Guardi's death in 1793. His ruins and impressionistic effects capture perfectly the spirit of a haunted land in the grasp of decay, with nature encroaching and threatening to reclaim her own.

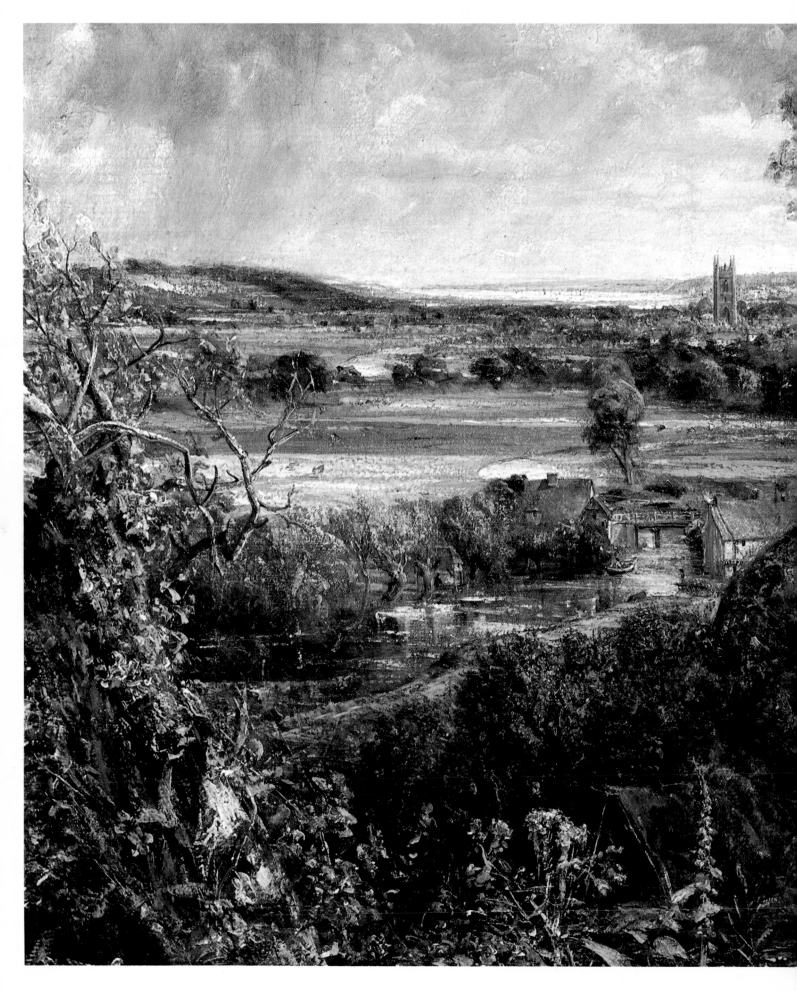

# Chapter Six

# The Rise of Landscape Painting in Britain

Constable, *Dedham Vale*, 1828 (detail, complete painting p. 82). National Gallery of Scotland, Edinburgh.
Our image of the English countryside derives so much from Constable that it is not easy now to see how unique and revolutionary his vision was. But all great art is exploration, and Constable's ambition to become a 'natural painter' meant a long struggle to express in paint the truth of his own experience of nature and his idyllic memories of his Suffolk childhood. This view, looking down the valley of the Stour as it winds towards the sea, was a favourite of Constable's which figures in many of his paintings and drawings. He had first painted it, in an only slightly different variation, 26 years earlier in 1802.

Romanticism is increasingly coming to be seen as, in Isaiah Berlin's words, 'a fundamental shift of consciousness' in terms of the dominant intellectual model western man has used to interpret the world. It was a vast transformation of ideas, and central to these was a new concept of nature. But although this deeper and more imaginative awareness of nature, which expressed itself in the landscape painting of Turner and Constable and the nature poetry of Wordsworth and the other Romantic poets, now seems typical of the English tradition, it developed only gradually. The remarkable development of British landscape painting during the 18th century involved a crucial preliminary change of sensibility, an emotional response to nature which centred on the idea of the 'picturesque', of poets and painters seeing nature in terms of pictures by Claude or Salvator Rosa. The landscapes of Claude were in a sense *poetic* landscapes, depicting nature in terms of the pastoral poetry ultimately stemming from Virgil. Now the process came full circle as poets like James Thomson in *The Seasons* described scenery in terms of Claude's paintings, and these poetic descriptions in their turn influenced the work of artists like Richard Wilson and Gainsborough.

One element in the growth of a taste for the picturesque was the Grand Tour of the continent. The traveller passed through the splendid scenery of the Alps on his way to Italy, where he encountered landscape painting; and since connoisseurship was as fashionable as the voyage itself, the tourist often bought a picture by Claude or Salvator Rosa or one of the Venetian or Roman view painters to bring back with him. A type of picturesque landscape gardening also became fashionable, and at places like Stourhead in Wiltshire trees, water, parkland and specially built temples, mills, cottages or grottoes were arranged in picturesque compositions imitating in three dimensions the painted landscapes of Claude.

Such picturesque scenes were not only artificially created but were also discovered to exist in the real world. In his discussions of visual discovery through art, Ernst Gombrich has pointed out that this is a reversal of the normal process of recognition and recall. Normally what we recognize in pictures are familiar sights that we already know in the actual world; but these 18th century poets and painters were recognizing pictorial images in the world about them.

*Top* Constable, *Dedham Vale* (*see* previous page).

*Right* Richard Wilson (1714–82), *View of Rome from the Ponte Molle*, 1754. National Museum of Wales, Cardiff. Wilson's Italian landscapes are idealizations in the manner of Claude. And here he has made his idealized composition by freely manipulating the relative positions of the actual topographical features, between the Ponte Molle on the left and the Villa Madama on the extreme right. He also learned from Claude how the unification of light and atmosphere could evoke an all-pervasive mood, as in this subtle representation of the poetry of twilight.

dmiration for Claude's symbols of serenity and
dyllic peace led them to discover the beauties of
uch 'picturesque' landscapes in their own sur-
oundings. Richard Wilson, for example, learned
om Claude how to isolate and represent the
eauties of his native Wales, not in ideal, imagin-
ry landscapes but in actual topographical views
ke that of Dinas Bran castle.

Wilson (1714–82) had been mainly a portrait
ainter, until, at the age of 35, he visited Italy and
as encouraged by his friendships with Zucca-
elli and Vernet to devote himself to landscape.
e stayed in Italy about six years, sketching
tensively in the Campagna. He inevitably came
nder the influence of Claude, from whose paint-
gs he learned how to make the centre of his
ndscapes an area of light, and how the uni-
cation of light and atmosphere could convey an
l-pervasive evocative mood. His work had
tracted buyers while he was in Italy, but al-
hough he continued to paint Italian landscapes
fter his return to England, they were much
ss successful: an Italian landscape bought in
ritain failed to endow its owner with the prestige
f the much-travelled Grand Tourist, especially
hen the artist had such a very British name. In
ddition Wilson was neither a sociable nor a tact-
ul man. One of his famous retorts, to Lord Bute
ho was negotiating to buy a picture for King
eorge III but objected to the price of 60
uineas, ruined him forever in the eyes of the
ourt: 'If His Majesty cannot pay the sum at
nce I will take it in instalments.' Perhaps even
orse, he capped Sir Joshua Reynolds' des-
ription of Gainsborough as 'our best landscape
ainter' with 'Yes, and the best portrait painter
o.' Even his attempts to follow Claude's ex-
mple and introduce mythological stories into his
ork did not change his fortunes. Yet despite his
creasing poverty Wilson persisted in painting
ndscapes along the River Thames and the
iver Dee which show an increasing naturalism.
his reached its fullest expression after he had
een left a small property in Wales, which solved
is financial problems and enabled him to paint
is native scenery at leisure. In his pictures of
nowdonia during the last phase of his life, his
eeling for the grandeur of mountain scenery
ound its most memorable expression. Yet these
iews of Welsh mountains, ravines and water-
alls were not just general expressions of the
ublime or picturesque, but real localities.

Ruskin said that with Wilson 'the history of
ncere landscape art founded on a meditative
ve of nature begins in England'. But British
aste in landscape was still for foreign masters.
nother 18th century pioneer, the marine painter
amuel Scott, was known as 'the English van de
elde' until he changed his style completely
fter Canaletto's highly successful English tour,
nly to find himself dubbed 'the English Cana-
tto'. But 18th century British society, 'a silly,
lfish and complacent society that had no better
se for great artists than to make them mirror
s own vanity and self-satisfaction', as Herbert

Read has put it, still overwhelmingly demanded
portraiture. Thomas Gainsborough (1727–88)
did paint landscapes whose freshness made
Constable find his memory 'in every hedge and
hollow tree' of the Suffolk from which they both
came: 'The stillness of noon, the depths of twi-
light, and the dews and pearls of the morning, are
all to be found on the canvases of this most bene-
volent and kind-hearted man.' It has often been
suggested that but for the spirit of the age, which
insisted on the superiority of figure painting,
Gainsborough might have given more time to
landscapes. Supporting evidence for this view is
provided by a much quoted letter to his friend
Jackson:

I'm sick of Portraits, and wish very much to
take my viol-da-gam and walk off to some
sweet village, where I can paint landskips
and enjoy the fag end of life in quietness and
ease. But these fine ladies and their tea
drinkings, dancings, husband-huntings, etc.,
etc., etc., will fob me out of the last ten
years . . .

*Above* J. R. Cozens (1752–
97), *The Aiguille Verte*,
c.1780. Watercolour.
Private collection.
Constable described J. R.
Cozens as the 'greatest
genius that ever touched
landscape'. Yet Cozens
restricted himself to
watercolour, which was
closely bound up with
travel, since the necessary
equipment was easily
carried. He accompanied
several aristocratic patrons
on the Grand Tour,
catching the grandeur of
the Alpine scenery.

*Above left* Wilson, *Cader
Idris: Llyn-Y-Cau*, c.1774.
Tate Gallery, London.
On his return to Britain,
Wilson continued to paint
Italian landscapes, as well
as English and Welsh
views which are often
picturesque and idealized.
But in his pictures of the
Snowdon region of North
Wales his feeling for
mountain scenery found
memorable expression, and
he has caught here a
grandeur of effect which is
purely naturalistic, not
dependent on any classic
formula. Wilson himself
said that 'everything the
landscape painter would
want' was to be found in
Wales. And his paintings
of its mountains, woods
and waterfalls, reveal the
golden or silvery light
learnt from Claude and
Italy which is found in all
Wilson's pictures.

Thomas Gainsborough
(1727–88), *Sandy Lane
through Woods with cottage
and donkey, c.*1748.
Kunsthistorisches
Museum, Vienna.
Despite Constable's claim
that he 'found
Gainsborough in every
hedge and hollow tree' of
their native Suffolk,
Gainsborough's early
landscapes owe as much to
art as to nature, blending
Dutch naturalism and
rococo artificiality. This
rococo element is seen here
not only in the feathery
foliage and silken texture
but in the way that the
winding track, the clouds,
the tree trunks and
branches all twist
themselves into rococo
shapes. The strong
sunlight produces a richly
varied pattern of light and
shade. And Gainsborough's
appreciation of the
importance of light as a
unifying factor, his
mastery of formal
composition, as well as his
freshness and spontaneity
make his best landscapes
revolutionary masterpieces.

To set against this there is the almost equally well known letter to Lord Hardwicke in which Gainsborough declines that patron's request for a painting of his park because 'with regard to *real views* from Nature in this country, he has never seen any place that affords a subject equal to the poorest imitation of Gasper and Claude.' But what Gainsborough was refusing here was a topographical view – and all the landscapes he did paint are much more ambitious and imaginative than that.

Eighteenth century academic theorists condemned landscapes as inferior because, as Richardson declared in *The Connoisseur* (1719), 'they cannot Improve the Mind, they excite no Noble Sentiments.' That is why the Royal Academy and its first president, Sir Joshua Reynolds, ranked landscape low in their strict hierarchy of subject matter, at the very top of which came 'History Painting' – those pictures of mythological or Biblical events which supposedly did improve the mind and excite noble sentiments. Titian and Poussin were admired for the way they used nature to project and enhance some classical or religious myth, but the landscapes of the great Dutch masters of the 17th century were

Gainsborough, *Wooded landscape with horseman and flock of sheep*, 1763. Art Museum, Worcester, Massachusetts.
The heavy dominating trees and dramatically contrasted areas of light and shadow are effects stimulated by Gainsborough's practice of painting by candlelight. The longing to get effects beyond those possible in oil paint caused him to invent his own peepshow

ox, in which
ransparencies lit by
ickering candles gave a
ch variety of effects such
s moonlight.

*Below* John Crome (1768–
821), *Moonrise on the
are*, 1811–16. Tate
allery, London.
rome was strongly
fluenced by Dutch art,
ith its long tradition of
ainting moonlight scenes.
ut his own freshness of
bservation of Norfolk
cenery is well seen in
ese bold, stark silhouettes,
hich give this scene of
oonrise on a river a
owerful emotional impact
hich makes it very
omantic.

*Below right* Francis Towne
1739–1816), *Source of the
rveiron*, 1781.
Vatercolour. Victoria and
lbert Museum, London.
n its massive oppositions
f light and dark and its
implification of form into
arge clearly-defined flat
hapes, this shows a
endency towards
bstraction which becomes
ven more marked in other
vatercolours by Towne.
This is a good example of
he inspiration given to
nglish artists by Alpine
cenery, and Towne's most
riginal work was done
uring the two years he
pent abroad travelling
hrough Italy and
witzerland, where he
eveloped his own highly
omantic but powerfully
imple view of the Alps, an
nterpretation in poetic,
legaic terms rather than
hose of strict topography.

not intellectually respectable because they had no uplifting content. Behind this academic hierarchy of genres lay a feeling that the value of art depends on its embodiment of some interpretation of life, whether religious or philosophical or poetic. What Romanticism did was to stand this argument on its head by putting landscape at the very top, asserting that nature and the landscapes which reflected it made a direct emotional impact on the feelings like that of music, the art which the Romantics valued most highly just because of its emotional immediacy, which needed no symbolic or allegorical or mythical story. This straining after the effect of music led Turner to near-abstraction during the Romantic period itself, and was later to play a major role in the abstract art of Kandinsky. For paradoxical though it may seem, it was the closer and closer study of nature and of its effects of light and colour in the landscape art of the 19th century that was eventually to lead art away from representation altogether, and thus usher in the radical movements of the 20th century.

One major element in Romanticism was a recovered sense of the numinous in nature, which primitive man everywhere had once possessed but which had been driven out of the West by centuries of Christian transcendentalism. Talking about this worship of nature in *Civilisation*, Kenneth Clark makes it appear not a recovery of wonder at the awe-inspiring mystery of nature (which I as an atheistic 20th century scientist fully share), but as a new-fangled religion which the Romantics invented. Christian belief had declined, says Clark, but 'People couldn't get on without a belief in something outside themselves, and during the next hundred years they concocted a new belief which, however irrational it may seem to us, has added a good deal to our civilisation: a belief in the divinity of nature.' And in *Landscape Into Art* he asserts that 'faith in nature became a form of religion', and that 'Although

this faith is no longer accepted so readily by critical minds, it still contributes a large part to that complex of memories and instincts which are awakened in the average man by the word "beauty".' However, these unspecified 'critical minds' certainly do not include the great physicists Einstein, Heisenberg and Schrödinger, who put forward the theories of relativity and quantum physics which have revolutionized our views of nature in the 20th century. All three wrote straightforward non-mathematical books which deserve to be better known; and indeed Schrödinger's *My View of the World* expresses an outlook which is essentially that of Romantic nature worship, preaching a 'reverence for life' like that at which Albert Schweitzer arrived from a very different standpoint, and which has much in common with Buddhism.

Romanticism is often thought of as a revolt of the imagination, or, as Yeats put it, a 'revolt of the soul' against the intellect. Yet this needs qualification, as Erich Heller has argued in *The Artist's Journey into the Interior* (a title which is itself a good description of Romanticism):

It has been said again and again that Romanticism was a rebellion of the imagination against the ever more arrogant claims of rationality, or an insurrection of sensibility

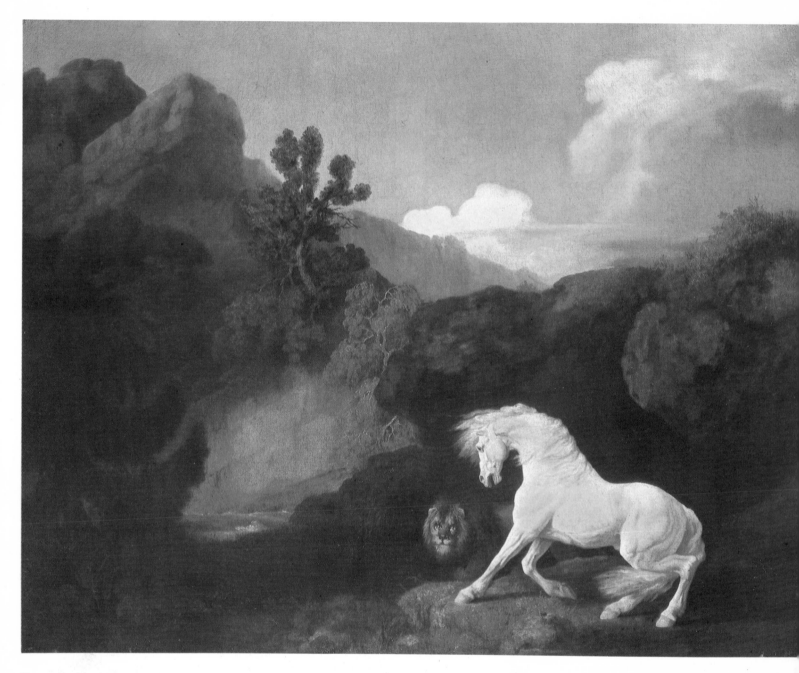

George Stubbs (1724–
1806), *Horse frightened by a
Lion*, 1770. Walker Art
Gallery, Liverpool.
Animal terror and violence
in nature haunted the
imagination of Romantic
artists. Stubbs only made
two 'pure' landscape
studies, but landscape
plays an important role in
most of his paintings of
animals. It has been
suggested that the lion and
horse theme relates to
ancient sculpture, rather
than to the actual sight of a
lion devouring a horse.
Whatever its origin, it was
a theme which haunted
him, and led to several
later pictures in a mood
corresponding to the
'Sublime' in landscape.

against autocratic Reason. This simple belief
looks like a village idiot as soon as it is
brought into the sophisticated company of
the first German Romantics, those exceed-
ingly learned men, great poetical talents,
transcendental speculators, and impassioned
synthesizers of all separate categories. Yes,
of course, Friedrich Schlegel was concerned
with the threatened falling apart of imagina-
tion and rationality, but he kindled no war
between them. He wished to play the part of
an honest broker, indeed a marriage broker:
the two must become one.

Schlegel was in fact calling for a view of life which
would be both imaginative *and* rational-analytic,
a 'universal poetry' within which 'we shall res-
pond to a scientifically explored world as if it were
a still intractable mystery, and to the mysteri-
ous as if it were the latest consequence of our
analytical intelligence.' A very modern view in

fact, since the more we know about science th
more we realize just how mysterious the world c
nature is. But, sadly, the popular view of scienc
has largely been conditioned by the classica
physics which held sway from the 17th centur
to almost the very end of the 19th, and whic
viewed the universe as a giant clockwork mech
anism. It was this mechanistic conception of th
universe that the Romantics reacted agains
along with the narrow materialism and rationa
ism which accompanied it. These were respon
sible for the strange cult of 'facts' which Dicken
satirized in his novel *Hard Times*. The ultimate i
pseudo-scientific reductionism comes when th
schoolmaster Gradgrind asks 'girl number twen
ty' if she knows what a horse is. She knows ver
well, since she comes from a circus and has live
and worked with horses all her life. What sh
doesn't know is Gradgrind's 'definition' of
horse, which his other pupils, who know nothin

*Above* Joseph Wright of Derby (1734–97). *An Eruption of Vesuvius*, 1775. Derby Museum and Art Gallery, Derby.
Volcanic action is one of the more spectacular of the geological forces which shape the earth, and the interest in it of such painters as Wright and Turner, who also painted Vesuvius in Eruption, was part of the Romantic fascination with the energies and forces of nature which were being harnessed to power the the industrial revolution. Wright clearly delighted in fiery energy of all kinds, natural or man-made, painting striking effects of light from fireworks, iron forges, scientific experiments, candlelight or moonlight. While in Italy in 1773–5 he saw Vesuvius erupt, making studies of the volcano on the spot, but continuing to paint versions of it on his return to England.

at matters about the living animal, have been ught to recite parrot-fashion: 'Quadruped. Graminivorous. Forty teeth, namely twenty-four grinders, four eye-teeth, and twelve incisive . . . ' And so on, by rote. '"Now girl number twenty," aid Mr Gradgrind, "you know what a horse is."'

But a horse is much more than this abstract escription of a few of its characteristics, or than he sum of its dead parts. The supreme English ainter of horses, George Stubbs (1724–1806), was as fascinated by dissection as Leonardo was, nd put an enormous amount of scientific study nto his famous book *The Anatomy of the Horse*. Among the ingredients in the development of landscape art in Britain were the sporting painting nd the painting of rural life, which Stubbs ransformed into vehicles for great art. But tubbs is a good example of the sort of complex approach to nature that was advocated by chlegel. Stubbs' precise anatomical studies how to the full the spirit of intellectual enquiry nd scientific analysis; but this also enabled him o achieve greater expressiveness in painting he living animals in their landscape backgrounds. nd in his various versions of the subject of a on attacking or frightening a horse, Stubbs rovides an early example of the Romantic bsession with the savagery of nature.

Just as Leonardo had moved from mechanism to organism, in the Romantic period all sorts of factors, including the development of science itself, contributed to ideas about organic growth in nature, in opposition to the mechanistic view which still prevailed in physics. This was of course before the modern blight of narrow specialization had occurred, when many people still shared a broad, speculative interest in the mysteries of nature. Many Romantic poets, most notably Goethe, were accomplished naturalists. Charles Darwin's grandfather, the Lichfield physician Erasmus Darwin, has often been mocked for setting out his views on botany and the laws of organic life in didactic couplets. But this was all part of a healthy and widespread interest in what was then called natural philosophy. Joseph Priestley revolutionized chemistry by discovering oxygen and nine other new gases while working at home over his kitchen fire. And the painter Joseph Wright of Derby (1734–97) was a natural philosopher in his intense, obsessive investigation of every sort of light and fiery energy, from moonlight and the various forms of artificial light (candlelight, lamplight) to the lurid eruption of Vesuvius. Painting an iron forge or an experiment with an air pump, he became, as he has been aptly described, the first painter 'to express the spirit of the industrial revolution'. Although the industrial revolution

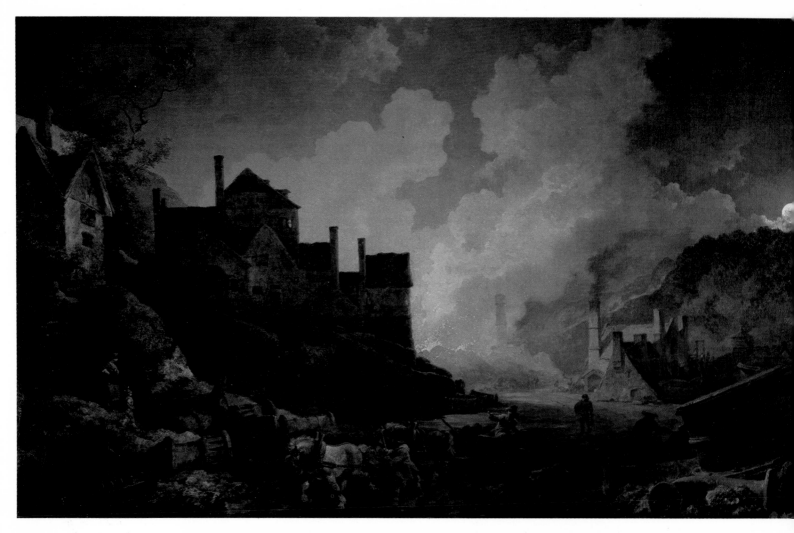

*Above* Philip James de Loutherbourg (1740–1812), *Coalbrookdale by Night*, 1801. Science Museum, London.

The dramatic appeal of the new industrial landscapes as examples of awe-inspiring sublimity is well caught by this painting of the flames and smoke belching into the night sky from the furnaces which made the iron for the very first iron bridge. This was the great age of the discovery of power, as nature's energy sources of wind, sun, water, steam and coal were all tapped to drive the industrial revolution. And the dynamic emotional style which de Loutherbourg's continental baroque training helped him to develop was as well suited to depict the forces unleashed by man in industry as those unleashed by nature in his dramatic painting of an Alpine avalanche (pages 8–9).

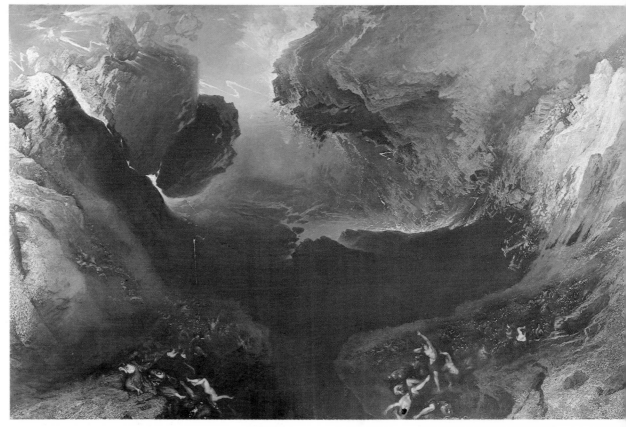

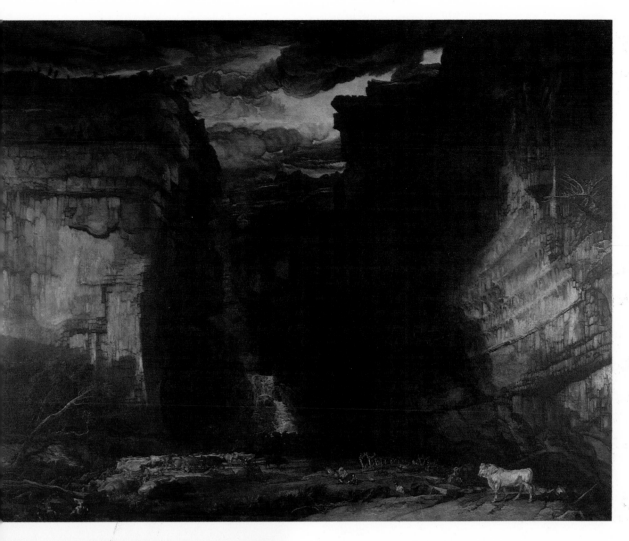

was ultimately to have a disastrous effect on much of Britain's landscape, it also became a new source of inspiration for such awe-inspiring essays in sublime landscape as the night view of the iron works at Coalbrookdale by Philip James de Loutherbourg (1740–1812). This artist was a master of special effects, not only in his own diorama, the Eidophusikon, with which he projected moving landscapes showing waterfalls, thunderstorms and other spectacles, but also in the ingenious effects he devised in stage designs for David Garrick and Richard Sheridan – effects suggesting fire, sun, moonlight and volcanic eruptions. De Loutherbourg came from Alsace, and his training in the continental Baroque gave him a mastery of the dramatic in nature far removed from the classical serenity inherited from Claude by the English landscape school.

Similarly, the glowing landscapes of 'Mad' John Martin (1789–1854) probably owe something to the industrial revolution. His apocalyptic scenes of Hell, or of ancient Babylon and Nineveh, are vast cosmic visions in which puny man is crushed by elemental forces; but they were partly inspired by the fiery atmosphere of the factory furnaces which were reddening the sky. It has also been suggested that the jumble of images in Martin's Hell could have been suggested by the pit disasters with which he was familiar from his

J. M. W. Turner (1775–1851), *Buttermere Lake, with Part of Cromack Water, Cumberland: A Shower*, exhib. 1798. Tate Gallery, London.
This early masterpiece dates from the period of Turner's most intensive exploration of the British countryside, when he developed his interest in effects of weather, atmosphere and sublime scenery. Turner knew this vision of a rainbow over a lake was poetic, and accompanied it by lines of poetry when exhibiting it. Despite its seeming naturalism, it already looks forward to Turner's later development since the essence of this picture is light and the grandeur it gives to the lake and mountains.

childhood in the Newcastle coalfield. The painter of these visions of cosmic doom was himself involved in devising innumerable plans to ensure the supply of pure water to London and the disposal of sewage. Thus Martin's tortured landscapes, then, express both Romantic awe at the power of nature and exultation over the ever-increasing power of science. For the love of science so strongly expressed in Shelley's poetry was as much part of the Romantic spirit as the deep mistrust and suspicion of it found in William Blake.

For Blake, Newton was the archetype of the self-obsessed rational man, the originator of the mechanistic universe which – along with rationalistic philosophy – Blake saw as the enemy of life: 'He who binds to himself a joy, Doth the winged life destroy'. Blake himself affirmed the holiness of all life, and the importance of the imagination rather than the rational intellect alone: 'To see a World in a Grain of Sand, And heaven in a Wild Flower'. Blake's own land-

scapes, small wood engraved illustrations t Virgil's *Pastorals*, carry out this visionary belie they are inspired transformations of the visibl Blake's pastoral vision inspired a number of fo lowers who called themselves the 'Ancient because of their response to Gothic art and the pursuit of ideals proper to an innocent 'Golde Age'. They retired to paint in the rural seclusio of the village of Shoreham in Sussex. Th most notable among them was Samuel Palm (1805–81), whose Shoreham period was th moment of perfect balance between inner an outer vision, expressed in little landscapes whos streams, shepherds and crescent moons are fu of both marvellously observed details and roma tic nostalgia for an imagined golden age innocence.

Blake's vision was a highly sensuous one, fu of a delight in natural energy. And since it nature's beauty and colour, and all the othe qualities we experience with our senses, tha poets and painters respond to, it is hardly su

ising that the mechanistic concept of nature ⸳es not appeal to them. Physics itself is an ⸳straction from nature, which deliberately sets ⸳t to get behind our sense experience and reduce ⸳e complexity of the observed world to an ⸳stract mathematical model. As Werner Heisen⸳rg says in *The Physicist's Conception of Nature*, ⸳Modern science, in its beginning, was character⸳ed by a conscious modesty; it made statements ⸳out strictly limited relations that are only valid ⸳thin the framework of these limitations.' But, ⸳his modesty was largely lost during the 19th ⸳ntury. Physical knowledge was considered to ⸳ake assertions about nature as a whole.' Heisen⸳rg suggests that science is 'a specifically ⸳hristian form of Godlessness', which would ⸳xplain why there has been no corresponding ⸳velopment in other cultures.' When modern ⸳ience was founded by Kepler, Galileo and New⸳n in the 17th century, the idea of nature in⸳rited from the Middle Ages still prevailed. On ⸳e one hand was a transcendent, supernatural

God, and on the other was nature, which was God's creation. So, unlike the Chinese, for whom there was no personal god and nature itself was awesome and divine, western scientists felt justified in treating nature as a machine, which greatly simplified the task of asking questions about it. Soon scientists were considering nature independently not only of God but even of man, and aiming at an 'objective' description of it. This was encouraged by the reductionist tendency of 19th century science, which because of its success in harnessing the forces of nature to man's purposes, grew more and more self-confident. The mechanistic view of nature, and the materialism that went with it, therefore remained dominant in the *physical* sciences until the 1890s, when the grand clockwork mechanism began to collapse as a result of new discoveries within physics itself. With the discovery of the electron (the first of the subatomic particles) and of radioactivity, it began to be realized that neither matter nor radiation was as simple as had earlier been thought.

*Below* Turner, *Snowstorm, Avalanche and Innundation in the Val d'Aosta*, 1837. Art Institute of Chicago. Turner's was a tragic vision of life, with an overwhelming feeling for the violence of nature and the helplessness of puny man in the face of its cataclysms. His many pictures of storms, of which this is one of his most turbulent, show their tremendous force and destructive power by means of swirling vortical curves. And it becomes increasingly obvious in these later pictures that Turner was much more than a painter of externals, that he saw and could project the operation of the underlying elemental forces of nature.

*Right* Turner, *Norham Castle, Sunrise, c.* 1840–5. Tate Gallery, London. As early as 1816 Turner's landscapes had been dismissed by Hazlitt as 'portraits of nothing, and very like'. And increasingly, in trying to depict the basic elemental forces of nature, he arrived at his own unique kind of semi-abstraction, constructing paintings out of light and colour, without solid outlines. Turner had painted Norham Castle many times since his topographical sketch when he first saw it on his tour of the north of England in 1797. But this final version is a completely liberated vision, seen at sunrise, with diffused light radiating through mist from a sun low on the horizon, so that water and sky are united in one continuous web of light.

Einstein resolved some of the difficulties with his discovery that matter, far from being stable and unchangeable, could be transformed into energy according to his famous formula $E = mc^2$, which ultimately made possible the atomic bomb and the whole atomic age. What had previously been thought to be a fundamental barrier, between material and immaterial agencies, between matter and energy, had crumbled. Then, during the decade 1925–35, the new ideas of Heisenberg and Schrödinger plunged us into the strange world of quantum theory, a world which even Einstein could not bring himself to accept because it abolished all the old absolute distinctions. One of its most revolutionary discoveries, enshrined in Heisenberg's Uncertainty Principle, is that you cannot leave man out of physics after all, because there is simply no way of making observations independently of the observer. As Heisenberg put it, science is 'part of the interplay between Man and Nature.' Or, in the words of Niels Bohr, the great Danish physicist who was responsible for building up the modern idea of the planetary atom, 'we must become conscious of the fact that we are not merely observers but also actors on the stage of life.'

This was something of which the Romantic poets and painters *were* conscious. The nature poetry and landscape painting of the Romantic movement represents a reaction against the mechanistic account of nature in favour of an organic view. We can now see that the mechanistic view of nature is a true but limited one, which describes the mechanical behaviour of inorganic objects within a certain well defined range of observation. But the science of the 17th century had set life and matter entirely apart, with life regarded either as simply the product of some extraordinary cosmic chance, or as the deliberate creation of an Almighty Designer. Because man's experience of living things is so varied and complex, it was more difficult to formulate problems in the field of the life sciences, to ask the right questions which would lead to fruitful research. But as biology developed in the late 18th century, a system of thought based on the concept of nature as an organism, rather than a mechanism, developed along with it. This concept was not only the basis of the poetry but also of the theoretical writings of Coleridge and Goethe. Goethe was himself a distinguished botanist who made beautiful drawings of the plants he observed; and, like Blake and Wordsworth in their different ways, he realized that dissection will not tell you enough to understand the functions of a living organism. The organic world can be truly appreciated not in terms of scientific abstractions, but only through the fullness of living experience.

This was also the great age of the discovery of power, as nature's energy sources of wind, sun, water, steam and coal were all tapped to drive the industrial revolution. And the new concept of nature as the carrier of energy, which revitalized science, also took hold of the Romantic poets and painters. The idea that

*Above* Constable, *Study for Haywain*, 1820–1. Victoria and Albert Museum, London.
Constable continually emphasized that painting was for him an expression of feeling. And his feelings are communicated most directly in those full size studies or sketches which in his lifetime were thought to be too little 'finished' for exhibition. For Constable was throwing artistic conventions overboard and relying on his own experience, the truth of what nature offered to his eye. And the intensity of his response to nature is expressed here in the boldness, freedom and nervous agitation of his brushwork. This view of the Stour from Flatford Mill looking downstream to Willy Lott's Cottage was not substantially altered in the final version, though the man and horse in the foreground were omitted.

*Right* Constable, *The Haywain*, 1821. National Gallery, London.
In the final version, which was actually exhibited in 1821, all the details are sharply defined, to comply with the Academy's 'classical' standards. Constable struggled throughout his career to carry the freshness and immediacy of his oil sketches made directly from nature into these more smoothly painted pictures. That he did succeed in maintaining something of that fresh realism here may be judged by the enormous impact of this picture on French artists. Gericault was 'stunned' by it, and when exhibited in the Paris salon of 1824 it caused such a sensation that the French King awarded the artist a gold medal. And it would be French artists who developed the possibilities latent in Constable's art.

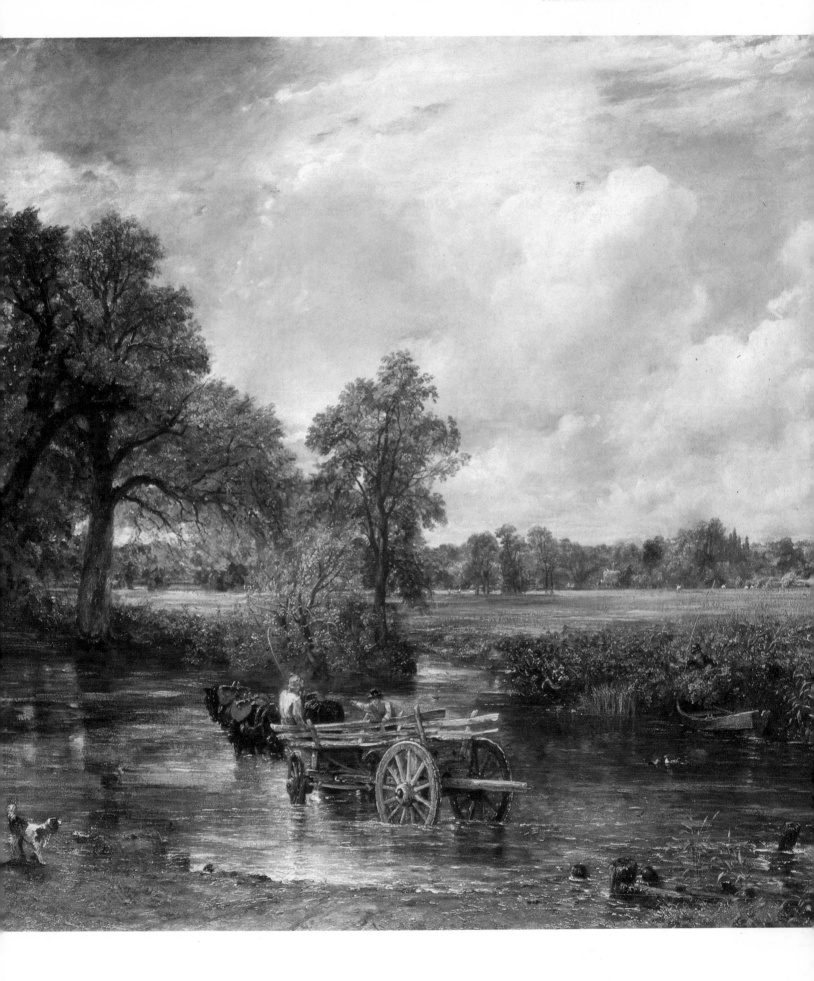

nature is the source of power, whose different forms are all expressions of the one central force – energy – is as powerful in Turner's paintings as it is in the poetry of Coleridge and Shelley. J. M. W. Turner (1775–1851) identified with the savage, uncontrollable aspects of nature, its destructive force and man's impotence in the face of it. He was passionately interested in the sea, one of the most powerful embodiments of the forces of nature. And in trying to express these underlying elemental forces instead of merely external appearances he arrived at his own unique kind of abstraction, constructing paintings out of light and colour, without the solid outlines which had hitherto been considered obligatory. This makes nonsense of the orderly progression of styles – Impressionism, Post-Impressionism, Cubism, Abstraction – which critics love to impose on the history of art. As elemental painting of fire, water, light and air, Turner's work is a counterpart to the great musical evocations of another innovative genius, Richard Wagner, who burst the bounds of traditional musical form and the traditional musical language of tonality by pouring into them his own intense emotions. But while Wagner became a crucially important figure because all composers after him had to come to terms with his achievement, almost all of Turner's work remained locked away in London and therefore comparatively little known.

If Turner anticipates modern Post-Impressionism in his penetration beneath the surface appearance, John Constable (1776–1837) is a direct forerunner of the French Impressionists, making sketches in which light dances on the surface of things, and in which he tries to capture some transient appearance in the scene before him. Turner travelled all over Europe recording the vastest and most elemental aspects of nature: towering mountains and precipices, or the infinity and grandeur of the sea – a stormy, Byronic vision, rooted in a feeling for the sublime. By contrast, Constable was drawn to a tranquil, creative contemplation which brings him close to Wordsworth; and he himself said that 'my limited and restricted art may be found under every hedge.' In deference to the taste for mountain scenery Constable did make a painting expedition to the Lake District in 1806, but he quickly came to feel that 'the solitude of mountains oppresses my spirits'. In this respect he was very different from Wordsworth, who lived in the Lake District, and who closely associated feeling for nature with mountains. Otherwise there is an extraordinary parallel between the poet and Constable, who brought to painting a similar freshness and spontaneity born of direct contact with nature, aiming, as he wrote, to capture 'light – dews – breezes – bloom – and freshness; not one of which had yet been perfected on the canvas by any painter in the world'. Wordsworth and Constable revolutionized their respective arts by ridding them of derivative mannerisms and going back to a direct intuitive apprehension

*Above* Constable, *Sluice in the Stour*, c.1834. Victoria & Albert Museum, London. This study from the last period of Constable's working life is still of the Stour, on whose banks he had spent his boyhood. For Constable's art, like Wordsworth's poetry, is obsessively concerned with his memories of a happy childhood in contact with nature.

*Opposite* Constable, *The Sea near Brighton*, 1826. Tate Gallery, London. This is one of the very few oil sketches which Constable is known to have painted outdoors in winter, when he went to Brighton to stay with his wife and family over the New Year. Inscribed on the back are his notes on the time and weather: 'Sunday, Jan 1st 1826. From 12 till 2P.M.

Fresh breeze from S.S.W. Constable set out to capture not just the surface appearance of nature but transient effects of light and shade, so that his vision changed according to the time of day and the state of the atmosphere. In this he anticipated the Impressionists, for painting in the open air demands the ability to catch fleeting impressions.

nature, expressed in images suggested by ctual objects. Academic landscapes had come to clude an obligatory brown tree, but Constable tonished the art world by discovering that ees were green. His aim was not to impose form n nature, as in classic landscape painting, but to nder nature exactly. Sir George Beaumont, ho owned the Claude paintings which both urner and Constable so much admired, re-arked that the colour of a landscape should be at of an old violin; without saying a word onstable took a violin and placed it on the green ass of the lawn. The academic convention of lour demanded above all a harmony of tone lues on the canvas, whereas Constable showed at the colours in a painting could be as fresh d vivid as the colours in nature.

'Painting is but another word for feeling, and I associate my careless boyhood with all that lies on the banks of the Stour', he said; and he never tired of the intimate landscape of his native Suffolk. 'The sound of water escaping from mill-dams, willows, old rotted banks, slimy posts and brick-work. I love such things. These scenes made me a painter, and I am grateful.' As his first biographer, C. R. Leslie, put it, 'the subjects of his works form a history of his affections.' But it took an enormous effort to realize these obsessive experiences in paint, and in marked contrast to Turner, Constable was a late developer, starting slowly and almost clumsily as he struggled to express his vision. Yet once he had succeeded in realizing his own vision it was quickly assimilated and imitated, so that at the end of the 19th century Robert Leslie, son of C. R. Leslie his first biographer, estimated that

there were probably more forgeries of Constable in existence than genuine works by him.

Does this mean that he had fully achieved his aim of being a 'natural' painter by producing an art of complete unquestioning naturalism? Reading Ruskin might suggest that this was so, for while using all his passionate eloquence to praise Turner's imaginative and expressive power, he damned Constable for being excessively literal. But then Ruskin was hardly a consistent critic, since he also praised the Pre-Raphaelites for their literal accuracy. Constable certainly strove after the ideal of truth to appearances, and when he painted light and weather he was concerned mainly with their effect on the landscape, his light being reflected by his subject rather than dissolving it as in some of Turner's later paintings. Constable is a forerunner of the Impressionists in his sketches and studies in which he tries to fix the transient appearance of the scene before him. He wanted his pictures to have the dew and sparkle of trees, bushes and grass in the real, light-drenched world. But Constable also held that 'we see nothing until we truly understand it', and he brought to his examination of the facts of nature a scientific thoroughness: 'Painting is a science and should be pursued as an inquiry into the laws of nature. Why then, may not landscape painting be considered as a branch of natural philosophy, of which pictures are but the experiments?' Such an attitude lay behind the celebrated campaign of sketching clouds – or 'skying' as he called it – on which he embarked in 1821. He violently rejected advice that his sky ought to be a 'white sheet drawn behind the objects', saying that in landscape painting the sky is the chief 'organ of sentiment', and 'that landscape painter who does not make his skies a very material part of his composition neglects to avail himself of one of his greatest aids.' Hence he interested himself in the rise of the new science of meteorology, which confirmed his belief that clouds must be collected and classified, and his campaign of 'skying' represented an attempt to sketch every variety of cloudscape.

Despite this, Constable's approach to nature was not coldly intellectual but sensuous, apprehending it with the same sort of physical passion that Wordsworth describes in 'Tintern Abbey'. Constable's revolution, like Wordsworth's, consisted in the artistic realization of this fresh, personal and directly sensuous vision of nature and emotional response to natural scenery. Wordsworth's great subject is the relation of the mind to nature, and his lyrics are a poetic record of his moments of inspired perception and emotion as his spirit is quickened by contemplating nature. Constable was similarly obsessed with the need to eternalize 'spots of time', of concentrated perception and emotion. In the letter in which he says 'Painting is but another word for feeling' and describes his delight in those boyhood scenes which 'made me a painter', he explains that 'I had often thought of pictures of them before I had

ever touched a pencil.' He noted with approv[al] a remark that the whole object and difficulty [of] art was 'to unite nature with imagination', but [it] was many years before he passed beyond imitati[on] and found the means to express his emotions [in] paint. That discovery can be seen taking pla[ce] in the small sketchbook which he filled wi[th] drawings of the Suffolk countryside in the sum[mer] and autumn of 1813. A remarkable chan[ge] can be seen in it as he gradually brings into foc[us] his new vision of landscape. His first biograph[er] tells the story of Blake looking at one of Co[n]stable's drawings and exclaiming 'This is i[n]spiration' – to which the more prosaic Constab[le] replied 'I took it for drawing.' But Blake was [of] course right. Constable had been drawing for [a] long time; but the drawings done in these yea[rs] were something different. Significantly, th[ey] were years of heightened perception and em[o]tional turmoil, when he was laying determine[d] and protracted siege to his future wife, Mar[y]

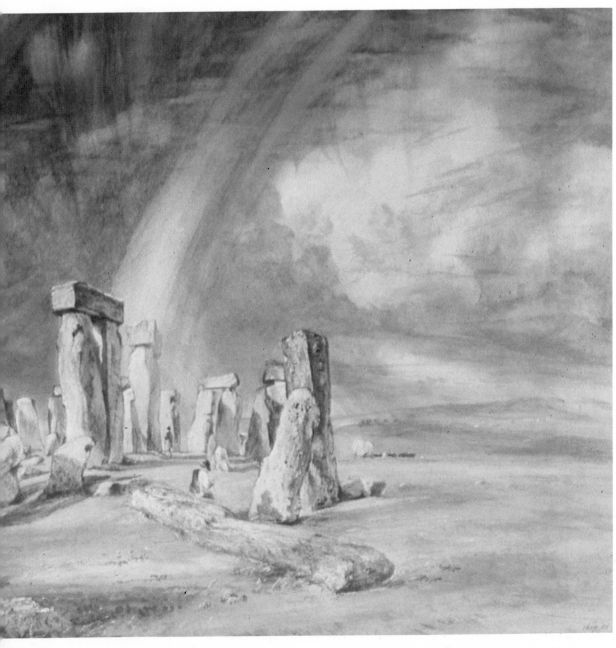

Constable, *Stonehenge*, 1836. Watercolour. Victoria & Albert Museum, London. This work, in which Constable expressed his desperate melancholy after his wife's death, clearly shows how far his art is from simple topographical naturalism. For the prosaic pencil sketch made on the spot is transformed into a dramatic study of time, permanence and change. Against 'the mysterious monument of Stonehenge, standing remote on a bare and boundless heath, which carries you back beyond all historical records into the obscurity of a totally unknown period', Constable sets a dramatic sky with a double rainbow, symbol of hope, but one of the most transient and fleeting effects of nature.

Bicknell, against the opposition of her wealthy and influential family. As Kenneth Clark has remarked in *The Romantic Rebellion,*

> Without any doubt the great works of Constable were done at the point where his desire to be a 'natural' painter and his need to express his restless, passionate character overlap. Through his violence of feeling, concealed under a conventional exterior, he was able to revolutionize our own feelings about our surroundings.

The root of all Constable's art lay in his idyllic memories of the harmonious world of the Suffolk of his boyhood. But it was the intense emotion of his love for his wife that gave him the means to bring those memories to fresh and vivid life in paintings. And after his wife's death he was plunged into desperate melancholy, expressed in such magnificent late works as *Stonehenge* and *The Cenotaph*, which clearly show how far his art is from simple topographical naturalism. It derives from an emotional response to nature and is completely subversive of the attitudes of our own technological age in which the despoliation of nature has reached unprecedented levels. Tourists flock to Constable Country and Wordsworth's Lake District, but human life is becoming increasingly divorced from nature and all that is instinctive and natural. The poetic attitude to nature, which is still very relevant, was magnificently expressed in words by Wordsworth in the closing lines of 'Tintern Abbey':

> – that serene and blessed mood,
> In which the affections gently lead us on, –
> Until, the breath of this corporeal frame
> And even the motion of our human blood
> Almost suspended, we are laid asleep
> In body, and become a living soul:
> While with an eye made quiet by the power
> Of harmony, and the deep power of joy,
> We see into the life of things.

## Chapter Seven
# The Northern Tradition of Expressionist Landscape

Caspar David Friedrich (1774–1840), *Landscape in the Riesengebirge* (or *Mountain with Rising Fog*), c.1815–20. Bayerische Staatsgemäldesammlungeen, Munich.

The religious feeling for mountain scenery has never been more powerfully expressed than by Caspar David Friedrich, whose works have an elemental simplicity which brings them close in spirit to the works of the Chinese landscape painters. Though the artist made sketching trips to the *Riesengebirge* (Giant Mountains) in northern Bohemia, such paintings as this are not simply topographical views, but reflect in their sense of solitude and haunting mystery the feelings that contemplating the mountains aroused in him: 'It is not the faithful representation of air, water, rocks and trees which is the task of the artist, but the reflection of his soul and emotions in these objects.'

The contrast between Constable and Turner shows some of the complexities of Romantic attitudes to nature. For though both had deep feelings about the natural world, their temperaments were so profoundly different that their styles seem to be diametrically opposed. Constable's close, affectionate approach to the natural world led him to *observe* it closely, while Turner, with his celebration of violent energy in nature and man, identified almost pantheistically with its natural forces. Constable's naturalism makes him a key figure linking the Dutch masters of the 17th century and the French Impressionists, and it is usual to regard this gradual progress of realism as a sort of mainstream in the history of art. Thus Ernst Gombrich in *The Story of Art* says:

> The break with tradition had left artists with the two possibilities which were embodied in Turner and Constable. They could become poets in painting, and seek moving and dramatic effects, or they could decide to keep to the motif in front of them, and explore it with all the insistence and honesty at their command. There were certainly great artists among the Romantic painters of Europe, men such as Turner's contemporary, the German painter Caspar David Friedrich (1774–1840), whose landscape pictures reflect the mood of the Romantic lyrical poetry of his time which is more familiar to us through Schubert's songs. His painting of a bleak mountain scenery may even remind us of the spirit of Chinese landscape paintings, which also comes so close to the ideas of poetry. But however great and deserved was the popular success which some of these Romantic painters achieved in their day, I believe that those who followed Constable's path and tried to explore the visible world rather than to conjure up poetic moods achieved something of more lasting importance.

What I have already said about Turner's near-abstraction implies my own disagreement with this. For curiously enough, both paths seem ultimately to have led to similar results. Closer and closer study of nature and its transient effects of light and atmosphere gradually led the Impressionists away from representation altogether, so that Monet at the end of his life was producing near-abstract works such as his water-lilies, not unlike the late paintings of Turner. And because Turner was trying to express not just surface appearance but the underlying elemental forces, he anticipates modern Post-Impressionist art in his dissolution of the image and discovery of the immediate sensual impact of colour. Such facts make nonsense of the neat, orderly progression of styles, from Impressionism through Cézanne to Cubism and so on to abstraction, which critics like to impose on art. Turner, in trying to express his intense identification with the underlying forces and energies of nature, had already almost arrived

at the sort of abstraction to which comparable expressive needs drove Kandinsky about a century later.

The other pioneers of abstraction, including Malevich and Mondrian, were similarly concerned with expressing their spiritual emotions in their art, and the sort of Paris-oriented art history which insists on deriving them from the Impressionists' purely visual approach to art simply will not do. In fact it will not do even for French art itself, since Gauguin and Symbolism played quite as important a part in Post Impressionism as Cézanne; and so did the essentially northern Expressionism of van Gogh.

The search for greater expressiveness and spiritual intensity has remained particularly characteristic of northern artists. One of Caspar David Friedrich's landscapes approached so near to abstraction that it was first hung upside

Friedrich, *Monk by the Sea*, 1809. Schloss Charlottenburg, Berlin. The existential loneliness of the single small figure in an immensity of space startled contemporary critics, as did the seeming emptiness of a picture which tends towards abstraction. The dramatist Heinrich von Kleist described the monk as 'the sole spark of life in the vast realm of death, the lonely centre of a lonely circle'. The artist has expressed the boundlessness of the infinite in finite terms largely by the horizontal emphasis, with only narrow strips of sea and sand dune below an immense sky, with each element separate, and implicitly stretching endlessly away on either side. The monk is completely dwarfed, reduced to insignificance as he stands contemplating nature in her vastness.

own, with its clouds mistaken for sea and its sea or sky. The absurdity of such an empty painting so infuriated Goethe, who had warmly admired the more naturalistic sepia landscapes with which Friedrich (1774–1840) began his career, that he felt like knocking it to pieces, finding it symptomatic of 'the great perversity of our present age'. Yet such developments in the arts were related to the organic view of nature which Goethe himself advocated. Closely linked to it, and absolutely central to Romanticism, is a belief in the organic nature of the creative process. Instead of having a set of rigidly defined artistic forms, like the sonnet in poetry or the sonata in music, into which the artist pours his ideas as though into a mould, Romantic and post-Romantic artists, whether painters, writers or composers, have usually allowed the content of their work to shape its form, so that the work grows organically like

a plant. This is one reason for the dissolution of form in all the arts. Not only did Wagner's operas abandon the old set arias and recitatives, but in his search for greater and greater expressiveness he stretched the old tonal language of music almost to breaking point. Schoenberg, in the late Romanticism of his early works, stretched it still further, to a point at which he felt it had broken altogether, so that he then had to search for a new atonal organizing principle in the 12-note system. Schoenberg was a painter as well as a musician, and it is no accident that it was his close friend Kandinsky, working in the same Expressionist context of a search for greater spiritual intensity, who discarded subject matter altogether and first developed pure abstraction in painting.

Though Caspar David Friedrich's art did not become abstract, his paintings and his own

statements about painting do raise critical questions, not only about Romanticism but also about the whole later development of contemporary art, including those questions of form and content which are crucial to abstract art. What does a painting, which may nowadays even be an abstract painting, have to say to us? Is a painting to be regarded as merely a certain arrangement of colours and forms on canvas, or does it express anything more? Can it, above all, express those religious feelings which Friedrich himself wanted to convey in his landscapes? Do his mountains indeed have something more spiritual about them than those of a painter who has aimed at little more than topography? Because his art raised such questions, Friedrich was often a centre of fierce controversy during his own lifetime. This was above all the case with his painting of *The Cross in the Mountains* (1807), which was commissioned as an altarpiece for a private chapel: Friedrich simply depicted a cross set on a lonely pine-clad mountain top, and was promptly accused of allowing landscape painting to usurp the place of religious art.

Now this issue of content is absolutely crucial to northern Expressionist artists, who do not fit in easily with the usual over-simplified picture of the development of realism from Constable through the Impressionists to Cubism. For as Robert Rosenblum has already argued in his pioneering book *Modern Painting and the Northern Romantic Tradition*, these artists must primarily be discussed not in formal terms but in terms of the religious crisis to which so many of them were responding:

> From Friedrich and Turner through Kandinsky and Mondrian, the Northern artists . . . were all confronted with the same dilemma; how to find, in a secular world, a convincing means of expressing those religious experiences that, before the Romantics, had been channeled into the traditional themes of Christian art.

The point on which I differ most from Rosenblum is that he insists on talking about the 'supernatural' and the 'transcendental'; for example he speaks of 'this search for a new means of conveying religious impulses in which nature alone, even without overt religious motifs, could reveal a transcendental mystery.' Now it is true that many of these northern artists remained Christians, as Friedrich himself did, and therefore saw themselves as responding to a nature which was God's creation. But there is no reason beyond a vestigial attachment to Christianity why response to nature as an awe-inspiring mystery should be taken to imply gods or spirits or anything *super*natural or transcendent, rather than the intense communion with nature itself that the Chinese artists, with no tradition of supernaturalism, have always recognized. Arthur Waley begins his essay 'Blake the Taoist' by describing a Chinese poet opening a volume of

Blake's poetry and exclaiming with a shock of recognition, 'This man is a Taoist.' Taoism is not a supernatural, transcendental religious faith, but simply a mode of living – quietly, in a complete harmony with nature, rather than the western way of extremes, either of Christian life-denial or of rushing around in ceaseless frenetic activity as 'getting and spending we lay waste our powers'. Romanticism came close to Taoism not only in its attitudes to nature, but also in its attitude to the imagination. Taoists, like Blake, distrusted those who exalted purely intellectual processes at the expense of the imagination. Blake called himself a Christian, though he was anything but orthodox: 'The vision of Christ that thou dost see, is my vision's greatest enemy.' He did not find his divinity in some impossible-to-locate heaven governed by the tyrannical Old Testament God whom he derided as 'Old Nobodaddy', but in the human imagination: 'Thou art a man, God is no more, Thine own divinity learn

Friedrich, *The Wanderer above the Sea of Mist*, c.1817–18. Kunsthalle, Hamburg.
The figures in Friedrich's landscapes almost always have their backs to the spectator, gazing in rapt contemplation into the vast boundless spaces in which the imagination can lose itself. Here, rather than the magical stillness found in many of his works, there is a more restless sense of the Romantic yearning for the unknown which has driven this wanderer to heights above the mist, alone, face to face with nature, watching the sun rise over the mountains.

o adore.' The human imagination created the gods in the first place out of man's experience of nature (Zeus speaking out of the thunderstorm, Poseidon making the waves roar angrily), and there is no reason for regarding experiences of intense communion with nature as being *super-natural*. The word is one I really have no use for; if, for example, we found that the most extravagant claims for extrasensory perception were indeed true, we should be forced to extend our concept of nature to cover them – and should still have no 'supernatural'.

Nature includes human nature, and the inner world of the subconscious which the Romantic imagination explored. The Romantic turning towards nature was not merely external, but also an inward turning, an exploration of the self, the feelings, the emotional and imaginative depths of the inner life. So the landscapes of a subjective visionary painter like Caspar David Friedrich are as much about this inner world as about external

nature. Unlike the realist Courbet, who held that 'the art of painting can consist only in the representation of objects visible and tangible to the painter', Friedrich declared 'the painter should paint not only what he sees in front of him, but also what he sees within himself.' Friedrich's brilliantly precise drawings show that he was a careful observer of the natural world, capturing the detail and individuality of trees and flowers, cloud forms, and such evocative phenomena as the mists over the low-lying Baltic coast and the harmonies of diffused light before dawn and after sunset. Nevertheless, he insisted that 'it is not the faithful representation of air, water, rocks and trees which is the task of the artist, but the reflection of his soul and emotions in these objects.' Like Blake he could 'see a world in a grain of sand', an image which he himself used when he showed a friend a study of reeds and said, 'God is everywhere, even in a grain of sand. Here I have revealed him in the reeds.'

Friedrich, *The Watzmann*, 1824–5. Nationalgalerie, Berlin.
Friedrich's own intimate communion with mountains was confined to the Riesengebirge and the Harz Mountains. He never saw the Alps, and this painting of an Alpine peak is based on a watercolour by another artist. In contrast to the Alpine scenes of realistic painters such as Waldmüller, who introduces mountain huts and cheerfully strolling peasants, Friedrich's is a deeply spiritual vision of the stillness and majesty of nature, with the snow-covered peak in stark isolation as an icy divinity.

*Right* Friedrich, *The Polar Sea* (formerly called *The Wreck of the 'Hope'*), 1824. Kunsthalle, Hamburg. Inspired by the actual shipwreck in the winter of 1819–20 of William Parry's expedition in search of the Northwest Passage, this ship trapped in the Arctic and shattered by great masses of ice becomes an image of death and despair, an example of that 'tragedy of landscape which the French sculptor David d'Angers declared Friedrich had discovered. The jagged central pyramid emphasizes the relentless motion of the ice as it crushes the trapped ship. Though the identification of this as the lost painting of the wreck of the ship *Hoffnung* (Hope) turned out to be wrong, it can still be read as an image of the indifference of nature and the inevitable transience of human life.

*Opposite* Otto Fröhlicher (1840–90), *View near the Handeck, c.* 1878. Kunstmuseum, Berne. An example of the late Romantic 'landscape of mood', painted by Fröhlicher, a Swiss artist who worked mainly in Munich, specializing in Alpine mountain scenes. Like his friend Hans Thoma he became an exponent of the characteristically Germanic mood landscape (*Stimmungslandschaft*), which developed under the influence of the Barbizon school and the open-air painting which was increasingly dominant in French art. But German painting between Romanticism and twentieth century Expressionism never really went through an Impressionist phase. For Germanic artists were not content just to copy the outward appearance of nature, but tried instead to look for its inner poetry, music, 'mood'.

Friedrich's methods make it equally clear that his landscapes reflected his own mind as well as the outside world. Before starting a picture he would put away all the sketches he had made from nature, and begin to paint only when the picture was clear in every detail to his inner eye. He himself expressed this by saying that a painter should 'close the physical eye so as to see the picture first with the mind's eye. Then bring to the light what you have seen in the darkness, so that the image may act on others in the opposite direction, from outside to within.' His sketches were only a point of departure, for he synthesized the images gathered from them in an act of inner vision, an organic re-creation through the imagination. His interior landscapes reflect a psychotic personality whose efforts to express the inexpressible ended in madness; in his fascinating self-portrait drawings Friedrich projected his

abnormal intensity and highly strung nature while nevertheless remaining scrupulously exac – the exactness being part of the obsession Similarly, his best landscapes are both com pellingly real and intensely visionary, illustratin the diarist Amiel's aphorism that 'a landscape a state of mind'. *The Polar Sea*, showing th wrecked ship *Hope* trapped in the Arctic an shattered by great masses of ice, becomes a com pelling image of death and despair, an example c the 'tragedy of landscape' which the Frencl sculptor David d'Angers declared that Friedric had discovered.

Such landscapes were the product of a intimate communion between the artist an nature, especially the more melancholy aspect of nature: gnarled and blasted trees, wild moun tain scenes, desolate seascapes, swirling mist These echo the artist's own moods and expres

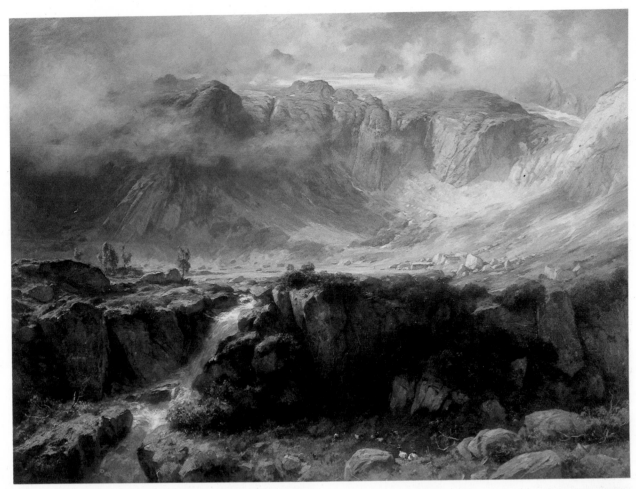

his inner state. Highly characteristic of Friedrich is an absolutely magical stillness, the figures with their backs to us, gazing in rapt contemplation into the distance and drawing us into a re-enactment of the process of spiritual vision which Friedrich described. The essential feeling of his work is a haunting mystery, in landscapes which are a sort of visual music, which invite the viewer into them to ponder the mysteries of life and space. The worst possible approach to these marvellous visual images, which speak so directly to the emotions, is the allegorical one which reduces them to trite formulae, as Helmut Börsch-Supan did so relentlessly in the catalogue of the 1972 Tate Gallery exhibition. For Friedrich's images, as his own statements imply, are much more deeply rooted in the subconscious and far more powerful than the Protestant literalism of such narrow interpretations.

That Friedrich's art is not really allegorical is best demonstrated by contrasting him with another German Romantic painter, Philipp Otto Runge (1777–1810). He too had a highly subjective approach to landscape as a revelation of nature, and this led him to call for a new kind of landscape painting which should have little in common with the classical tradition derived from Claude. The new landscape was to be subjective, an expression of the artist's inner self and the emotions landscape inspired in it; and it was to be *symbolic* of man's relation to, and oneness with, nature. But Runge, who was one of the most

speculative artists who have ever lived, suffered precisely from an excess of speculation. He talked and wrote endlessly about the New Landscape, declaring 'From my youth on I have always longed to find words or symbols or something else, with which I could communicate to others my innermost feelings.' But it was left to the more intuitive Caspar David Friedrich actually to paint such landscapes, whose visionary intensity can still speak to us directly, 'from heart to heart'. These last are actually Beethoven's words, which he inscribed on his *Missa solemnis*, but Friedrich himself expressed a similar thought: 'The only true source of art is the heart, the language of the pure and innocent soul. A painting which does not have its genesis in that can only be vain sleight of hand.'

Runge's extreme, indeed paralyzing intellectualism hardly fits in with the simplistic idea of Romanticism as a revolt of the imagination against the intellect. Yet what Runge was proposing was a new art which would not exist in isolation, cut off from society, but would realize that favourite dream of the Romantics which Wagner strove for in his music dramas, a total art form or *Gesamtkunstwerk* which would involve all the senses. Runge studied the interconnection of mathematics, music and colour, coming to conclusions similar to those that a century later would lead Kandinsky to abstract art. But Runge died long before he could complete the series of *Tageszeiten (Times of Day)* which he intended to

Arnold Böcklin (1827–1901), *The Isle of the Dead*, 1880. Metropolitan Museum of Art, New York. Though Böcklin's art grew out of naturalism, he increasingly painted dream landscapes which anticipate the Surrealists by projecting states of mind. This famous picture is central to his work, and he painted several versions which show a steady increase in the dark, sombre mood. The boat with a coffin in its prow crosses a dark, silent sea to land on the desolate island, a sinister mass of perpendicular volcanic rocks, with a hollow in front filled with dark cypresses. Böcklin himself described this haunting image as '. . . a dream picture. It must produce such an effect of stillness that any one would be frightened at hearing a knock on the door.'

hang in a suitable architectural setting to be viewed while music was played. So, as W. D. Robson-Scott has put it (in *The Romantic Period in Germany*), 'The curious fact is that all this elaborate corpus of ideas, philosophizings, theorizings and mystic lucubrations, found concrete artistic expression in one work only – and that, characteristically, was never completed.'

Response to nature as a means of self-discovery was a common trait among German Romantic artists. The young painter Karl Philipp Fohr, who went to Rome to join the circle of the 'Nazarene' painters but was tragically drowned in the Tiber at the age of 23, spoke of the 'externalization of emotion', which 'can only be developed when I gaze in wonder at nature'. But with the later movement towards naturalism which occurred all over Europe, the emotive response tended to give way to more dispassionate, 'objective' description. The Alpine landscapes of Ferdinand Waldmüller, who has sometimes been grandiosely called 'the Austrian Constable', are characterized by a meticulous, almost photographic realism which is emphasized by bright sunlight and strong shadows. But the sense of mystery which was so strong in Friedrich's paintings is absent from them. Yet despite varying degrees of naturalism, often influenced by the French Barbizon school, German painters usually strove

to capture the poetry or mood of nature, so that their work became called in German *Stimmungslandschaft*, 'landscape of mood' – for instance Hans Thoma, whose landscapes were mainly of his native Black Forest, and the Swiss artist Otto Frölicher, who lived in Munich and painted Alpine views.

It was above all the Swiss artist Arnold Böcklin (1827–1901) who became the painter of emotionally charged landscapes of mood. Though his art grew out of naturalism, he moved towards dream landscapes which project states of mind and anticipate the Surrealists, who responded enthusiastically to Böcklin's work. Reproductions of his most famous painting, *The Isle of the Dead*, once occupied the place in German drawing rooms held by Landseer's *The Stag at Bay* in the corresponding English context. Not that Böcklin was a German Landseer – though Landseer himself had been an interesting landscape painter before concentrating on sentimental Victorian animal pictures. The effect of Böcklin's work is far from a straightforward realistic representation of literal truth to nature: the island, with its sinister mass of perpendicular volcanic rocks and its tall black cypresses under a menacing, storm-laden sky, has a haunting, surrealist quality of macabre suggestion. Böcklin's early works are mainly landscapes done in Switzerland or in

Ferdinand Hodler (1853–1918), *Lake Thun*. Musée d'Art et d'Histoire, Geneva.
Hodler's use of bold simplification relates his work to the linear style of illustrators of the age of *Art Nouveau* like Aubrey Beardsley and Toulouse Lautrec. Without modelling the effect is flat, and such effects had already been used in landscape by the Japanese masters of the colour print to suggest the elemental feeling of their views of Mount Fuji. Hodler similarly used this linear style in his later landscapes to give a monumental, elemental quality to scenes from which man has been eliminated, and only the Swiss mountains and lakes remain. In contrast to the transitory effects of the Impressionists he wanted to depict firm, unchangeable forms, writing: 'One can create feeling in a landscape, in the immensity of space.'

aly, which drew him so strongly – as it did so many northern artists – that he spent much of his fe there. These early landscapes represent real cenes, but they also embody the tendencies of German Romanticism, containing significant mood-setting elements and expressing subjective ates. As Böcklin increasingly explored the world of dream and mystery, he used what he had observed from nature to build up compositions n his imagination, so that ponderous critical discussions of the originals of his later landscapes re as pointless and irrelevant as allegorical interpretations of Friedrich. But Böcklin did have a trongly mythological imagination, so that instead f interpreting the mysterious energies of nature directly, as Turner did, he turned many of his paintings into romantic nature idylls populated y centaurs, nymphs, satyrs, Pan playing his ipes, and other enchanting creatures which the magination of man has conjured up from the onstant flux of the natural world. Many artists have tried to depict the ambivalent restessness and sullenness of the sea. In *Triton and Water Nymph* Böcklin does so by showing a riton sitting on a storm swept rock blowing his onch, while a water nymph turns away from him o flirt with a sea serpent. In other words he tarted from the poetic experience of nature but xpressed it in terms of mythological naturalism.

Hodler, *The Jungfrau from Schynige Platte*, 1908. Musée d'Art et d'Histoire, Geneva.
Many artists have painted the Alps, but Hodler's image of these majestic mountains is unique. He does not view them towering above him from the valley, but from high up on another mountain, so that only their summits are seen, suspended in sublime isolation, separated from the earth below by a sea of mist. Sometimes it is as here a single peak, at others the regal trinity of the Eiger, Mönch and Jungfrau soaring like Olympian deities above the clouds, or bathed in moonlight. The works painted during his final illness have been described as 'planetary landscapes' because of their massive mountains and cosmic spaces, in bold colours in an intense, transparent light.

Edvard Munch (1863–1944), *Dance by the Edge of the Sea*. National Gallery, Prague. Munch used the expressive powers of line and colour to project his own intense emotions into his landscapes, so that through swinging rhythms and heightened colours they become images charged with basic emotional states like joy, melancholy, loneliness and anxiety. The undulating coastlines of Norway's fjords could be reflected and intensified in his undulating Art Nouveau lines. While his landscapes also reflect the extremes of nature in these northern latitudes, from bleak, dark winters in his snow scenes to those luminous poetic summer nights when the sun never completely disappears and the dance of life is recharged with new energy.

Böcklin's 'magic realism' proved intensely controversial, though these pantheistic nature pictures do often convey such feelings as an ominous mystery and violence. But the most haunting of his paintings are undoubtedly those dream landscapes in which he tried to convey the poetic mood directly. It was this inner music which influenced Surrealists like de Chirico and Salvador Dali, and which musicians were hearing in composing symphonic poems such as Rachmaninov's *Isle of the Dead* or Reger's four tone poems based on pictures by Böcklin.

The other major Swiss painter of the 19th century, Ferdinand Hodler (1853–1918), ultimately developed a flat, linear style related to Symbolism and Art Nouveau; with this he painted visions of elemental nature of a stunning simplicity – lakes and mountains which are monumental presences from which everything human or transitory has been obliterated. Hodler's life was overshadowed by illness and death.

During his adolescence his whole immedia family – both his parents and all five of h brothers and sisters – died of tuberculosis. Lat his own son was to suffer from and eventually die of the same disease. Like his exact conten porary Vincent van Gogh, Hodler was at fir strongly attracted to religion and wanted become a pastor; then, at the age of 27, he pass through a religious crisis. But, again like v Gogh, he redirected these spiritual experienc into his art, which is specifically concerned wi the basic questions of life, love and death. As van Gogh and Rembrandt, self-portraits occu an important place in the work of Hodler, an arti constantly self-questioning but without self-pit Hodler's middle period is primarily occupie by figure compositions in which he wrestled wi the primal mysteries of birth and growth. But h large scale murals helped him to see Alpi landscape in monumental terms as well, an to express it monumentally. And his sty

came increasingly abstract and elemental, with growing sense of silence and stillness. In his rly years he had painted many naturalistic dscapes, copying the successful Alpine land- pes of the Swiss painters François Diday and exandre Calame, who delighted in the wild ama of nature, with jagged mountains, tor- ntial waterfalls, glaciers and devastating storms. t when Hodler returned to painting mountains his later years, he turned to the other side of omanticism, emphasizing not these windswept blimities but stillness, spareness and purity. He veloped a unique feeling for the monumental- of mountains, seeking not the transitory, like e Impressionists, but firm, unchangeable rms. These are not at all earthbound, but are inted from high up another mountain, so they e seen without a foreground, or floating above ea of mist. They have the haunting character frozen, timeless symbols without any trace of an, fixed far above the invisible plane of the rth. Robert Rosenblum suggests that for Hod- r, whose tubercular son was confined to a ountain sanatorium, 'these Alpine summits and rified altitudes must also have had an intensely rsonal meaning, associated, like Thomas ann's *Magic Mountain*, with a strange world,

remote from earthly time and society, where ultimate questions about human destiny can be asked.' Most of these mountain scenes were painted in the first two decades of the 20th century, during Hodler's last years; but in spirit they are close both to Friedrich and the Chinese landscape painters of the Northern Sung.

The obsessive images of the Norwegian artist Edvard Munch (1863–1944) are also visionary and compelling, but in quite a different way. Munch was ten years younger than Hodler, and resembled him not so much in personality as in the bitter experiences both had suffered during adolescences haunted by illness and death. Munch grew up in a neurotic atmosphere ridden with anxiety and disease, and blighted by the deaths of his mother and sister; and its images remained with him all his life. His early work was created out of them, in a state of feverish excite- ment and tension. 'Art is crystallization', he asserted, and what crystallized in his mind were obsessive images of some basic human emotion: fear, jealousy, loneliness, horror of death – and also an attitude to physical passion which came close to Strindberg's obsessive view of woman as a vampire. Once Munch had discovered the expressive properties of line and colour he moved

Munch, *Summer Night at the Coast*, c.1902. Kunthistorisches Museum, Vienna.
Munch was linked to a whole school of 19th- century Norwegian landscape painters who included Johann Christian Dahl (1788–1857), the Norwegian artist who had been a friend and disciple of Caspar David Friedrich. And Munch, too, often uses such imagery as solitary figures on the shore with their backs to us, lost in silent contemplation of the majesty of nature. But here a similar psychological charge is achieved without any figure: a view from the rocky Norwegian coast, looking out over the sea to the far horizon where it meets the sky, the two elements linked vertically by the light reflected on the water, but otherwise each stretching boundlessly away on either side.

away from the Impressionistic naturalism with which he had begun, and set out to interpret the problems of his times by portraying 'the modern life of the soul', humanity's passions and sufferings from conception to death. Above all, then, he was painting the inner world, attempting to express states of mind. His almost faceless, anxiety-ridden people transmit their feelings to the landscape and the sky, since Munch made his landscapes express his own violent emotions. In his famous *The Cry*, the whole of nature, land,

*Above* Emil Nolde (1867–1956), *Friesland Farm under Red Clouds*. Victoria and Albert Museum, London.
Nolde's landscape painting is deeply rooted in his native region, the bleak low-lying marshy land along the North Sea coast of Germany. Only the scattered farms rise above the low flat land, though

the sky with its storm clouds is a constant source of movement and change and elemental force.

*Above right* Paul Klee (1879–1940), *Mountain in Winter*, 1925. Watercolour. Kunstmuseum, Berne. German expressionist artists in the 20th century painted a wide variety of landscapes. Some followed

Nolde's example in concentrating on the scenery of particular regions, as Kirchner did with the lake district near Dresden or Pechstein with the East Prussian coast. Klee's vision was quite different and more elemental, an attempt almost to see from the inside and grasp the essence of the miracles of

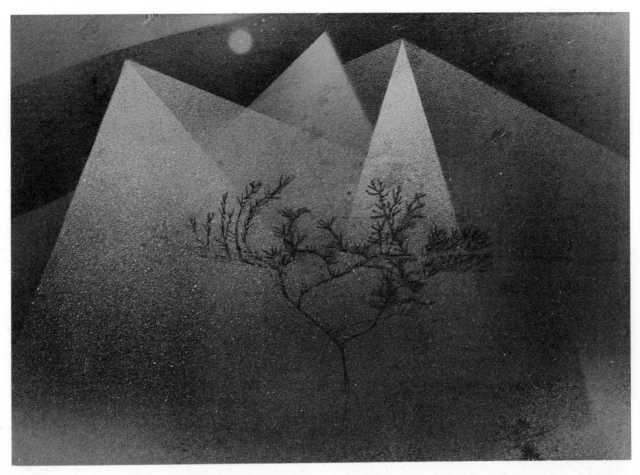

rganic growth and change
1 such phenomena as the
lossoming of plants.
*Mountain in Winter* is a
osmic image of death in
inter and the promise of
:birth, a snow-covered
iountain landscape with
nly a single lone tree set
gainst it, offering in its
uivering branches a hope
f renewed life.

sea and sky, expresses in its swirling rhythms the feeling that he had at sunset, walking along a road, that he had experienced 'a loud, unending scream piercing nature'. All his work sprang from such strongly felt moments of heightened vision: 'I don't paint from nature – I take from it, or rather I help myself liberally from its rich dish – I paint not what I see, but what I saw.' And because the same place looks different according to the observer's mood, Munch's landscapes show how feelings transform the look of a place. His pictures of the Norwegian fjords, with their undulating coastlines and craggy boulders, are particularly successful in expressing his melancholy moods through swirling lines. Sometimes he used pure landscapes, but more often he projected these moods by using the common Romantic image of a lonely figure caught in an intense emotional dialogue with nature, often facing away from the viewer and into the landscape; these recall Caspar David Friedrich's lonely figures contemplating the ultimate mysteries of nature.

Munch lived in Germany during the 1890s, and had an important influence on the development of German art and the 20th century Expressionist movement. The Expressionist tendency to distort form and colour in order to express heightened emotions has already been seen as a recurrent phenomenon in northern art, going back to Grünewald. But the term was first coined to describe various groups in 20th century German art, who were expressing revolt and

anguish in the period before and after the First World War. However, nature and landscape still played an important part, especially in the case of artists such as Emil Nolde (1867–1956) who emerged directly from the German nature lyricism of the artists' colonies in north and south Germany at small villages like Worpswede and Dachau, before the founding there of the first Nazi concentration camp gave it rather different associations. Nolde travelled extensively in the Far East and Polynesia, but his landscape art is centred above all on his native countryside, the low, flat coastal area around the Danish–German border, with its characteristic dykes and causeways. Nolde was so deeply rooted in this area that he took the name of his native village, Nolde (his own name was Emil Hansen), though when the village became Danish after the First World War he moved just over the new border to stay in Germany. Apart from his landscapes, his art is often demonic, expressed through frenzied religious scenes and tortured-looking figures. But it was in landscape that he expressed his special feeling for his native region, with its bleak marshlands where human habitation is sparse or non-existent, and there is a seemingly infinite extension of earth, sky and horizon. Nolde understood this land with the insight of a peasant living close to the soil, but his astonishing feeling for colour enabled him to transform these elemental scenes into paintings of a primordial simplicity, full of an essentially religious awe at the miracle of nature.

## Chapter Eight

# Nineteenth~ Century French Landscape Painting

Claude Monet (1840–1926), *The Rocks of Belle Isle*, 1886. Musée Saint-Denis, Reims. Impressionism placed a new emphasis on painting landscapes out of doors and catching fleeting impressions of light and atmosphere. And the logical result of Monet's obsession with transient effects was the practice he developed in the 1880s of painting series, in which what mattered was not so much the subject of haystack or cathedral, but the play of light on it. Yet at the same time he travelled restlessly through France looking for new effects to challenge him. He was fascinated by the stark grandeur of the island of Belle Isle, off the coast of Brittany, and this study of the waves battering against its barren rocks gives a vivid feeling of the tumultuous conflict of land and sea.

*Above* Delacroix (1798–1863), *View of the Sea from the Heights above Dieppe*, 1852. Private collection, Paris.
Although this is Delacroix's only pure landscape in oils, he was to become an important influence on later landscape because of his intense awareness of colour and light as the sensuous means of art. He was a profoundly original colourist, obtaining effects by the juxtaposition of complementaries which anticipated Seurat. For Delacroix, nature was a dictionary to be consulted rather than slavishly copied: 'The essence of art is to recreate Nature, not to copy it.'

*Right* Paul Huet (1803–1869), *Breakers at Granville, Normandy*, 1853. Louvre, Paris.
Huet was the first French artist to try to catch the grandeur and savagery of nature in landscapes, and he was particularly admired for his waves and storms. When he first saw the sea at Honfleur in 1826 he had enthusiastically tried to capture it on his canvas, writing that 'Anyone who could paint these masses of water rising by some uncanny power . . . and crashing down again . . . would be a great painter.'

Romantic artists like Turner and Constable had placed landscape painting at the forefront of artistic development, where it remained throughout the 19th century. This was above all true of France, although in contrast to Britain and Germany, the French Romantics had not concentrated on landscape, largely because of the continuing strength of the Neo-classical tradition. Neo-classicism, which became closely identified with revolutionary France, found landscape admirable only when it was integrated as background into some narrative figure composition. French Romantic landscape did have one forerunner of genius in Georges Michel (1763–1843), whose paintings of the countryside around Paris show a real feeling for weather in their stormy skies. The greatest of the French Romantics, Eugène Delacroix (1798–1863), reveals his response to natural beauty in his journals, and his paintings often have outdoor settings and landscape backgrounds. Yet apart from his many beautiful watercolour sketches, he produced only a single pure landscape, or rather seascape, a view from the heights above Dieppe. Delacroix's love of the savage forces of nature is more characteristically expressed in his power-

ful images of horses frightened by lightning, or in the tigers, leopards and lions he loved to study in the Paris zoo and introduced into his oriental scenes.

The role played by the idea of the picturesque was less important in France than in England, and the first French painter to really try to capture the fury and majesty of wild nature in landscape was Paul Huet (1803–69). His impressive paintings of storms led the poet Théophile Gautier to define the dramatic character of his landscapes as 'Shakespearean', in the sense that Huet's wild horizons would make excellent backgrounds for *King Lear*. He was a friend not only of Delacroix but of the short-lived English painter Richard Bonington (1802–28), who lived and worked mainly in France, painting small scenes whose hazy distances have an atmospheric freshness reminiscent of Constable.

Bonington and Constable were among the English artists whose works were shown in the Salon of 1824, opening the eyes of French artists to a totally new attitude to the natural world. For the rest of the century the exploration of nature and attempts to define the real and natural were central preoccupations of French landscape

*Below* Gustave Courbet (1819–77), *Ornans Landscape*, 1864. Bowes Museum, Barnard Castle. Courbet's Realism meant painting only what could be seen by the eye. It therefore broke with the idealization and story-telling which were still strong in French Neo-classical landscape. Courbet's landscapes concentrate on the massive and permanent, rather than the transitory and ephemeral effects of atmosphere, light and weather that became so important to the Impressionists. All his life Courbet was profoundly attached to his native town of Ornans and its surrounding region, with its hills crowned by the typical Jurassic limestone escarpments which feature in this and so many of his other paintings. 'To paint a country you have to know it,' he said. 'I know my country and I paint it.'

painters, that familiar sequence from Corot and the Barbizon school to the Post-Impressionists. The fact that the Impressionists saw the world in a new way, in which the act of seeing became itself all-important, led Gauguin to declare that 'Painting begins with Manet'; but from that point of view it might have been better to say that painting began with Constable, that crazy Englishman who stepped out of the studio into the wind and rain, and who Delacroix himself described as 'the father of our school of land-scape'. For Constable was a major source of the thoroughgoing naturalism whose possibilities were further explored in French art. With Constable the narrative tendency which had dominated art for so many centuries vanished completely, and he discarded all conventions to rely purely on his own experience: the only truth was what nature offered to his eye.

Constable's career was a struggle in which he tried to carry the freshness and immediacy of his oil sketches, made directly from nature, into the larger, more finished pictures he painted for the Royal Academy. This is most clearly seen in the large Constable paintings that exist in two different versions, the more spontaneous study and the 'finished' version in which all the details are sharply defined to comply with the Academy's 'classical' standards. What was revolutionary about the French painters who followed Constable was that they broke with the academic art of the Salon altogether, and deliberately set themselves up in opposition as a self-conscious avant-garde. Ever since Claude in the 17th century, artists had been going out into the open air to make studies direct from nature and using them to build up finished pictures in the studio. But the story of French art in the 19th century is increasingly one of artists who went out and tried to capture reality exactly as they saw it, regarding the result as the finished painting, rather than a mere study to be worked up later into some more idealized vision.

It was this lack of any attempt to idealize or beautify that made Gustave Courbet's realism shocking to his contemporaries – so shocking that Napoleon III is said to have attacked one of his paintings with a riding crop. Instead of idealized nudes, Courbet (1819–77) simply paint-ed naked women. He was a revolutionary in politics as well as in his art, which was itself a criticism of society, aiming deliberately to 'shock the bourgeois' by breaking their conventions. Realism is one of those stylistic terms which is bound to have a certain ambiguity, since every artist is likely to claim that he is in some sense depicting 'reality'. The realism of the mid-19th century was in part a product of the political, economic and social conflicts which found expression in the revolutionary upheavals all over Europe in 1830 and 1848. It aimed to give a truthful representation of the real world, based on meticulous observation of contemporary life. The realists abandoned history painting and opened up a whole new realm of subjects pre-

viously considered unworthy: the poor, the ugly, and the ordinary situations and objects of daily life.

Courbet was a self-conscious revolutionary, who thought of himself as a subversive force, a radical hero who was changing the course of art. Yet he grew up in a village, his work remained deeply rooted in the countryside, and landscape was one of his major preoccupations. Landscape was very much a mirror of his own feelings, in a way that was quite different from his Romantic predecessors. This is well illustrated by Cour-bet's painting of his first visit to the Mediterran-ean. He was born in a house which jutted out over a river, and water runs constantly through his work like a favourite theme. He became one of France's greatest painters of the sea, and in his picture of the seashore at Palavas he depicts himself standing on a rock gazing out at the horizon. Robert Rosenblum has already pointed out how close to Friedrich's works this is in motif – and how utterly different from them it is in feeling. Friedrich's figures gaze into the land-scape, spellbound in silent contemplation of nature's mysteries; Courbet instead makes his own figure strongly self-assertive, and his com-ment in a letter was typically egoistic: 'Oh, sea, your voice is formidable, but it will not succeed in drowning out the voice of fame shouting my name to the whole world.'

Courbet was the prototype of the sort of modern painter who makes his own experience of life the centre of his art. So his landscapes are in a sense a record of his own life and travels, includ-ing scenes along the Channel coast and on the shores of Lake Geneva, where he ended his life in Swiss exile after being imprisoned for partici-pating in the Paris Commune. But he was above all a landscape painter in his native Jura moun-

*Above* Courbet, *The Artist on the Seashore at Palavas,* 1854. Musée Fabre, Montpellier.
Courbet portrays his own first encounter with the Mediterranean. But nothing could be further from Caspar David Friedrich's figures silently meditating on nature's mysteries than this frankly autobiographical picture, with its self-assertive pose as Courbet waves his hat in ecstatic salute to the sea.

*Right above* Courbet, *The Source of the Loue,* 1864. Kunsthalle, Hamburg.
Porous limestone makes the Jura mountains an area of underground drainage, where streams can gush fully formed from a cavernous grotto. The source of the river Loue is a beauty spot which Courbet often painted.

*Right below*: Jean Baptiste Camille Corot (1796–1875), *Forest of Fontainebleau.* National Gallery, Washington.
The Forest of Fontainebleau near Paris offered land-scape painters a remarkable variety of subjects, with majestic woodlands, rocks and pools. It was here that Corot came into contact with the Barbizon school, sharing their practice of sketching directly from the subject out of doors.

tains, with their characteristic limestone escarpments and pine forests. 'To paint a country you have to know it', he said. 'I know my country and I paint it.' The porous nature of the limestone gives this the underground drainage typical of karst country, with heavy rainfall seeping through the rocks to form underground streams and caverns, so that a river like the Loue emerges at its source (which Courbet painted several times) as an already considerable stream.

Courbet's landscapes concentrate on the solid and massive and permanent rather than the transitory and ephemeral effects that were to become so important to the Impressionists. In his heroic materialism he is rather an ancestor of Cézanne and the Cubists. But the importance of his realism was that its emphasis on ordinary everyday life gave the final death blow to the old hierarchy of subject matter which had caused the story-telling element to linger on in French landscape long after it had declined elsewhere. Even Camille Corot (1796–1875), whose tranquil poetic landscapes have been so popular that he became one of the most imitated and forged of

Corot, *Ville d'Avray*,
*c*.1835–38. Louvre, Paris.
One of Corot's small
outdoor landscapes, this is
a good example of his
ability to reconcile a
classical geometrically
structured composition
with fresh, spontaneous
vision and a concern for
*plein-air* effects. His innate
classicism, which relates
him to the French tradition
running from Poussin to
Cézanne, enabled him to
express the permanent
qualities of a landscape
even when he was also
responding to the play of
changing light. But
despite the simplicity and
directness of the luminous
landscape sketches he
painted directly from the
subject out of doors, he
was still so strongly
influenced by the French
tradition that the works he
actually submitted to the
Salon were not these
studies from nature but
more conventionally
classical 'history
landscapes'.

*Left* Corot, *The Bridge at Mantes*, 1868–1870. Louvre, Paris. Corot was always fond of bridges and arches and the way they disseminate light and shade. And here the bridge is a very solid object which helps to structure the landscape. Yet he completely breaks with the classical tradition by intersecting the foreground with bare tree-trunks, whose roughly vertical lines set up an irregular rhythm across the whole composition, giving the background a new vitality. And he has here moved away from the clear-cut outlines of his earlier classicizing landscapes towards his own personal treatment of light in terms of tonal values rather than colour and drawing – soft grey and green tones which result in the characteristic hazy, poetic effect of his later style.

*Right above* Corot, *L'etang de ville d'Avray.* Louvre. An example of the sort of later Corot landscape which made him enormously popular. Corot's was a contemplative art in which the actuality of nature was reconstructed through his sensibility, so that one contemporary critic could say Corot 'does not so much paint nature as his love for her'. And his later landscapes became nostalgic distillations of experience, some of which he actually called *Souvenir.* This wistful poignancy is increased by the hazy treatment of light in soft crepuscular tones.

*Right* Théodore Rousseau (1812–67), *The Forest of Clairbois.* Museum and Art Gallery, Glasgow. Rousseau's landscapes almost always exclude the human figure, concentrating on wild nature. The writhing tree forms in this forest reflect the hours Rousseau had spent studying twisting branches, but this close analysis of natural forms went with a dramatic approach to landscape in which he used nature as a vehicle for his own violent emotions, giving even his forest scenes an air of tragic grandeur.

painters, believed that there could be no landscape worthy of the name without figures to enliven it. So despite the spontaneity of his early sketches from nature, these were intended simply as material for later compositions, the historical landscapes with classical or Biblical scenes which he exhibited at the Salon. Corot's fundamental classicism, which made him want to follow in the footsteps of Poussin and Claude, prompted his three visits to Italy, with whose scenery he fell in love. And it was while painting on the spot in the Campagna that he produced those wonderfully fresh and naturalistic views which he thought of as 'the raw material of pictures', but which have since been seen as his real achievement. In these small spontaneous studies from nature he developed his characteristic treatment of form, light and distance in terms of tonal values rather than colour. Though he was sharply aware of transient sense impressions, and was one of the first artists to actually use the word 'impression' in such statements as 'Let us never lose that first fine impression of what has moved us', his art was not at all Impressionistic in the modern sense. 'What we feel is as real as anything else', he said, and his art was a deeply contemplative one in which the actuality of nature was reconstructed through his sensibility. It is this deep sense of classical structure which makes him a link between Claude and Poussin and Cézanne: from the raw material of nature he distilled a picture which, by simplification and synthesis, contained the essence of what he had seen. Corot's stay in the forest of Fontainebleau in the early

1830s placed him in close relations with the Barbizon school. But his style combined Barbizon realism with his innate classicism of structure. Later he developed a misty, poeticizing manner, painting trees at twilight in muted harmonies of silver-greys and greens, and it was these nostalgic distillations of experience which made him one of the most imitated and forged of painters ('Corot painted 1,000 pictures, 1,500 of which are in America'). These late paintings have often been criticized as sentimental, yet the manner could be effective even in a follower of Corot like Stanislas Lépine, an atmospheric painter whose pictures of the Seine capture the muted diaphanous beauty of silvery water beneath lightly misted skies.

Despite the number of his imitators, Corot was aware that we do not necessarily see in the same way, and he is said to have advised his own pupils 'to choose only subjects that harmonize with their own particular impressions, considering that each person's soul is a mirror in which nature is reflected in a particular fashion'. His advice was therefore not to imitate 'Papa Corot', or to follow others, but to paint precisely what they saw. This echoes Courbet's statement that beauty was to be found in nature, not in artistic conventions. The same idea of truth to nature was also expressed by Millet:

Whatever the temperament of the artist, and whatever the impressions he is open to, he should only be prepared to receive them from nature. You must believe that nature is

Rousseau, *Storm Effect: The Plain of Montmartre*. Louvre, Paris.
This violent, grandiose painting of old Montmartre and its windmills under a stormy sky reflects Rousseau's rugged and powerful conception of nature. This was not one of Impressionist detachment but of a Byronic, self-dramatizing identification with nature's moods, especially stormy moods which reflected his own emotional character, so different from Corot's quiet and restrained classicism.

rich enough to provide for every experience. Whatever you love with the greatest passion and rapture becomes your embodiment of beauty and conveys itself to others. Each painter must confront nature on his own.

This growing impulse to paint only what one could see encouraged landscape painters to leave their studios and work directly from nature in the open air. But this involved learning to see differently, since sunlight is quite unlike artificial light in the way that it suffuses everything and constantly changes. Painting directly from nature means being constantly confronted with evanescent effects of sunlight and shadow, of light, colour and atmosphere.

Trying to catch these transient and changing effects was to become a major aim of the Impressionists. The first steps towards this revolutionary Impressionist art were taken by the painters who formed the loose-knit Barbizon school. The village of Barbizon is on the northern edge of the forest of Fontainebleau, famous for its enormous oaks and picturesque rocks, but also with views away from the forest across a plain stretching to the horizon. It offered a true flight to nature and a withdrawal from the city, though it was only some thirty miles from Paris. Between 1830 and 1875 it became a regular summer haunt of artists who included Théodore Rousseau, Narcisse Virgil Diaz, Jules Dupré, and several artists who specialized in animal paintings, as well as Millet and Corot. Naturally they differed considerably in their work and attitudes, but all were interested in representing nature realistically. The strongest personality in the group was Théodore Rousseau (1812–67), who defined his own aims by saying, 'You do not copy what you see with a mathematical precision, but you feel and translate a real world in all of whose fatalities you are involved.' This still has a strong element of Romantic subjectivism in it, in contrast to the Impressionist aim of complete detachment. Rousseau was interested in the analysis of natural forms and of light, yet he

Charles-François Daubigny (1817–1878), *Sunset on the River Oise*, 1865. Louvre, Paris. Daubigny's views of river scenery were painted from a special studio boat which allowed him to move freely up and down the river, constantly changing not only the views he painted, but the relationships in them between the elements of water, sky and land. It helped him to carry the practice of painting in the open air a stage further than the Barbizon painters by consistently finishing his work on the spot. He thus became an important link with the Impressionists. Monet admired his work, and copied the boat idea in his own floating studio, which he could moor either on the riverbank or in the middle of the river, surrounded by water, sky and shimmering reflections.

retained an emotive and dramatic approach to landscape, identifying with nature's moods. Like Constable, he preferred skies that were filled with storm clouds, and the two painters are kindred spirits in many ways. Rousseau was the first artist to make a painting tour all round France, yet like Constable he preferred to achieve depth of understanding by painting the same few places over and over again.

The Barbizon painters helped to blur the distinctions between a sketch and a 'finished' picture which Constable had maintained. They did so by further emphasizing the practice of working out of doors, although most of them still only made sketches which were finished off in the studio. Apart from Monet's teacher Boudin, the only landscapist of this generation who actually finished his pictures out of doors seems to have been Charles-François Daubigny (1817–78). Historians of Impressionism like John Rewald have cited various attacks on his work which actually use the word 'impression' in criticizing him for sacrificing the literal truth so as to come closer to an impression of the ever changing aspects of nature. Even the otherwise sympathetic poet Théophile Gautier wrote that 'It is really too bad that this landscape painter, who possesses such a true, such a just and such a natural feeling, is satisfied by an *impression* and neglects details to this extent. His pictures are but rough drafts . . .' But that was of course the point: the closer painters remained to their first visual impressions by actually working in the open air, the more they preserved their spontaneity and

avoided imposing their own style or mannerisms on nature.

As early as 1857 Daubigny constructed a small boat which he could use as a kind of floating studio in order to paint the beautiful river scenery of northern France – an example that Monet was later to copy. He also painted seascapes on the Normandy coast, using a specially wide canvas which was suited to convey space and distance. It was on the Normandy coast that Impressionism was born, as Eugène Boudin (1824–98) and the young Claude Monet (1840–1926) regularly painted together in the open, on the beaches and in the resorts. Boudin's statement 'Henceforward it is necessary to study the simple beauties of nature' is essentially the lesson of the Barbizon school. But it led to rather different results in the still forest glades and on the breezy coasts with their restlessly changing cloudy skies and their transient flashes of light dancing on the waves. This constantly changing beauty demanded the ability to catch a fleeting impression. And it was light itself that came to fascinate Monet, so that more than any other painter he sought to capture the passing moment rather than the solid outlines of things: 'Light is the principal person in the picture.' He became insistent that open-air scenes must be painted on the spot rather than in the studio. But it was not until the summer of 1869, when he and Auguste Renoir (1841–1919) were painting together at the riverside café of La Grenouillère, that they finally left naturalism behind and developed the new Impressionist technique in their attempts to

Monet, *Hyde Park*, 1871. Museum of Art, Providence, Rhode Island. Monet's first visit to London was as a refugee from the Franco-Prussian war. It was a critical moment in his artistic career, and his views of th[e] river and royal parks don[e] at this time show only hints of the impending transformation of landscap[e] painting which his Impressionism was to bring about, thus making fascinating contrast to his later fully Impressionist London paintings. In particular the muted colours of this Hyde Park painting contrast strongly with the bright, pure colours that have come to be associated with the movement. When Monet returned to France in 187[2] and once more began painting with Renoir, his palette grew more brillian[t]

*Right above* Pierre August[e] Renoir (1841–1919), *The Path through the Tall Gras[s]* 1874/5. Jeu de Paume, Par[is] In the early years of Impressionism, when Monet and Renoir often painted together, their work is very similar. But Renoir's has a feathery

htness of touch well
en in this delightful
ocation of a summer day
the country. Renoir was
hedonistic painter of the
nsual enjoyment of life.
his makes him in some
ys a quintessential
pressionist in catching
e fleeting beauty of
ture's ever-changing
enes, though he eventu-
y came to feel that that
as not enough in itself,
d sought for his own
y of giving Impression-
m something of the
lidity of the old masters.

ght Renoir, *The Gust of*
*ind*. Fitzwilliam
useum, Cambridge.

A typically Impressionist
landscape in its evocation
of a particular place at a
particular time, a windy
day in wild, open country-
side with the clouds threat-
ening to bring rain. It is
without the charming reds
and other bright touches of
colour with which Renoir
enlivened his Argenteuil
canvases to give the
impression of leaves in
sunlight or ripples on
water. Yet its success in
capturing the essence of
something as insubstantial
and transient as a gust of
wind is a vivid illustration
of the new element that
Impressionism brought
into landscape painting.

Camille Pissarro (1831–1903), *Crossroads, Pontoise*, 1872. Museum of Art, Carnegie Institute, Pittsburg.

Pissarro was the oldest of the Impressionist group, and he had already worked his way systematically through the various forms of Realism in landscapes influenced by Courbet and Corot before arriving at a point where the radical qualities of Monet's viewing of nature directly under different conditions of light and atmosphere seemed the inevitable next step. But his work always retained a greater solidity of form and construction than Monet's, and is far removed from the lyrical sensuousness of Renoir. In fact his closest associate while he lived at Pontoise was Cézanne, who stayed with him and painted the same scenes. This typically everyday scene shows the lighter palette Pissarro was developing on his return from London after the Franco-Prussian war.

reproduce the sparkle of sunlight on the water. The new method had not yet acquired a name, which was to come with the first joint exhibition by Monet, Renoir and other sympathetic artists. In this banding together Impressionism marked the decisive break of a self-consciously avant-garde art with the Salon and the Academy. Monet had actually had earlier paintings accepted for the Salon but with their growing unortho-doxy this became more and more difficult, until in 1874 a group including Monet, Renoir, Camille Pissarro (1831–1903), Edgar Degas (1834–1917) and others joined together to arrange an exhibition in the studio of a photographer. Although not a single picture was sold, it at-tracted a torrent of abuse from critics, not only because of the new Impressionist technique, but because these painters had the audacity to portray simple, everyday scenes instead of the grand historical and mythical subjects that were still fashionable. It is not easy to recapture the sense of outrage that this first Impressionist exhibition provoked. The Impressionists have given us some of the most popular images of the painter and of paintings, and they have taught us all to see nature in terms of fleeting impressions. It is often claimed that Impressionism is the starting point for the multiple art revolutions of the 20th century. Yet it is as true that it represents the final link in a chain stretching back to the Renaissance.

For Impressionism was not really a fundamen break with the Renaissance conception of t work of art as to some extent a description of t objective natural world, conforming to cert familiar spatial perceptions. All the Impressio ists did was to carry the old masters' discover about aerial perspective and the nature of colo one logical stage further. The one importa respect in which they broke with the Renaissan tradition was in discarding the rigid concept classical form in favour of an attempt to captu the fleeting moment. However, this was ce tainly startling at the time. As Ernst Gombri points out, the story of art repeatedly sho how much we are inclined to judge pictur by what we *know* rather than by what we s Since the medieval period with its landsca of symbols, great artists had made a whole seri of discoveries which allowed them to presen convincing picture of the visible world. But no of them had until now challenged the convicti that each object has a fixed form and colour.

Impressionism was in fact the ultimate sta in the process of painting not what the mi knows but what the eye sees. And both its virtu and its limitations are summed up in Cézann statement, which is both criticism and praise, th 'Monet is only an eye. But what an eye!' T great virtue of the movement was that it enlarg our range of vision and gave everyone a great

Pissarro, *Gelée Blanche*, 1873. Jeu de Paume, Paris. In Monet's landscapes the human figure plays a very subordinate role. His studies of nature are above all studies of light and its transient effects. And Monet loved water, whether along the valley of the river Seine or the Normandy coast. But Pissarro was above all a painter of the land, and his landscapes also make up a pictorial record of the life of the countryside and the work of the peasants in the fields. His interest in peasant life reflected his political views, and relates him to Millet, though Pissarro's gentle utopian anarchism was far removed from Millet's fatalism.

Monet, *Waterloo Bridge, Sun in Fog*, 1903. National Gallery of Canada, Ottawa.
There are about 100 paintings in the later London series which Monet began to paint in 1899. And like the *Haystacks*, *Poplars* or *Waterlilies*, they form a true series, in which the artist made a sustained exploration of one particular aspect of the problem of translating the appearance of the natural world into paint. Monet painted 42 Waterloo Bridge pictures, giving them sub-titles like 'sun in fog' to indicate light and weather. He worked in London during three successive winters, choosing this season because the great attraction of the city was its fog, and the way the foggy, smoky atmosphere reacted with sunlight and the water of the river to produce such shimmering visions as this.

awareness of the changing play of light. But it fastened on one *kind* of truth only, the truth of the transient impression. It was essentially a response to purely visual sensations, which allowed little room for the imagination, and for the brooding, contemplative attitude which played such a large part in landscape painting from Claude to Caspar David Friedrich. If art should be concerned with our whole being, then Impressionism is relatively superficial. Some of its practitioners, like Cézanne, came to feel that charm was not enough, and began to seek a more profound art. And so by about 1880 Impressionism had effectively broken up, with each artist now following his own path. It was Monet who remained most faithful to the original Impres-

sionist vision. Many of his late pictures form series which show light falling at different times of day on the same object: the façade of Rouen Cathedral, haystacks, poplars, Westminster Bridge, the water-lilies in the beautiful garden he had created for himself. The series of late water-lilies is particularly remarkable because in this final stage of near-abstraction Monet's art resembles that of Turner, whose evolution and aims were so different. Impressionism has had a huge and continuing popularity because it offers such a beautiful vision of the complexion of nature, the surface beauty that comes and goes with the fluctuation of light – a lyricism that is the perfect expression of one aspect, though not of the whole, of nature.

Pissarro, *View from my Window, Eragny*, 1888. Ashmolean Museum, Oxford.
Pissarro's response to the crisis of Impressionism wa to systematize his brushwork, and in 1885 he took this a stage further by adopting Seurat's pointillism. This whole canvas is covered in small touches of colour, giving a vibrant and luminous effect. However, he soon came to feel that the method 'inhibits me and hinders the development o spontaneity of sensation'.

So he was already looking
for a way of combining the
purity of pointillist dots
with impressionist
spontaneity, shown here
for instance in the small
dabs of paint varying in
size and direction. This
view from a window pre-
dates the eye disease which

after 1889 increasingly
forced Pissarro to paint his
later landscapes from
behind closed windows.

Monet, *The Bridge with
Waterlilies*, 1899. National
Gallery, London.
The last of Monet's series
exploring a single subject

under different conditions
of light and atmosphere is
the *Waterlilies*. This is an
early stage, still clearly
showing the reality of his
water-garden, with its
Japanese-style bridge, and
trees overhanging the
pond. As the series
progresses reality recedes,

until the water with a few
plants floating amid
reflections on its surface
becomes a vast shimmering
near-abstract vision.

# Chapter Nine
# The Spread of Landscape Painting to America

Cole, *Mountain Landscape with Waterfall*, New York, 1847 (detail, complete painting p. 140). Museum of Art, Providence, Rhode Island.

Cole longed to portray the American scene in all the grandeur and freshness which so impressed him, preferring to paint 'the wild and great features of nature: mountainous forests that know not man'. Waterfalls thundering over the rocks are a vivid example of the hidden energies of nature being made visible, and the grandest of them all, Niagara, became a perpetual challenge to American painters, including Cole's pupil Frederic Edwin Church. But Cole was not just interested in splendid scenery but tried through his rich heightened pigments and visible and tactile brushwork to underline the living creative qualities he felt in nature.

James Abbot McNeill Whistler (1834–1903), *The Coast of Brittany*, 1861. Wadsworth Atheneum, Hartford, Connecticut. Whistler's first major seascape, though close to the realism of Courbet in its sharply outlined rocks, already shows hints of the future Whistler in its interplay of large areas of colour. But the girl dressed in Breton costume and the title *Alone with the Tide* under which it was first exhibited still conform to the taste for anecdotal genre scenes.

The art of James McNeill Whistler (1834–1903) represents an even more complete break with the traditional emphasis on subject and story than that of the Impressionists, since it was designed to focus attention on colour harmony and abstract design. Although Whistler had been influenced by both Courbet and the Impressionists during his years in France, other influences such as Japanese prints were equally important to him. American-born but growing up partly in Russia, where his engineer-father was helping to build the railways, he developed as an artist in Paris but then worked principally in London. He was in fact not only a truly international but a highly individual painter; his landscapes are typical of his work as a whole in starting with a

realism close to Courbet's and then movir further and further from the subject to a nea abstraction in paintings to which he gave music titles such as *Nocturnes*.

Whistler was a true revolutionary wh attacked the received opinions of his day verball and made a radical break with them in his pain ings. The revolutionary nature of his art ha however, been overshadowed by his legenda reputation as a wit and dandy who moved in th same circles as Oscar Wilde; his caustic humou often scandalized people as much as Wilde's, an he even wrote a book called *The Gentle Art Making Enemies*. We can now see his landscap as evocations of mood which make a dire emotional impact in much the same way as musi

hich is why he called them *Nocturnes, Symphonies* and *Harmonies*. But they were a direct challenge to the Victorian emphasis on the rimacy of subject matter and narrative content – all the ideals of that great moralistic critic John uskin, who believed that pictures should tell a ory with highly finished detail, as the Preaphaelites' paintings did. It is difficult to concile Ruskin's admiration for Turner's late orks with this, but he certainly drew the line at Vhistler. The painting of fireworks at night alled *Nocturne in Black and Gold, The Falling Rocket* became the most controversial of all that rtist's paintings when he sued Ruskin for libel in escribing it as 'flinging a pot of paint in the ublic's face'. This famous case indicated the breach that was opening between the avant-garde artist and the public, a breach which has since widened into a yawning chasm.

Whistler was an international artist who happened to be born in America – and he sometimes denied even that, giving himself several widely differing birthplaces including the Russian capital, St Petersburg. To one impertinent enquirer he retorted, 'I shall be born when and where I want.' But a distinctive American school of landscape *had* developed during the 19th century, one whose essential aim was to define the special character of the American environment. The awareness of a national consciousness, of an American spirit distinct from European ways of thinking and feeling, was crystallized in the 19th

Whistler, *Crepuscule in Flesh and Green: Valparaiso*, 1866. Tate Gallery, London. An intermediate stage between realism and the 'Nocturnes', with the colours of sea and sky brought near to each other, but without the monochromatic harmony and blurring of objects which later take Whistler further towards abstraction. And he challenged the Victorian belief in the primacy of subject matter by choosing abstract titles.

*Right* Whistler, *Nocturne in Black and Gold: Entrance to Southampton Water*, 1872–4. Chicago Art Institute.
In such Nocturnes as this Whistler has moved further towards abstraction, so that the whole composition is a harmony almost of one colour, a unity in which the blurred ships, the faint shoreline and the misty moon all help to create the effect of great haunting spaces. It was another *Nocturne in Black and Gold*, subtitled 'The Falling Rocket' now in Detroit) that led Ruskin to make his famous attack on Whistler for 'flinging a pot of paint in the public's face'. That great Victorian moralistic critic disliked such paintings because they had no 'moral intention', but were detached, amoral comments on the visible world.

*Right* Samuel B. Morse (1791–1872), *View from Apple Hill*, c.1829. New York State Historical Association, Cooperstown, New York.
Morse belonged to that tragic generation of American artists who had broken with Europe but had not yet created a native American art. He painted portraits for a living, and this charming view has been well described as 'a portrait of a place which also includes smaller portraits of two members of the family that lived there.' Morse longed to become a history painter, but was unable to find patrons, and so he gave up art, and proved his contention that America was a better place for an inventor than an artist by becoming famous as the inventor of the electric telegraph and the Morse code that went with it.

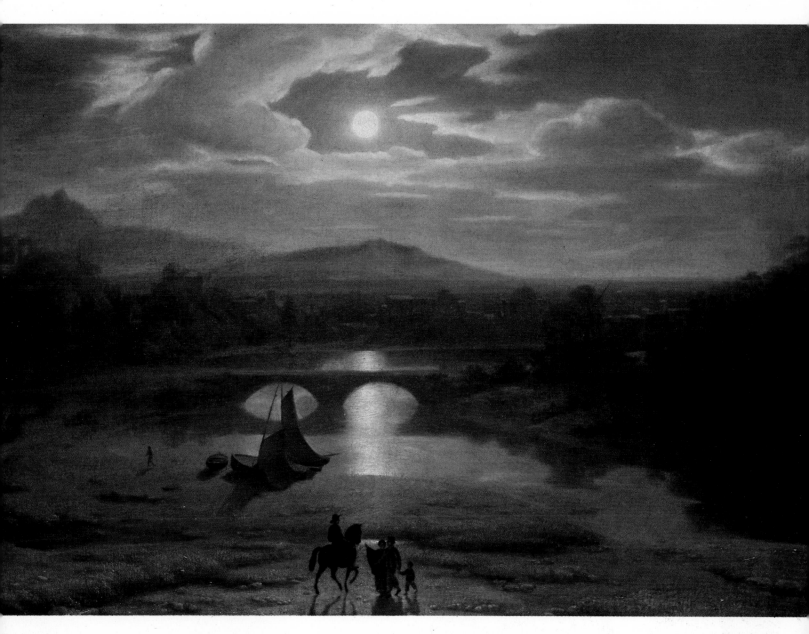

entury by such writers as Melville, Hawthorn, Emerson and Thoreau. And the history of art in America became the story of artists' efforts to free themselves from European models, and to capture the essence of the American experience and landscape. In the late 18th century the leading American painters, Benjamin West and John Singleton Copley, had settled in England and become famous for paintings of historical subjects – so successfully that West was appointed president of the Royal Academy when Sir Joshua Reynolds died in 1792. But the spell of history and religious painting in the Grand Manner, as advocated by Reynolds, had to be broken before American artists could create a tradition of landscape painting. It was a spell which all too often led to achievement falling short of ambition, and so to tragi-comic careers like that of the English painter Benjamin Robert Haydon, who ended his life in frustration, imprisonment for debt and suicide.

Similar frustrations were the lot of several American artists who painted interesting land-scapes but longed for success in history painting, trying to copy the grandeur of past European art rather than being content to catch the sublimity of America's spectacular scenery. John Vanderlyn ended his career in bitterness and despair. The more practical Samuel B. Morse gave up painting at the age of 40, deciding that there were more opportunities for inventors than for artists in America, so that he is now best known for the electric telegraph and the Morse Code. The ambition to become a successful history painter was also a tragedy in the life of Washington Allston (1779–1843), the first important American landscapist and the artist who introduced the spirit of Romanticism into American painting. Allston spent 17 years in two extended visits to England, where he studied under Benjamin West. The respect he acquired for history painting resulted in a frustrating 25-year struggle to complete the ambitious *Belshazzar's Feast* with which he hoped to rival the visions of John Martin – though the gigantic canvas remained unfinished at his death, having become,

Washington Allston (1779–1843), *Moonlit Landscape*, 1819. Museum of Fine Arts, Boston.
This enigmatic picture, mysterious, suspenseful, is a good example of Allston's 'landscape of mood'. Only the moon peeping from the clouds, and its unnaturally bright reflection in the river, light up an eerie scene which has something of the magic timelessness of a dream. Though based on Allston's nostalgic recollection of the Alban hills by the Tiber, this is really a haunting landscape of the mind, looking forward to Surrealism and the strange brooding vistas of De Chirico's metaphysical paintings.

as one friend put it, 'the incubus, the tormentor of his life'. Allston's Romanticism found a more personal expression in landscapes in which he at first tried to express the dramatic and terrifying aspects of nature such as a thunderstorm at sea or a deluge. But after his final return to America in 1817 he turned to quieter scenes which reflect the mystery of nature, and which his biographer called the 'landscape of mood'. Allston's ideas about colour anticipated later artists such as Whistler and Kandinsky, since he became aware of its direct emotional impact, which he compared to that of music. These later dreamlike pictures make him the forerunner of the subjective and visionary trend in American landscape painting.

Yet the return to nature which was basic to Romanticism did eventually establish landscape painting as the main form of artistic expression in America – above all in the work of the Hudson River School, which was so

named because its artists first turned for inspiration to the dramatic scenery of the Catskill Mountains and the Hudson River Valley. The were the true founders of American landscape painting. Their leader, Thomas Cole (1801–48 was born in England, and emigrated with h family to the United States in 1819. There l became passionately devoted to the natur scenery, the sheer freshness of 'primeval forest virgin lakes and waterfalls', which contraste with the scenery of Europe, 'hackneyed and wor by the daily pencils of hundreds'. Cole claime that it was this delight in America's natur scenery which made him choose to be a painte On a sketching trip in 1825 he made his fir paintings of the still unspoilt scenery along th Hudson River, settling the following year in th village of Catskill. He spent the rest of his li trying to capture the qualities he felt so strong in American scenery, the feeling of wildness, the overpowering vastness of a land on whic

*Below* Cole, *Mountain Landscape with Waterfall.* Complete painting (*see* also p. 134–135).

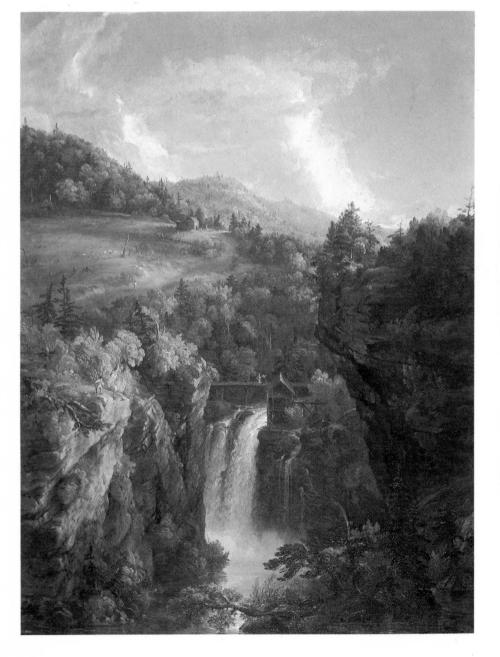

*Above* Thomas Cole (1801–48), *Sunny Morning on the Hudson River.* Boston Museum of Arts.
Cole eloquently expressed in his writings the desire for a direct approach to the 'divinity in nature' through landscape. And this early painting of the dramatic scenery of the Hudson River Valley catches the clear air and vast distance the primeval, virginal quality of this still unspoilt land.

an had so far made so small an impact that it emed to come 'fresh from the creation.' Cole as therefore not simply interested in scenic onders, but approached nature with a contemlative attitude very similar to that of a German omantic artist, or to the American novelist mes Fenimore Cooper, who saw 'the hand of od . . . in the wilderness'. Cole's, then, was a ecial sort of nature mysticism, experienced fore what the poet William Cullen Bryant escribed as 'scenes of wild grandeur peculiar to r own country'; it was the revelation of a ilderness untouched by man and therefore pressing directly the forces of creation. Like e German Romantics, Cole was fond of painting ose moments at which it is possible to see early, and interpret visually, the mysterious ergies of nature – not merely the outward and sible forms of nature, but also the inner life d harmony that pervades it. Chinese painters d been doing this for centuries, but western

artists were affected by the legacy of centuries of Christian supernaturalism and a still strong pull towards narrative content. And so Cole, despite the enormous success of his pure landscapes, succumbed to the lure of historical landscape, introducing Biblical themes and overt imagery to create landscape cycles on human destiny. He had a strong vein of fantasy, and his obsession with such Romantic themes as change, the passage of time and the mutability of earthly things led him to create great allegorical cycles which combine landscapes with such themes as the growth and decay of empires or the voyage of life from childhood to old age.

The Hudson River School painted a much wider range of landscape than their name suggests. This is particularly true of Cole's only pupil, Frederic Edwin Church (1826–1900). He travelled all over North and South America, from the bleak rocky coasts of Labrador to the remote tropical valleys of the Andes, as well as crossing

*Below* Asher B. Durand (1796–1886), *Kindred Spirits*, 1849. New York Public Library.
The painter Thomas Cole is seen contemplating the beauty of a Catskill glen with the poet William Cullen Bryant, who shared a similar attitude to nature, expressed in such philosophical nature poems as 'The Snow Shower' and 'To a Waterfowl'. This was painted as a tribute to Cole, the year after his death, by his leading follower. But Durand was unlike Cole in working out of doors, paying close attention to atmospheric gradations, so that here the effect is of gradually receding into a hazy expanse.

*Above* Cole, *The Oxbow*, 1836 or 1846. Metropolitan Museum, New York. This panoramic view of a famous bend in the Connecticut River is an example of the increasingly larger vistas to which Cole was led in trying to express his view of nature as revealing the forces of creation, seen at work in the stormy wind heaping up black clouds in contrast to the calm vista in the distance. And Cole's favourite image of a lightning-blasted tree is a reminder of nature's constant growth and decay, the passage of time, and the mutability of all earthly things.

*Right* Cole, *Titan's Goblet*, 1833. Metropolitan Museum, New York. Even Cole's closely observed realism was part of a mystical attitude towards the world of nature as the revelation of God in the wilderness. And it was combined with a strong vein of imaginative fantasy which produced such dream images as this gigantic object, allegedly based on the Norse legend of the Tree of Life, but anticipating Surrealist landscapes of the mind. The vast goblet is perched among the mountains as though left there by some vanished race of giants. Boats sail on the waters inside it, and little men scurry about like ants, dwarfed by the great stone object looming above them.

the ocean to paint the pyramids of Egypt. Church was very much a painter of the sublime, choosing subjects such as a Mexican volcano, Niagara Falls, and icebergs off the Labrador coast. Robert Rosenblum feels that Church's paintings lack the inner magic of Caspar David Friedrich, that 'his sublime landscapes can often be mistaken, unlike Friedrich's, for thrilling travelogue views that simply document strange, natural wonders'. Yet Church never lost his own sense of wonder, and his artistic travels were inspired by the works of the great German naturalist von Humboldt, who was intensely concerned with man's changing relationship to the natural world and wrote at length about landscape painting as a means of understanding and revealing

'the great enchantment of nature'.

Each different kind of scenery has been felt b the landscape artist as a challenge to tame th wilderness by capturing its essence. As th American frontier was pushed westwards Georg Catlin recorded the vanishing life of the India who were being thrust aside, while George Cale Bingham portrayed the life of the fur traders an other pioneers. When the Civil War ended i 1865, the United States embarked on a period expansion which transformed it from a sma agricultural nation into a great industrial powe Enthusiasm for the vast extent and majest scenery of the country is reflected in the paintin of the Rocky Mountains by the German-bo Albert Bierstadt (1830–1902), who pictured th

rairies teeming with the vast herds of bison at were soon to be slaughtered. The explora-ons of the landscape painters were comple-ented by those of the artist-naturalist John mes Audubon, who wrote and illustrated the mous *Birds of America*. Many of his subjects, ke the passenger pigeon, were found in such st numbers that flocks of them blotted out the n, until they were finally exterminated by man the 20th century. Many of the scenes that the udson River School and others painted were so soon destroyed by the rapid growth of in-ustry and cities and railway lines. For the idea of merica as the new Garden of Eden, which spired so many of the painters, came into sharp onflict with the dominant exploitative attitude

of western man, for whom unspoilt nature was simply a barrier to progress. However, alarm at the destruction and despoliation of nature helped to produce the conservation movement, and some artists actually had a practical influence on this: when Thomas Moran accompanied a govern-ment expedition which explored the Yellowstone Valley, the views he painted actually helped to get it declared the first American National Park in 1872.

The later 19th century in the United States has been called the 'Gilded Age', a period in which vast private fortunes were made from the growth of new industries, and the prevailing mood was one of determined materialism. This hastened the decline of Romanticism in all the

Albert Bierstadt (1830–1902), *The Rocky Mountains*, 1863. Metropolitan Museum of Art, New York.
In 1857 Bierstadt had joined the expedition that was to map out the wagon route to the West, and his views of the prairies with their herds of bison, and the majestic scenery of the Rocky Mountains, made him the most popular inter-preter of the West – so popular that banners were strung across Broadway to announce the first showing of this colossal picture.

143

*Above* Thomas Moran, *Grand Canyon of the Yellowstone*, 1872. U.S. Dept. of the Interior, National Park Service. The painter Thomas Moran was a member of the government expedition sent to explore the Yellowstone Valley in 1870. His paintings helped to convince the U.S. Congress that the natural beauty of the region should be preserved, and in 1872 it became the country's first National Park.

arts, and the change from the spacious panoramas of American Romantic landscape to a more intimate naturalistic approach is seen in the work of George Inness (1825–94), who had lived in France and knew the work of Corot and the Barbizon school; in his later paintings, however, he evolved a personal style which conveyed his own subjective response to nature.

Many American artists became expatriates in Europe to make their careers – not only Whistler but also the Impressionist Mary Cassatt, who worked closely with Degas, and John Singer Sargent, a brilliant landscapist who earned his living as a fashionable portrait painter, though he finally abandoned formal portraiture around 1908 to concentrate on his murals and landscapes. But three major masters of American painting at the turn of the century were largely untouched by this new wave of European influence. Of the three, Thomas Eakins (1844–1916) was the most straightforwardly realistic, and landscapes come into his work mainly as a setting for outdoor sports like sailing and rowing which he frequently painted.

The art of Winslow Homer (1836–1910) comprises a sort of visual autobiography. A New Englander from Maine, he began his career with black and white illustrations for magazines which show his gift for naturalistic recording, for instance of the Civil War - sharp objective drawings of battles, soldiers getting ready for action, or coming back wounded. After this he made several trips to Europe and to various parts of the United States, avidly recording what he saw. He loved nature, and spent many summers hunting, fishing and sketching in the mountains. And so he became a painter of the rural scene in the fresh raw world of America, though it is extraordinary

to recall that his contemporaries could find the charming scenes ugly, as Henry James did:

> Homer goes in . . . for perfect realism, and cares not a jot for such fantastic hairsplitting as the distinctions between beauty and ugliness . . . He is almost barbarously simple, and to our eye he is horribly ugly . . . We frankly confess that we detest his subjects – his barren plank fences, his glaring, bold blue skies, his big, dreary, vacant lots of meadows, his freckled, straight-haired Yankee urchins, his flat-breasted maidens, suggestive of a dish of rural doughnuts and pie . . .

In 1881 Homer went to England, spending two summers at the North Sea port of Tynemouth, painting the sea, the shore, the fishermen and their boats. When he returned to America he settled on a storm-battered point on the Maine coast. Here he produced a series of paintings of wild Atlantic seas and the lives of Maine fishermen which form an epic of man's battle with

*Left* George Inness (1825–44), *The Monk*, 1873. Addison Gallery of American Art, Phillips Academy, Andover, Massachusetts.
Inness was one of those visionary painters who tried to represent not so much the outward appearance of nature as its inner poetry. He was a follower of the religious mystic Swedenborg, and in later paintings such as this he evolved a personal style which would convey his own feeling of the sense of mystery that nature evoked in him. The tiny white-robed monk walks quietly through a landscape whose air of stillness is enhanced by the towering umbrella pines framed against the evening sky.

*Below* Winslow Homer (1836–1910), *Sunlight and Shadow*. Cooper-Hewitt Museum, Smithsonian Institution, Washington. Looking at the way Homer has caught the effects of light streaming through the trees or reflected from the grass, it is easy to see why he has been linked with the Impressionists who were his contemporaries in France. Yet his technique, with its strong draughtsmanship and colour harmonies, is totally different.

ture. In these confrontations of man with the a, human endurance and survival in the face of stile nature are the main theme. But Homer ally eliminated man altogether, and in the ost original phase of his art he made his subject e battle of the elemental forces themselves.

The visionary painter Albert Pinkham Ryder 847–1917) was one of the grand eccentrics of t, though lonely, isolated and unrecognized in s own lifetime. He was born on the coast of assachusetts, in New Bedford, then the great-t whaling port in the world, as described in erman Melville's *Moby Dick*. All his life Ryder as haunted by the mystery of the sea. Living in sperate poverty in New York, he painted in a uttered room with his back to the window, edging up landscapes of the mind from deep ithin his unconscious. Myth, Wagner's music, d the poetry of Byron, Tennyson and Edgar len Poe were important to him, yet he is never iterary or illustrative painter, but a creator of mpelling images in which he always tried to go

beyond the visible world and express the unseen forces by which life is shaped. He himself expressed this by saying, 'Have you seen an inch worm crawl up a leaf or twig, and then clinging to the very end, revolve in the air, feeling for something to reach something. That's like me. I am trying to find something out there beyond the place on which I have a footing.' Ryder was a self-taught artist whose technique of laying paint on thickly with a palette knife has caused some of his paintings to crack and deteriorate, but they remain haunting images.

In the early years of the 20th century, American art developed a sort of double avant-garde: one group emphasized form, the other content. The first group followed the European avant-garde in abandoning traditional attitudes to form and colour and experimenting with cubism or abstraction, while the other explored

Homer, *Northeaster*, 1895. Metropolitan Museum of Art, New York.
Like Turner and other Romantics, Winslow Homer was fascinated by the elemental power of the sea as one of the most striking manifestations of natural energy. During his last 27 years he lived on the Atlantic coast in Maine, painting the confrontations of man with nature, the struggle for existence of lonely fishermen in the midst of the limitless expanse of the empty ocean. And in late paintings such as this he omitted man altogether, concentrating on the hostile solitude where sea,

sky and coastline contend with each other, heedless of the existence of man. Here the thunderous surf crashes over the rocks as the savage northeasters strike the coast.

*Right above* Albert Pinkham Ryder (1847–1917), *Toilers of the Sea*, before 1884. Metropolitan Museum, New York. Ryder had a truly poetic imagination, and while living in desperate poverty in New York he painted dreamlike, moonlit seascapes, sometimes with a lone sailing boat, which hauntingly convey his fascination with the mystery of the sea.

*Right below* Georgia O'Keeffe (b. 1887), *Red Hills and the Sun*. The Phillips Collection, Washington D.C. Georgia O'Keeffe's desire for remoteness and for closeness to nature led her to find her spiritual home in the arid deserts of the American Southwest. But her sublime and monumental paintings of i are drastically simplified to catch its essence rather than its detailed topography, even when they do relate to specific places. And often the landscapes of this very intuitive painter are near-abstract, yet full of a pantheistic feeling of the life of nature

This painting expresses the very essence of sunrise or sunset, the sun forming a radiant semicircle above a hot desert of hills contoured with soft feminine breast-like forms, like a primordial meeting of sky god and earth mother-goddess.

subject matter quite foreign to earlier ideas of beauty. The Ash Can School, for example, dedicated themselves to an urban realist art which showed the seamy life of the streets, the dingy cafés, and the shabby city slums and tenements in front of which the ash cans stood guard. But despite their search for a truly American identity and their new and specifically American content, in style the Ash Can School appeared conservative in contrast with its rivals who modelled themselves on the European avant-garde. There then began a long debate about realism and modernism, later followed by controversies over figuration and abstraction. Much of the polemic has been unreal, since the essence of the idea of the avant-garde as it grew up in the wake of the Romantic movement is that form and content are inextricably bound together. The really great creative artist is of special imaginative vision, whose need to express some new way of seeing or feeling demands a new form to hold it. As will be seen later, even the artists who pioneered abstraction, including Kandinsky and Mondrian, did so by gradually abstracting from nature in an attempt to express their own heightened feelings and vision more forcefully.

The most interesting landscape painters in 20th century America are certainly those who have been responsive to modern art but have something of their own to express – often connected with special love for a particular place. Since Winslow Homer's time the coast of Maine has continued to act as a magnet for painters like Marsden Hartley and John Marin, with a special fascination for the sea. Marin (1870–1953) was particularly notable as a brilliant watercolourist who first tackled urban views in which he tried to catch the 'warring, pushing forces' of modern city life. But from 1914 onwards, having discovered the coast of Maine, he spent his life there painting freely lyrical semi-abstractions of its sea and rocky shores and wind-blown pines and the elemental forces of nature.

In contrast, Georgia O'Keeffe (born 1887) found her own special artistic world in the arid deserts of New Mexico. She has always had a gift for dramatic simplification, and much of her early work seemed to be abstract, though it was always inspired by natural forms, from which she derived a highly personal vocabulary. She has probed into the hidden depths of flowers in giant close-ups, producing curving feminine forms that seem to express a voluptuous sensuality which catches something of the generative forces of nature. When she discovered the Southwestern deserts in the 1920s she immediately recognized her spiritual home in their austere beauty. Her majestic landscapes of the region, although inspired by specific places, are evocations rather than literal descriptions of nature. They are also symbolic equivalents for inner emotional states, their feelings of strangeness and timelessness often enhanced by her inclusion of the almost abstract forms of bleached bones from the many animal skeletons littering the desert.

147

# Chapter Ten
# Russian Landscape Painting

Isaak Levitan (1860–1900), *Secluded Monastery*, 1890. Tretyakov Gallery, Moscow. Like Constable, Levitan preferred not to paint spectacular mountain scenery but his own native region. And nobody has better caught in paint the immensity and the quiet melancholy beauty of the central Russian landscape and the mighty river Volga and its tributary streams. He told his pupils: 'Do your utmost to depict what you feel, the state of mind that gazing at this or that spectacle of nature produces on you.' And his paintings draw the observer in and make him take part in the mood of nature. Thus here we are drawn across the little river spanned by its rickety wooden bridge to where the last rays of the setting sun are gilding the green onion domes of the monastery and the trees of the pine forest which surrounds it.

149

Russia too the growth of landscape painting began with 19th century Romanticism and nationalism. Pushkin, Lermontov and Gogol initiated the great flowering of Russian literature which was to include Turgenev, Tolstoy and Dostoevsky, just as the musical nationalism of Glinka led on to Mussorgsky, Borodin, Rimsky-Korsakov and Tchaikovsky. But the two major Russian Romantic painters were less successful in giving the foundations of a national art. Both succumbed to the lure of history painting and both were tragic failures in their different ways. Turgenev summed them up pithily when he contrasted the empty bombast of Bryullov's history paintings, those 'great machines' like the once famous *Last Days of Pompeii*, with Ivanov's unrealizable religious projects: 'Bryullov had the gift of expressing whatever he wanted to, but he had nothing to say. Ivanov had plenty to say, but his tongue stuttered.'

In many respects Alexander Ivanov (1801–58) resembled his fantastic contemporary Gogol. Both men left St Petersburg dissatisfied in the early 1830s to seek a new source of inspiration in Italy, attracted by Romantic nostalgia for the lost beauty of classical antiquity. Gogol ended a prey to despair and religious mania, starving himself to death after burning the only manuscript of the second part of *Dead Souls*. Ivanov spent nearly a quarter of a century dreaming of and making studies for two titanic works, ultimately doomed to failure because his aspirations far exceeded anything which could be realized in paint. Like Gogol he had a strange mystical belief that his art would lead to the spiritual rebirth of mankind, and he longed to incorporate his entire religious philosophy in a single visual work which would elaborate the theme of man's moral renewal in this world. But his struggles with the subject of Jesus appearing to the people on the banks of the Jordan were ultimately as futile as Washington Allston's with Belshazzar's Feast. Ivanov himself expressed it well: 'While leaving the old modes of art, I have not yet built any firm foundations for the new, and find myself, involuntarily, an artist of transition.' The foundations of the new art were in fact to be built on landscape and, had he only realized it, Ivanov was working on lines which others would develop. For the hundreds of landscapes which he regarded as merely studies for the background of his great pictures are beautiful paintings, and in some ways anticipate Impressionism in their brilliant effects of light and colour.

Several other Russians went to Italy and painted the Italian scenes already so familiar as motifs. But the particular quality of the Russian landscape, its forests, steppes and great rivers, its vast bleak distances and extremes of climate, were first captured in paint by the loose group of mid-century nationalist artists known as *Wanderers (Peredvizhniki)*, from the travelling exhibitions they organized to bring art to the people. Their movement was sparked off by a revolt in the Academy, which still propagated international Neo-classicism and favoured mythological and Biblical subjects. In 1863 thirteen students simply refused to paint the set subject of Odin in Valhalla, were expelled, and formed their own society. The most interesting outcome was the discovery of the Russian landscape. Painters like the short-lived Fyodor Vasilyev (1850–73) and

*Left* Alexander Ivanov (1801–58), *Trees by Lake Nemi*. Tretyakov Gallery, Moscow.
Ivanov resembles his American contemporaries who painted beautiful landscapes while longing to excel in history painting. In their brilliant effects of light and colour his landscapes anticipate those of the Impressionists. But for the artist they were merely studies towards a titanic but quite unrealizable religious picture which would redeem the world.

*Below* Fyodor Vasilyev (1850–73), *The Thaw*, 1871. Tretyakov Gallery, Moscow.
Although Vasilyev died at the early age of 23, his work shows a remarkable, lyrical approach to the Russian countryside. In Russia spring comes as a dramatic rebirth of life after the icy winter, and this was naturally one of the subjects which attracted Vasilyev and other Russian artists making up the group known as *Peredvizhniki* or 'Wanderers', the first artists to try to record the distinctive essence of the Russian countryside.

Vassily Kandinsky (1866–1944), *Murnau with Rainbow*, 1909. Städtische Galerie in Lenbachhaus Munich.
A dramatic picture which shows Kandinsky's heightening of colours, dramatizing the atmosphere of a break in the storm, and simplifying the outlines, which would lead him to complete abstraction the year after this was painted.
Kandinsky's simplification of form and heightening of colour were intended to express an inner truth of feeling, which he eventually came to feel would best be achieved by moving away completely from representation and producing paintings like visual music.
Paradoxically, it was precisely through constant study of nature and its effects of light and atmosphere that artists had gradually moved away from descriptive painting towards the communication of such pure experiences.

Aleksei Savrasov (1830–97), who has been called 'the father of Russian landscape', convey in their paintings of *The Thaw* a feeling of the coming of spring after the harsh Russian winter as the ice melts and life begins to return to the frozen landscape. Levitan, the greatest of the Russian landscape painters, was a pupil of Savrasov, and in his obituary notice of the older master he summed up the essence of these springtime landscapes:

> Savrasov was the first to display both a lyricism in the presentation of landscapes and an unbounded love for his native land. Look at his best pictures, such as *The Rooks are Here*. What is its subject? On the outskirts of a small town, an old church, a rickety fence, a field covered in half-melted snow, and in the foreground a few trees on whose branches the rooks have settled. That is all. How simple it is. Yet in this simplicity there lies a whole world of wonderful poetry.

Isaak Levitan (1860–1900) was a close friend of Chekhov, who drew on the painter's numerous passionate love affairs in some of his stories and plays, including *The Seagull*. Chekhov used to be misinterpreted, especially in England, as the poet of twilight Russia, conveying an atmosphere of gentle melancholy in which everything is suffused in an autumnal glow as the sun sinks for the last time over a cherry orchard ringing with the sound of axes chopping it down. This is much truer of Levitan's landscapes, which often have an elegaic mood of autumn days, of the evening dusk, the utter stillness of a moonlit night or the gloom of a stormy sky. Nobody has better caught in paint the immensity and the quiet, melancholy beauty of the central Russian landscape and the mighty River Volga: Levitan loved them so much that on a visit to Italy he was so overcome with nostalgia for the Russian countryside that he hurried straight home. When he died of a heart attack at the age of 40, Diaghilev, a great admirer of his work, wrote a lengthy appreciation of it in his magazine *The World of Art*, concluding that:

> If one seeks in our painters' canvases the freshness of Turgenev's mornings, the scent of Tolstoy's hay, or the precision of Chekhov's description, one is inevitably drawn to the conclusion that, among all the Russian landscape painters . . . Levitan is alone in rising to the level of these great poets.

The group of artists Diaghilev gathered around him before launching his ballet seasons in Paris played an important part in the great ferment of Russian art which from the 1890s through the first two decades of the 20th century made a significant contribution to the modern movement. Yet side by side with the exploration of the new went a rediscovery of the past, which in Russian art meant a rediscovery of the brilliant colours of folk art and the extreme formalism and rigid abstraction of religious icon painting. These were to have a profound influence on the develop-

ment of artists as different as Kandinsky (1866–1944) and Malevich (1878–1935), both of whom gradually moved towards non-figurative, abstract art, lyrical in Kandinsky's case, geometric in Malevich's. But both began by painting landscapes, and gradually abstracting from them in the search for greater expressiveness. In fact although Malevich with his Black Square arrived at the most uncompromisingly geometric abstraction possible, on the way to this he painted peasant scenes which represent a Tolstoyan return to the earth, a sort of spiritual pantheism.

Kandinsky's first love was music, and he had intended to be a musician, but it was his successive experiences of medieval icons, Russian folk art, and an exhibition of the art of the French Impressionists that led him to study painting in Munich. He moved from an early Impressioni

with rainbows and mountain sunrises and sunsets; his colours became brighter and more arbitrary, his forms less representational and more rhythmic. Then, according to his own account, came the sudden apocalyptic moment in which he found what he was looking for. Returning to his studio one day he was thrilled to see a picture of astounding beauty which had no recognizable subject. Finally he realized it was one of his own paintings, standing on its side. This crystallized the conception towards which he had been working – that form and colour, used symbolically without any actual figures, could communicate emotions directly, just as music does. While he explored this discovery in paint, he also began to work out a theory of art to justify it, which he published in 1912 as *Über das Geistige in der Kunst* (*On the Spiritual in Art*).

Kandinsky's ideas are very similar to those of Romantic artists like Caspar David Friedrich, for instance in stressing that art is not just concerned with representing the visible world, but with the inner world of the artist:

> A work of art consists of two elements, the inner and the outer. The inner is the emotion in the soul of the artist; this emotion has the capacity to evoke a similar emotion in the observer . . . In this respect painting is in no way different from a song: each is communication.

Kandinsky's argument is full of such musical analogies, since his whole object in freeing colours and forms from their descriptive function was to allow them to act directly on the emotions. He was a close friend of Schoenberg, who was himself a painter as well as a composer. The two men often discussed the aims of their respective arts, concluding that their aims were fundamentally the same: to express an inner emotional state, turning vague feelings into precise forms. The idea that these emotions could be expressed most powerfully not by painting landscapes but by making the forms abstract came to Kandinsky in the moment of revelation when he was confronted by his own unrecognized painting, glowing with colours and expressive in form. Yet he continued to paint landscapes until 1913, since it was some time before he found a form of abstraction which satisfied him – a lyrical abstraction closer than any other painting to visual music.

Kandinsky's art and ideas raise all sorts of basic issues about the communication of emotion in the arts, and these have a profound relevance to landscape painting. The history of landscape shows critics repeatedly dismissing it for not having any uplifting 'content', until the Romantics re-valued it by claiming that it had more, not less content than the overtly religious pictures which had hitherto been most highly valued, since it communicated emotion directly. Kandinsky's abstract art and his arguments for it are already implicit in this development. Yet later American hard-edge abstractionists such as Frank Stella have dismissed these claims to

style to abstraction by simplifying his outlines and heightening his colours, so that his landscapes consisted of large blocks of colour. These became so simplified that the figurative element eventually disappeared altogether. Apparently aware that he was on the threshold of an important breakthrough in his art, in 1908 Kandinsky discovered the small, isolated village of Murnau, south of Munich in the foothills of the Bavarian Alps, and decided to settle there. By chance, most of his works done in the crucial years that followed were kept together in one collection (now in Munich), since Kandinsky left it behind when he fled from Germany back to Russia on the outbreak of the First World War; so it is possible to trace his development quite closely. The village and its surrounding countryside became in Kandinsky's paintings a sort of enchanted Arcadia,

*Above* Kandinsky, *Romantic Landscape*, 1911. Städtische Galerie in Lenbachhaus, Munich. Kandinsky loved horses and riders, and the three horsemen dashing down the hill are the most clearly representational part of a landscape which is otherwise described in the barest possible way as the horsemen gallop madly through it. Everything is subordinated to the sense of speed and energy of the riders.

*Right* Kandinsky, *Study for Autumn*, 1910. Städtische Galerie in Lenbachhaus, Munich.
The Bavarian village lying between mountains is still clearly visible here, even though everything has been reduced to outlines and barest essentials. Nor are the colours representational, though they do capture the warm glow of autumn. The actual landscape has supplied Kandinsky with raw material, and he has then abstracted from nature. Much pioneer abstract art, including that of Mondrian and Malevich, arose by a similar method of gradual abstraction from nature and landscape. Kandinsky said at the time that 'if the artist has outer and inner eyes for nature, nature rewards him by giving him inspiration'. And his Murnau landscapes have been compared in their visionary intensity to those that Samuel Palmer painted in his inspired Shoreham period. Kandinsky was interested not just in the superficial appearance but in the creative energies of nature, an interest which had already led Turner to near-abstraction. A tendency

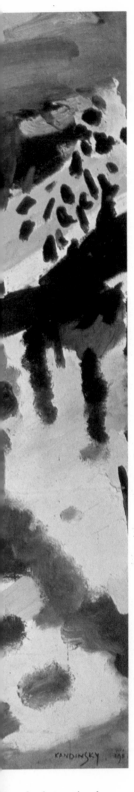

metaphysical or emotional content – made by abstract artists from Mondrian to Barnett Newman – as mere defensive self-justification by artists whose work was not publicly accepted, and therefore no longer necessary now that society values non-figurative art. Stella's own sole concern is with the 'visual presence' of his work, with the painting as an object, existing in its own right and entirely self-referring:

> I always get into arguments with people who want to retain the old values in painting – the humanistic values that they always find on the canvas. If you pin them down, they always end up asserting that there is something there besides the paint on the canvas. My painting is based on the fact that only what can be seen there *is* there. It really is an object . . . All I want anyone to get out of my paintings, and all I ever get out of them, is the fact that you can see the whole idea without confusion . . . What you see is what you see.

Now Kandinsky argued the opposite: 'The inner element, that is, the emotion, must exist; otherwise the work of art is a sham. The inner element determines the form of the work of art.' In other words Kandinsky was predicting in advance that such works as Frank Stella's garish fairground decorations would be precisely what they seem to me to be: a sham. Critics discuss them under such titles as 'Shape as form', but if art really is about flatness, or shape, or objects as objects, then it seems to me a pure waste of time. But as recent American art has grown more and

more minimal, so the accompanying critical discussions of it in purely intellectual and formal terms have grown more and more elaborate. Tom Wolfe has acidly summed it up as 'The Painted Word' – the art may be junk, but the theories are nice. Yet standing in front of one of Mark Rothko's paintings, which completely avoid hard edges so that it is simply not possible to look at it purely as form, most spectators are surely drawn into the glowing colours as I am, to receive an intense subjective sensation. Such issues are very well discussed in relation to landscape by Robert Rosenblum in *Modern Painting and the Northern Romantic Tradition*, a book which begins by juxtaposing Mark Rothko's *Green on Blue* with Caspar David Friedrich's *Monk by the Sea*, and shows that there are real analogies of form and feeling between them. Both have a subjective intensity arising from the personalities of their artists – Friedrich went mad, and Rothko committed suicide. It is true that it is difficult to state objectively just how Friedrich's mountains communicate an aura of intense emotional mystery in a way that those of more straightforwardly topographical painters do not. But this is the essential mystery of all artistic communication. Is Beethoven's Violin Concerto *merely* the scraping of horsehair on stretched animal gut? Shakespeare sums it all up in the scene in *Much Ado About Nothing* where Benedick comments on the effect of music on Don Pedro: 'Now divine air! Now is his soul ravished! Is it not strange that sheep's guts should hale souls out of men's bodies?'

wards abstraction has deed been a recurrent henomenon in the history f northern art, as Wilhelm orringer demonstrated in s famous book *bstraction and Empathy*, ublished in Munich in 908 by Kandinsky's own ublisher, two years before e began to write his own ok *On the Spiritual in rt*.

# Chapter Eleven
# Post-Impressionists and Fauves

Paul Cézanne (1839–1906), *La Montagne Sainte-Victoire*, 1898. Baltimore Museum of Art, Baltimore. Post-Impressionism was a variety of very different responses to the central problem of what painting was about if it was no longer simply an attempt to represent the external world as accurately as possible, as the art of the Impressionists was. With Cézanne it became an attempt to depict the solid and enduring forms of nature. This rugged limestone mountain, which he could see from his studio, came to fascinate him to the point of obsession, and he painted it over and over again. Some of his earlier versions are more representational. But here its essence is caught through simple contrasts between blue peak, orange rocks in the foreground, and green bushes.

*Above* Cézanne, *Chestnut Trees at the Jas de Buffon,* 1885–7. Minneapolis. Cézanne had become most clearly an Impressionist while working closely with Pissarro at Pontoise in 1872, an experience which taught him to draw his inspiration from nature rather than imposing a personal, romantic mood on it. But by the time he painted these chestnut trees he had begun to turn away from Impressionism, seeing art no longer as an attempt simply to copy nature but as a transformation of nature by the formative mind.

*Right* Cézanne, *The Jourdan Cottage,* 1906. Kunstmuseum, Basel. Cézanne's increasing search for simplification led him to speak of 'reducing all the shapes of nature to cylinders, cones and spheres', an idea which later artists would develop into Cubism. But Cézanne's own concern with order and structure enabled him to give a monumental quality to the simplest scene. The Jourdan Cottage, in the country near his home at Aix, turned out to be his last painting. While working on it, he was caught in a rainstorm, collapsed and died a few days later.

Movements in modern art have often taken over the derisive names given them by hostile critics. The journalist Leroy, reviewing the group exhibition of 1874, seized on the title of one of Monet's paintings – *Impression: Sun Rising* – to dub the new school 'Impressionists', the name by which they have been known ever since. But the term Post-Impressionism is quite different, since it was coined long after the event to describe painters who had not been even loosely associated in joint exhibitions, and had little in common except that they could be seen as reacting against Impressionism, though each in very different and individual ways. For European art had reached a crisis with Impressionism, which had brought to a climax the Renaissance ideal of the accurate representation of nature. Artists had learnt not only how to represent the world, but how to render changing effects of atmosphere and sunlight and air. Yet now mere surface imitation and the capture of the fleeting moment came to seem superficial. Something vital seemed to have gone out of art, and Cézanne, van Gogh and Gauguin all set out in different ways to rediscover the lost dimension. For Cézanne it was above all the sense of order and balance, since it seemed to him that the Impressionists' preoccupation with the fleeting moment had made them neglect the solid and enduring forms of nature. For van Gogh, a late-comer to art who had first tried to direct his missionary zeal into religious work, it was the spiritual dimension, the feeling of identification which he felt with his fellow men and all creation. And for Gauguin it was the intensity of feeling which was expressed so strongly in primitive art, but which seemed to have gone out of art and of the city life which Gauguin had led when earning

a living as a stockbroker. The originality of all three artists came from the uncompromising individualism with which each followed his chosen path despite misunderstanding and opposition, and each in the process made a decisive contribution to the development of modern art.

Even chronologically, 'Post-Impressionism' is a faulty and inadequate term, since Paul Cézanne (1839–1906) was actually older than Renoir and Monet, and both of them outlived him. But it was Cézanne's ambition to make of Impressionism something as solid and enduring as the art of the Old Masters that made him such a crucial figure in the subsequent development of art, since it led him to try to grasp the underlying structure beneath appearance, the 'bones of nature'. Although Cézanne had at one time been loosely associated with the Impressionists, he became a recluse who painted away in stubborn isolation for years, only really 'emerging' in 1895, when he had his first one-man show at the age of 56. In mid-life he had realized that Paris was not for him, that he could only be completely himself and fully develop his talent in his native Provence, trying to capture the essence of its landscape. He wanted to see nature not as other artists saw it but with his own special vision, discovering his own way of creating form and light and colour. He

defined his aim in his famous remark, 'Painting from nature is not copying the object, it is realizing one's sensations.' Unlike the Impressionists he worked slowly, making deep and subtle analyses of the form of natural objects, not trying simply to capture his impressions and sensations but to give them the highest possible degree of pictorial unity, 'realizing' his sensations in compositions as firm and lasting as those of the Old Masters. Thus he achieved his goal of 'doing Poussin again after nature'.

While Cézanne sought to give his works stability and permanence by analyzing form, the much younger but short-lived Georges Seurat (1859–91) was seeking a different solution by analyzing colour. He followed the Impressionists in using pure colours, but whereas they had worked empirically, Seurat tried to base himself on the latest scientific discoveries in optics, using them to work out what he thought of as a scientific approach towards colour. He developed the method of pointillism, using pure dots of colour applied with meticulous regularity in carefully ordered compositions. A considerable part of his comparatively small output consists of landscapes and seascapes. The seven large compositions he painted were done in Paris during the winter months, but he spent most of his summers

Vincent van Gogh (1853–90), *Harvest – The Plain of La Crau Arles*, June 1888. Rijksmuseum, Amsterdam. Van Gogh went to the south of France in the same way that Gauguin went to Tahiti, in search of an ideal. It was the ideal he had formed from Japanese prints, and in Arles he wrote 'This country seems to me as beautiful as Japan as far as the limpidity of the atmosphere and the gay colour effects are concerned.' Within a few weeks he had painted a whole series of pictures of orchards in blossom which capture the image of spring, and this panoramic landscape in the year is the epitome of harvest.

on the Normandy coast in little coastal ports like Honfleur and Port-en-Bessin. In their shorelines and quays and lighthouses he found an actual geometry of form which perfectly suited his pointillist technique, since the spots of pure colour produced a scintillating effect uniting sea, sky and land into a shimmering yet serenely reposeful vision, a marvellous evocation of the trance-like atmosphere of these sleepy little harbours. Seurat seems at first sight to represent in an extreme form the 19th century faith in science. His researches into colour were followed by researches into line, and generally into the scientific basis of aesthetic harmony. 'If with the experience of art, I have been able to find scientifically the law of pictorial colour', he asked, 'can I not discover an equally logical, scientific and pictorial system to compose harmoniously the lines of a picture just as I can compose its colours?' Yet if pointillism seems

cold-blooded and restrictive of the imagination as Pissaro found it after using it for a time, in Seurat's own hands it proved a surprisingly expressive technique which might well have developed interestingly had he not died at the early age of 31.

Vincent van Gogh (1853–90) was a total contrast, a thoroughly northern and expressionist artist, intensely concerned with the meaning and purpose of life, whose work was inextricably bound up with his religious quest. As with other northern artists, for him nature became a direct extension of his emotions; through his reaction to it he expressed his own happiness, anxiety or despair, and his feelings about the ultimate mysteries of birth and life and suffering and death.

Van Gogh decided to become a painter only in 1880, only ten years before his suicide. Previously he had tried to channel his passionate

Van Gogh, *Starry Night*, Saint-Rémy June 1889. Museum of Modern Art, New York.

Van Gogh's painting was an expression of his own passionate feelings, and though he had abandoned his earlier Christianity he still had 'a terrible need of – shall I say the word? – of religion. Then I go out at night to paint the stars . . .' That letter referred to an earlier *Starry Night* painting of September 1888. For like other Romantics, van Gogh found in the night sky an awesome revelation of the mystery of the universe. Here nature is transformed into ecstasy as sky, stars and crescent moon are all caught up in the same powerfully undulating rhythm, while the cypress tree shoots up like a flame into the heavens.

Van Gogh, *Olive Trees*, Saint-Rémy, Sept–Nov 1889. Minneapolis Institute of Arts, Minneapolis.

Van Gogh's passionate sympathy with every aspect of nature while reading into it his own emotions is well seen in the series of 14 paintings of olive trees which he began in late summer 1889 while living in the asylum at Saint-Rémy. He always tried to choose subjects which expressed the local climate and seasons, and the olive trees and their harvest are characteristic of the south. But the heightened colours, including the yellow sky, and the turbulent brushstrokes, help to transform these gnarled trees writhing in the rocky landscape into an expression of his own anguish in this period in the asylum, a few months before his suicide.

163

Van Gogh, *Wheatfield with Crows*, Auvers, July 1890. Rijksmuseum Vincent van Gogh, Amsterdam. 'There are vast stretches of corn under troubled skies, and I did not need to go out of my way to try to express sadness and the extreme of loneliness', wrote van Gogh on 9 July 1890, three weeks before his suicide. This was one of the paintings he was working on at the time, and it is a marvellous expression in paint of that feeling of terrible isolation. The crows, which like so many black birds are traditionally associated with death, surge over the golden wheatfield to become menacing omens of approaching disaster. Van Gogh wrote in that same letter 'my life too is threatened at the very root, and my steps too are wavering'.

religious feelings into his relations with his fellow men, only to meet with failure and rejection. This was largely due to the very intensity of his fervour, since he was too whole-hearted in putting his gospel into practice. When he turned to art he brought to it the same subjective intensity. In his letters he writes of his search for a means of self-expression: 'I can very well do without God, both in my life and my painting, but I cannot . . . do without something which is greater than I, which is my life – the power to create.' He needed to express and communicate the feelings that caused such tension in his restless, searching spirit. And with his sunflowers and cypresses he succeeded in creating a popular ar which remained true to his own feelings. But h began with rather dark pictures of the simples aspects of Dutch landscape and peasant life. Hi art was transformed after he discovered the ligh of the south and the expressive power of colou used not descriptively but emotionally. Th Gothic artists had seen light and colour as almos a form of divine revelation, and for van Gogh the did indeed transform the world. But it has bee equally characteristic of northern artists to com bine expressiveness with meticulous realism with that marvellous eye for the observed detail of the natural world for which the artists of th

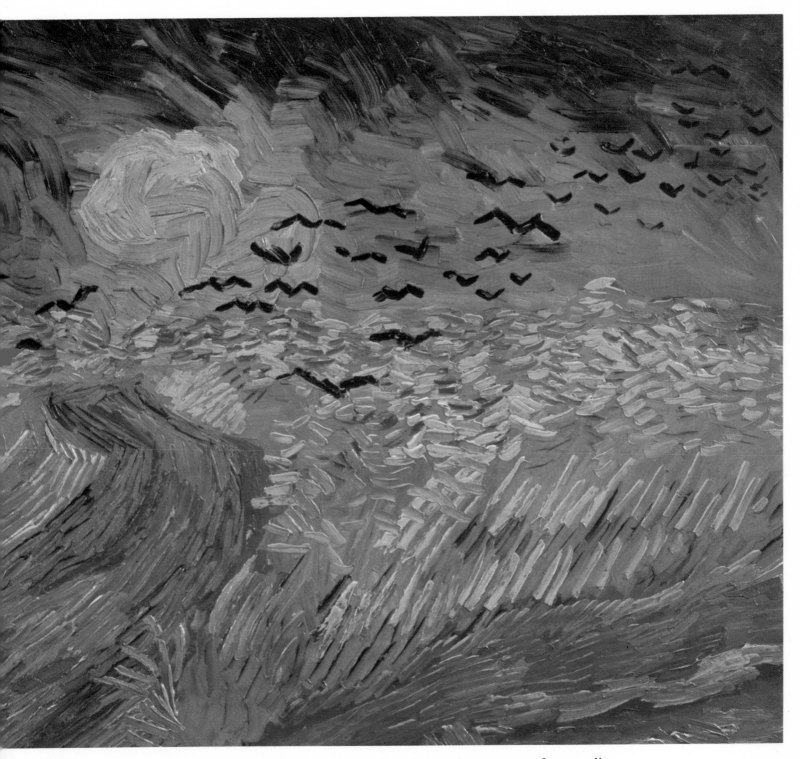

Low Countries have been famous since the 14th century. And van Gogh had a passionate empathy with all the aspects of nature he painted, from a sunflower to a sunset.

For this reason van Gogh could not remain satisfied with Impressionism, though his first experience of it entranced him as a revelation of colour after the relative darkness of his Dutch period. So, briefly, in Paris he was himself an Impressionist painter. But Impressionism offered a purely surface beauty in which the meticulous detail of the natural world was lost. Impressionist painting could show the lyrical beauty of nature, but van Gogh wanted something much

more profound than that – to *transfigure* reality, to give his landscape the *intensity* of his own deepest feelings when confronting nature. Although he called himself an 'arbitrary colourist', who also distorted the shapes of objects, these distortions were adopted in the interests of that very intensity, since the realism he wanted was a heightened truth, not photographic accuracy: 'My great longing is to learn to make those very incorrections, those deviations, remodellings, changes of reality, so that they may become, yes, untruth if you like – but more true than the literal truth.'

Van Gogh's greatest works were done in the last two years of his life, after he had discovered

Paul Gauguin (1848–1903), *Seashore at Martinique*, 1887. Ny Carlsberg Glyptotek, Copenhagen. The mature style which Gauguin called Synthetism was an expression of emotion and mood through stylization, rejecting naturalistic representation in favour of simplified outlines and brilliant non-naturalistic colours. His voyage to Martinique in 1887 was a crucial stage in this development, since it introduced him to an exotic, luxuriant tropical setting. Although there are not yet any drastic simplifications of outline in this painting, the colour scheme is more brilliant and the contrasts more accentuated than in his previous work. Yet the exhibition he held on his return to Europe disappointed his admirers who, as Gustave Kahn wrote, 'did not understand this foretaste of an evolution' which had not yet taken on its full vigour.

*Opposite* Gauguin, *The Breton Shepherdess*, 1886, Laing Art Gallery, Newcastle-upon-Tyne. It was during his second stay in 1888 at Pont-Aven in Brittany that Gauguin began to interpret natural scenes such as the waves rolling up a beach in terms of stylized arabesques and brilliant colours. But this landscape with a Breton shepherdess dates from his first visit in 1886, and is still essentially in the Impressionist tradition, though Gauguin departed from Impressionism in building up such paintings from preparatory studies rather than directly on the spot. And already he is here trying to go beyond Impressionism by simplifying and exaggerating the rhythms of the Breton landscape in an attempt to find pictorial forms which expressed more fully the quality of the landscape and its people.

the South. Everything about Provence entranced him, whether it was the blossoming almond trees or the blue sky and clear air. So feverishly did he try to get all its aspects down on his canvases that he felt obliged to accompany the first batch of paintings he sent to his brother Theo with an explanatory note:

> I must warn you that everyone will think I work too fast. Don't believe a word of it. Is it not emotion, the sincerity of one's feeling for nature, that draws us? And if these emotions are sometimes so strong that one works without knowing one does so, when sometimes the brush strokes come with a sequence and a coherence like words in a speech or in a letter, then one must remember that it has not always been so, and that in time to come there will again be dreary days, devoid of inspiration. So one must strike while the iron is hot . . .

But despite the frenzy of creation which produced the masterpieces of his last years, van Gogh could not escape from the 'extreme isolation' of which he spoke just before his suicide. The paintings done in the last few weeks of his life, for example *Field under Thunderclouds*, are bleak, lonely landscapes stretching in a broad sweep to the horizon. They convey a similar tragic mood of terrible loneliness and an almost menacing power in a simple landscape that Caspar David Friedrich had explored. Existential loneliness seems to have inspired the landscapes of both men, as they tried to find an expression for the subjective intensity, the unbearable tensions of their almost psychotic personalities,

by singing the glory of the world and the beauty of nature.

The life story of Paul Gauguin (1848–1903) has made him the archetype of the artist trying to return to nature by discovering the lost Arcadian paradise. He searched for it first in Brittany, then in the Caribbean, and finally in the South Pacific. The enigmatic title of one of his most famous Polynesian paintings, *Where do we come from? What are we? Where are we going* seems to imply a spiritual quest, for instance into the meaning of birth, love and death. But Gauguin himself insisted that he was aiming at pure aesthetic responses, and it seems clear that his search for new artistic roots was, by comparison with van Gogh's, sensual rather than religious. Van Gogh sought to express his passionate love for his fellow beings and for the natural world, first in religion and then through art. In the process he created an art which embodies his passionate feeling for and identification with every aspect of nature. But Gauguin, with intense memories of colour and sunlight from a childhood spent partly in his mother's native Peru, was above all hungry for the sensuous delights of colour, luxuriance, natural beauty and gaiety and brilliance, everything that Baudelaire summed up in the words 'luxe, calme et volupté'.

Whereas van Gogh was searching for new spiritual meaning, Gauguin's search was for something which van Gogh had in abundance – intensity of feeling. His northern Expressionism was alien to the temperament of Gauguin, whose whole career was determined by a longing for the directness of primitive instinct and feeling with

which modern city man, cut off from nature and fed on a dreary diet of fact, has increasingly lost touch. Before Gauguin gave up his successful career as a stockbroker and left his wife and children to make himself into a bohemian artist, he had painted in the Impressionist style. But he soon came to regard this purely visual art as superficial. It was turning into a formula, a conventional method of representing light and atmosphere. So Gauguin began his search for the sort of intensity and directness present in folk and primitive art. He was not alone in this quest. Debussy's music was revitalized by drawing on Indonesian gamelan music, and the Pre-Raphaelites in England hoped to find a similar directness and simplicity in the pre-Renaissance art of an age of faith. Russian artists like Kandinsky and the Diaghilev group who electrified Paris with

the gorgeous exoticism of their ballet décors had a still living tradition of folk art to draw on.

The first stage on Gauguin's quest was Brittany, where he hoped to find a living peasant culture in the rich Celtic tradition. Its other attractions included the splendid scenery of its rugged coastlines and sandy beaches, and the prehistoric past visible in the great stone monuments of Carnac. There was also an important practical consideration – the existence of a landlady in the little fishing village of Pont-Aven who liked artists and gave them long-term credit. On his first visit to Brittany in 1886 and his voyage to Panama and Martinique the following year, Gauguin was moving towards the brighter colours and simpler forms which characterize his own bold, definite style. Back at Pont-Aven he became the centre of a group of younger

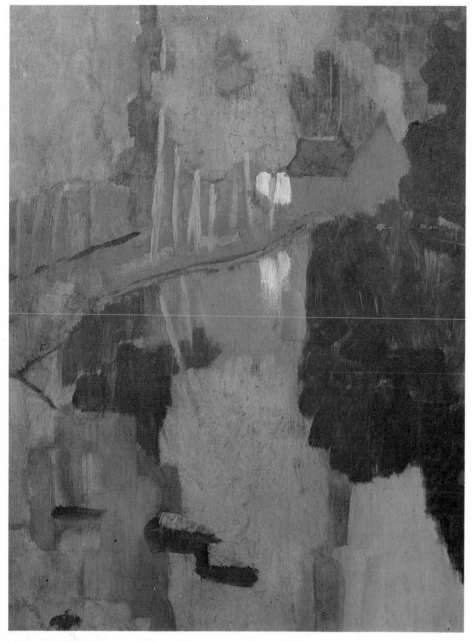

Paul Sérusier (1863–1927), *Landscape at the Bois d'Amour* (Le Talisman), 1888. Private collection. This revolutionary little landscape painted on a cigar-box lid under Gauguin's direction became the talisman for his admirers because of its drastic simplification of forms and colours. Maurice Denis claimed it was a decisive image for the evolution of later artists because instead of being a photographic representation of the external world it showed that 'all works of art are a transposition, . . . the passionate equivalent of an experienced sensation. Though painted from nature, it represented not just what the artist saw, but what he *felt*.

artists, including Emile Bernard and Paul Sérusier, who espoused his ideas; the basic one, influenced by Japanese prints, was that a painting is essentially a flat surface covered with areas of colour which must possess their own decorative coherence, irrespective of their relation to the natural objects depicted. The small landscape that Sérusier painted on a cigar-box lid in the woods under Gauguin's direction was to have a great impact on other artists. Gauguin's teaching method was to ask, 'How do you see these trees? They are yellow. Well then, put down yellow. And that shadow is rather blue. So render it with pure ultramarine. Those red leaves. Use vermilion.' Sérusier showed the resulting beautiful little work to his fellow students at the Académie Julian, who included Bonnard, Vuillard and Maurice Denis. They hailed it as a revelation, and they adopted it as 'the Talisman' when they founded their own art movement the following year, calling themselves

the Nabis (from the Hebrew for 'prophet').

Gauguin had found what he needed – an attitude to design in which the artist's need for expression took precedence over the natural scene he was representing. At the Café Voltaire in Paris he moved in the circle of the Symbolist poets Mallarmé and Verlaine, and now he had arrived at an essentially Symbolist view of art – that its purpose was not to copy nature but to externalize the artist's feelings. To convey those feelings he needed strong, clear symbols, which Gauguin found in his bold flat areas of vivid colour. The basic point of literary symbolism, which was a reaction against the prosaic naturalism of novels such as Zola's, was the idea that poetry should not so much describe as evoke, conveying emotions in an essentially musical way. And this is exactly how Gauguin defined his own aims in such statements as 'In painting one must search rather for suggestion than for description, as is done in music.' It was an idea which went

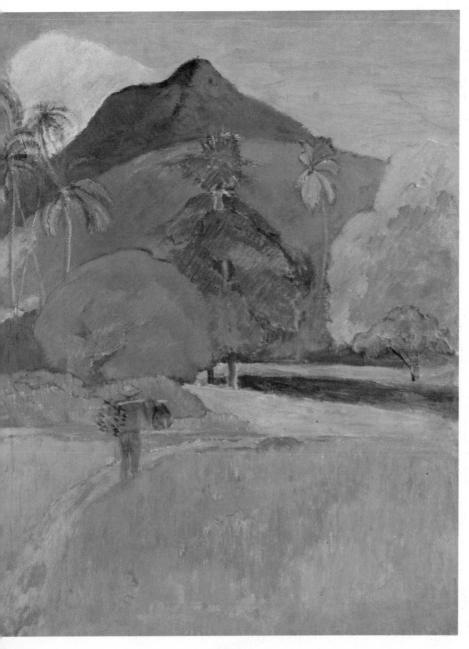

Gauguin, *Tahitian Landscape*, c.1891. Minneapolis Institute of Arts, Minneapolis. Gauguin's ideal of the tropics combined mystery with a sensuous, easy life lived from the fruits of nature. And on first arriving in Tahiti in 1891 he was held spellbound by the incredible beauty of the islands and their people. In his attempt to capture this beauty his earliest Tahitian landscapes revert to an almost Impressionist manner, though still showing something of the simplified forms and large areas of uniform colour which were to become dominant in the later Tahitian paintings.

back to the Romantics, for whom music was the supreme art because it expressed emotions directly, without the descriptive associations of words or painting. The idea became still stronger in the late 19th and early 20th centuries developed by a line of artists from Whistler to Kandinsky, in whose art it helped to lead to pure abstraction. Gauguin himself never broke completely with representation, though in his Tahitian paintings the semi-abstract patterns and coloured shapes contribute much to the mood of exotic mystery and ambivalence. Kenneth Clark's claim that Gauguin had 're-created the landscape of symbols' and that 'his Tahitian landscapes are true successors to the tapestry landscapes of the fourteenth century' seems to me to ignore the profound difference between the specific, allegorical meanings of medieval symbolism and the non-specific, musical meanings of the Romantic symbolism of mood. Gauguin's symbolism was related by contemporary critics to the ideas of

Baudelaire, who held that mysterious correspondences existed between nature and feeling. Baudelaire's poem *Correspondances*, beginning '*La Nature est un temple . . .*', portrays nature as a temple of *vague* symbols whose scents, colours and sounds are 'like long-drawnout echoes vast as darkness and light . . .' Clouds, the forest, the sea, the cool starlit shadow of night offer shifting and variable analogies to which the individual artist or poet responds according to his individual personality and changing moods. Baudelaire's famous poem suggests something basic in human experience: the sense of both haunting mystery and significant pattern behind the forms of the natural world – a sense shared by artists like Baudelaire and Gauguin and Caspar David Friedrich, scientists like Sir Isaac Newton, Einstein, Heisenberg and Schrödinger, the Chinese Taoists and the great religious mystics, who however have all responded in their own different ways, interpreting the experience in the light of their own very different ideas.

Symbolism has always been seen as one of the foundations of the modern movement in literature, whereas in painting its importance has sometimes been played down because critics have until recently tended to overemphasize the line of development from Impressionism through Cézanne to Cubism. But the new syntheses of vision and expression achieved by van Gogh and Gauguin were quite as important for the future, in the complex web of modernism in which German Expressionism, Italian Futurism, Russian Futurism and Constructivism all played a vital part. And there are many important artists who do not fit into any neat category, like Henri Rousseau (1844–1910), generally known as 'Le Douanier' because he spent his life working as a customs officer. His exotic jungle landscapes have a spontaneity and freshness and imaginative power that make them haunting evocations of the life of the tropical forests. According to his own account Rousseau had been to Mexico with the French army sent to assist the Emperor Maximilian, but his fantastic settings were probably derived from the combined zoo and botanical garden of the Paris Jardin des Plantes.

At the beginning of the 20th century, European art was still to some extent a description of the natural world, but more and more also a product of the artist's own feelings and imagination. And in the wealth of experimentation that makes up the great modernist breakthrough of the first three decades of the century, the natural world retreated still further. This can be seen in the group known as the Fauves ('wild beasts'), another name coined derisively by a critic, who disapproved of the violence of their colour when they first showed together in the Salon d'Automne in 1905 – a date often chosen for the birth of the modern movement in painting. The acknowledged leader of the group was Henri Matisse (1869–1954), who was passionately interested not just in colour but in its *constructive* power. Gauguin had used bold colours in large

Henri Rousseau (1844–1910), *La Jungle: Tigre attaquant un buffle*, 1908. Cleveland Museum of Art, Cleveland, Ohio. Gauguin's quest for a revitalization of his art through contact with the primitive was part of a recognition of the validity of other forms of expression besides those central to the European artistic tradition. This led to a new appreciation not only of exotic art from places as diverse as Japan and Africa, but also of the untutored vision of naïve artists like Henri Rousseau. His exotic jungle scenes are marvellous products of the imagination. Yet Rousseau was also a thorough perfectionist, thoughtfully working everything out and then transferring his sketches with great accuracy to the canvas, using a carefully matter-of-fact technique. He himself believed so strongly in the reality of his enchanted tropical forests that he would open his window at night so as not to be smothered by the perfume of their imaginary flowers.

André Derain (1880–1954), *Hyde Park*. P. Levy collection, Tioges. Derain, like several of the Impressionists before him, spent some time in London, painting scenes in Hyde Park and along the river, using bold, simplified outlines, and often pure colours of extraordinary intensity. But though he is best remembered for the major contribution which he made to the development of Fauvism, his Fauve period was short and he soon turned to a darker style and moved in the direction of Cubism.

areas which looked flat, since he had discarded many of the ideas of perspective and modelling stemming from the Renaissance. Matisse, with his genius for decorative simplification, carried this process still further. 'Matisse, you were born to simplify painting', said his teacher, the Symbolist painter Gustave Moreau. And Matisse's slow, steady development towards even greater simplification of form and colour is in marked contrast to the restless change and experiment of Picasso's art. His basic belief, underlying Fauvism and almost all his subsequent work, was that colour and form can have a direct effect upon the feelings almost regardless of what is represented. And 'simple colours can act upon the inner feelings with all the more force because they are simple.' This was a further move away from naturalism or realism towards abstraction. As another of the Fauve painters, Derain, remarked, 'The great thing about our experience is that it has freed painting from all imitative or conventional contexts.'

Not that the Fauves divorced themselves from the natural world as completely as the later abstract painters: the work of Matisse, Derain, Vlaminck and the rest includes some very beautiful landscapes in typically brilliant colours with bold, simplified outlines. Only with the cut-out paper gouaches made at the very end of his life did Matisse come close to pure abstraction, even though, as names like *The Snail* implied,

the cut-outs were based on organic forms. When they were exhibited in the 1950s, colour was becoming increasingly a key fact in modern painting, and they came as a revelation which caused a drastic reappraisal of Matisse. For in the prevalent critical view, which believed in progress in art, after about 1908 he had ceased to be the leader of the Paris avant-garde, and a new avant-garde – many formerly his own followers – had begun to form in reaction against his influence. Picasso was now seen as the great innovator; yet while Cubism was directing art in a quite different and much more structural direction, Matisse's development continued to lie in the direction of ever bolder use of brilliant decorative colour in a comparatively flat design.

Matisse himself was very articulate about his creative anxieties in following the isolated path he had chosen. And his relentless severity with himself was paralleled by bitter attacks from critics. The sensuous beauty of his work, his delight in colour, and statements like 'What I dream of is an art of balance, of purity and serenity, devoid of troubling or depressing subject matter' only increased the hostility. Many of the critics felt that an artist who frankly celebrated the joy of life, and gave his paintings titles like *La Joie de vivre* and *Luxe, calme et volupté*, was just not serious enough. The common tendency was to admit the charm of his colour and the sensuous beauty of his paintings,

Henri Matisse (1869–1954), *Landscape at Collioure*, 1905. The State Hermitage Museum, Leningrad.

It was at the small port of Collioure, near the Spanish border, that Fauvism evolved in the works that Matisse and Derain painted in the summer of 1905. Both were filled with enthusiasm for the landscape, which inspired them to paint in a way that made colour the most important thing about their work. Matisse recalled in 1929 that one of his central ideas at that time was a 'search for intensity of colour, subject-matter being unimportant'. And these landscapes have an intense colour which makes them non-naturalistic and emphasizes their expressive qualities. Yet despite their expression of feeling through intense colour, these landscapes still retain their contact with the real world which stimulated them.

out to qualify this by dismissing him as *merely* a decorative painter, who *ought* to have been more disturbing. In retrospect, however, it is much easier to see the consistent and gradual evolution of Matisse's art, and to recognize how much experience was concentrated in the drastic simplifications of his late cut-paper gouaches. It was also possible to understand why this simplification – of means and of colour – could only come right at the end of his career, quite apart from the crippling illness which made them a physical necessity. Matisse's work makes nonsense of any rigid distinction drawn between figuration and abstraction. For though his hedonistic art was too concerned with reflecting the delights of the natural world to lead him to pure abstraction, his basic beliefs about the emotional and spiritual value of form and colour were close to those which had led Kandinsky to discard subject matter altogether. As Matisse firmly declared, a work of art must carry in itself its complete meaning and impose it upon the viewer even before he can identify the subject matter.'

# Chapter Twelve
# Landscape Painting in the Twentieth Century

Georges Braque (1882–1963), *Le Ciotat*, 1906. John Hay Whitney collection, New York. Before playing a major part in the development of Cubism, Braque briefly used the brilliant colours of Fauvism, as in the landscapes he painted at La Ciotat, where he first came in contact with the bright Mediterranean light. Fauvism was essentially a response by northerners to the southern sun. But the landscapes he was painting a year or so later at l'Estaque already show the stylization and simplification into geometrical forms which made Matisse exclaim that they were made up of 'little cubes', and led the critic Louis Vauxcelles to introduce the term Cubism. And since in this new style the function of colour was no longer descriptive but constructive, Braque simultaneously moved away from bright colours to a much more restricted palette.

Matisse, *Moroccan Landscape*, 1911. National Museum, Stockholm. Matisse spent the winters between 1911 and 1913 in Morocco, and the landscapes he painted amid this exotic scenery combine simplified but still naturalistic forms with highly imaginative colours. For while Braque had by this time made his steady progress right away from naturalistic representation to Cubism, Matisse's hedonistic art was too firmly rooted in reflecting the sensuous delights of the natural world to move easily towards complete abstraction, even though

Modern art accurately reflects the chaos and pluralism of modern life, in which no one system of belief or interpretation prevails, and there is no universally accepted standard of values. So where previous ages have often shown a single dominant tendency, the modern movement has consisted of a great many warring styles and groups. Indeed, the proliferation of styles and ideas in the first two decades of this century contained the seeds of almost everything that has happened since. One of the major developments was the breakdown of the figurative language of art and the development of abstraction, which would seem at first sight to leave landscape painting as a possibility for only that minority of artists who remained faithful to the figurative.

Yet all the radical changes of the early 20th century were implicit in, and stemmed directly from, the various kinds of landscape painting that had dominated the 19th century. It has already been stressed that the emergence of landscape painting in European art was not only bound up with changing attitudes towards nature, but also with changing attitudes towards the role of narrative in painting. Once it was no longer true that every picture told a story, the essential content of a painting could be seen as either emotional or aesthetic. The more purely aesthetic, art for art's sake strand stemmed from the purely visual art of Impressionism to Cézanne concentrating on the structure of nature, in such a way that Picasso and Braque could regard themselves as making a logical extension of his art when they invented Cubism. But though it often used to be claimed that Cubism was the parent of all forms of abstraction,

the basic belief underlying his work is that colour and form can have a direct effect upon the feelings almost without regard to what is represented.

Piet Mondrian (1872–1944), *Moonlit Landscape*, 1907. Stedelijk Museum, Amsterdam. Mondrian's early moonlight or twilight landscapes recall the mystical moonlit landscapes of Caspar David Friedrich. Here the moon is surrounded by a halo of mist, and shapes become ghostly blurs in the haze, so that already detail is lost, and the process of gradual abstraction which can be traced in a steady progression through these early naturalistic landscapes has begun. Shortly after this Mondrian became obsessed with series of drawings or paintings on the same subject. One such subject was a line of trees by moonlight, reflected in a river, with the series beginning naturalistically and becoming more abstract until the trees are little more than their basic vertical forms seen against the rising moon.

hese were actually developed by artists in the northern Expressionist tradition. Once pictures no longer told a story they were primarily about feelings and moods, and all the pioneers of abstract painting began by painting landscapes and abstracting from them in the search for underlying structures or expressive forces; the process has already been discussed with regard to Kandinsky. Similar interests in nature, mysticism and music were the driving forces behind the development of abstraction about the same time by the Dutchman Mondrian, the Lithuanian Čiurlionis and the Czech Kupka. The short-ived Mikalojus Čiurlionis (1875–1911), who died in St Petersburg at the age of 35, was indeed also a composer. He felt impelled to express his passionate feelings about nature in paintings as well, and many of these have musical titles such as *Spring Sonata* and *Sonata of the Stars*; while in musical compositions such as the symphonic poems *The Sea* and *In the Forest* he was clearly inspired not only by the particular qualities of the sea and the rustling pine forests but by the boundless mystery of nature. Čiurlionis must surely be the only artist to have had two mountains named after him. One is a great 20,000 foot peak in the Pamirs. The other is on one of the Arctic islands in Franz Josef Land, and was named by a Russian polar explorer who discovered its towering cliffs looming out of the mist in front of him, and was irresistibly reminded of the Čiurlionis painting *Calm*, a landscape which is not yet abstract, but looks rather like a great prehistoric beast rising out of the sea.

Piet Mondrian (1872–1944), unlike the other pioneers of abstraction, was influenced at a fairly

late stage by Cubism. But what motivated his art was a deep mystical passion, a religious quest for harmony which he pursued to its logical conclusion in a rigidly geometrical abstraction governed by his strict Calvinist upbringing. Its intensity never left him, although under the influence of his crucial mystical experience his religious horizons expanded to include theosophy, which also influenced Kandinsky. Like his fellow countryman, van Gogh, he hesitated between whether art or religion was his true vocation. But whereas van Gogh's art was transformed by the light and colour of the South, Mondrian's travels in Spain left him unmoved, and he remained obsessed with the landscape of his own country. His early naturalistic landscapes show a fascination with features that had already inspired so much Dutch painting from the 17th century onwards – the wide, flat countryside, with windmills, farmhouses and trees reflected in the still waters of long straight canals, and the low horizons with vast cloudy skies. The strong horizontal and vertical axes which became the dominant forms in his abstract work are already well defined in such Dutch scenes. And like the German Romantics he was fascinated by moonlight and twilight, special times of day when details melt into the back-

ground, leaving only basic forms. This dou Dutch artist was searching for underlying, uni versal truths, trying to abstract from the varie surfaces of nature some pattern of stark sim plicity that would evoke elemental forces an mysteries, immutable realities behind the ever changing appearances of things.

These distillations from nature led to a turn ing point in Mondrian's development during long summer of arduous, fruitful work in 190 around the small village of Oele, near the Germa border. The trees in his paintings of the wood became a skeleton of strong vertical axes, and th sun setting behind them became a pretext fo using intense bright blues, reds and yellows. A this point Mondrian seems almost to have becom aware of the path he was later to follow i developing pictures out of the simplest elements straight lines and pure colours. But during th next few years he still painted direct from nature often the same simple scene over and over again as in the famous tree series where the tree become progressively more abstract, or the beac and dunes at the seaside resort of Domburg on th Dutch coast. In these dune landscapes h reduced nature to a few primal elements of sea sky and sand – a reduction of the sort alread achieved in Caspar David Friedrich's *Monk b*

Mondrian, *Woods near Oele*, 1908. Gemeentemuseum, The Hague. This key work marks a turning point in Mondrian's development. Broad, rapid brushstrokes build up a framework of long vertical axes for the trees, while the rising or setting sun (or it has been suggested it may even again be the moon) shining through them sparks off bright primary colours, reds, blues, and yellows, of a startling intensity. Mondrian's attempt to extract the essence of the scene here produces a starkly simple pattern anticipating his later abstract painting, with strong verticals and horizontals and bright primary colours. Mondrian's whole aim was to distil from the rich abundance of nature a pattern of stark simplicity that will evoke not a transient impression but elemental forces and mysteries.

he Sea a century earlier. In 1911 the influence of Cubism helped Mondrian to move into pure abstraction. But this was a perfectly logical development and certainly not 'the most complete turn about ever made by an artist' that one critic has oddly called it. It was not until 1917 that Mondrian joined two other Dutch artists, van Doesburg and Rietveld, to found the magazine De Stijl which has since given the group its name. All three shared the same Utopian idealism, a belief that their work was part of a new form of life in which individualism and chance would give way to mathematical perfection and abstraction, realizable in architecture that would change the environment. But these artists should certainly not be written off as agreeable manipulators of colour and line, producing work of purely visual and decorative significance. They were trying to represent what was for them the truth of universal harmony, and De Stijl was a very Dutch, puritan vision of a Utopia of absolute order.

In the 20th century the concept of art has been expanded to include all sorts of new media, from hanging mobiles to light projections. 'Landscape' can now be used to mean environmental and land art, which work directly with the countryside itself. In traditional paintings on canvas, one new development was the mental landscape as produced by so many of the Surrealists. In its exploration of the subconscious and the imagination, Surrealism was a reassertion of Romanticism. But though there was an element of strong inner emotion in Romantic landscape, it was combined with a close study of the world. The Surrealists, however, turned inwards to discover poetic dream images brought up from the depths of the mind, often with little relationship to anything in the external world. Even this was not a radical break with the past, but a logical extension of Böcklin's landscapes of mood, which influenced Giorgio de Chirico (1888–1978) in his so-called Metaphysical Painting. These silent, hallucinatory cityscapes, with dummies instead of people, devoid of movement and bathed in a mysterious light, gain an even more haunted quality of solitude from the meticulous realism with which they are painted. This sort of illusionistic, dream-like style also became important in the work of Magritte and Dali, and sometimes appears in Max Ernst's paintings. In contrast to such realistic or veristic landscapes, which depend on strange juxtapositions, or on imparting a haunting quality to apparently real scenes, are the semi-abstract images of Tanguy and Miró. The

Mondrian, *Dune Landscape*, 1911. Gemeentemuseum, The Hague.
Between 1908 and 1914 Mondrian made annual summer visits to the small seaside resort of Domburg, concentrating on many repetitions of the same few motifs: church, lighthouse tower, and dune. In his paintings of the sand dunes which have reclaimed the low flat land of Holland from the sea, Mondrian eliminates all traces not only of man but even of the plants which are so essential in binding the dunes together. Nature is reduced to a few primal elements of sea, sky and sand – a point of elemental economy which Caspar David Friedrich had already reached in his *Monk by the Sea*. But in the paintings which followed, such as the Pier and Ocean series, Mondrian moved through the use of horizontal and vertical lines to complete abstraction.

*Right* Max Ernst (1891–
1976), *Antipodean
Landscape*, 1936. Edward
James Foundation.
Max Ernst's landscapes of
the mind are more varied
than those of most of the
other Surrealists. For he
was very inventive in
developing techniques such
as *frottage*, rubbing a soft
pencil over paper placed
for instance on floorboards,
the resulting pattern
becoming the starting
point for his fantsy. This
strange landscape seems to
have begun by scraping
paint across the canvas and
developing the result as
mountain ranges. Even
without the monstrous
beasts and fruits it would
be a land of fantasy, and
these complete the feeling
of being 'antipodean', not
in the geographical sense,
but in upsetting expecta-
tions and altering the
perception of the world.

characteristic paintings of Yves Tanguy (1900–
55) look like desert, marine or lunar landscapes
in which strange, amorphous animistic shapes
suggest the first day of creation. They realize the
Surrealist ambition to create a spontaneous visual
imagery of the unconscious, having no other
source than the inner reality of emotions, longings
and dreams, though perhaps patterned after
far-off memories of childhood among the strange
dolmens and rocky coasts of Brittany.

But Max Ernst (1891–1976) was the most
inventive in creating highly original methods of
drawing in an attempt to put himself directly in
touch with his subconscious, declaring that
'The painter's role is to project that which is
within him.' But though his works are land-
scapes thrown up by the submerged part of the
mind, when he went to America he chose to live
in Arizona because he was enchanted to discover
a real landscape which actually looked like his
surreal fantasies. The various methods devel-
oped by Ernst were intended, like the 'automatic
writing' of the Surrealist poets, to revive spon-
taneity of expression. For as well as exploring

*Left* René Magritte (1898–1967), *The Domain of Arnheim*, 1962. Acquavella Galleries, New York.
Magritte's paintings break free from the rigid concepts of the mind which usually imprison man's beliefs. They are full of highly original visual puns which provoke surprise, and yet have a totally coherent logic of their own. For these strange encounters and juxtapositions to make their maximum impact, the artist had to use a completely realistic style. The association of eagles with mountains is a real one, yet here the eagle spreads its wings to become a mountain. And the bird-mountain image is further reinforced by the eggs perched on a ledge. Magritte made several different variations on this theme, using the same title, from a story by Edgar Allan Poe, whose fantastic tales were much admired by the Surrealists.

*Right* Yves Tanguy (1900–1955), *A Large Painting which is a Landscape*, 1927. Private collection, Japan.
Tanguy's desert, marine or lunar landscapes in which strange, amorphous objects or creatures proliferate in a boundless dream-space are among the finest realizations of the Surrealist ambition to create a spontaneous visual imagery of the unconscious. Already in this early painting Tanguy has discovered his characteristic style, creating an ambiguous plain which might be a desert, though the seaweed-like strands suggest a sea floor. This haunting mental landscape is scattered with organic shapes which are mostly little more than globules, suggesting a world in process of formation.

179

the world of the subconscious, Surrealism aimed at 'the transformation of everything into a miracle'. The poet and novelist Louis Aragon argued that this could best be achieved by imaginative description of the enchantment of real places and everyday things, thus releasing the quality of the marvellous that already exists in them. This idea is really a new version of Blake's 'To see a World in a grain of sand And a Heaven in a wild flower', and might be a good description of the aim and achievement of much of the landscape painting of the past. Aragon tried it himself, using words, in his book *Le Paysan de Paris* (*Paris Peasant*), in which he lets his transforming imagination meditate on favourite Surrealist haunts in Paris such as the cafés and seedy lodging houses round the Opera, or a night walk through the park of the Buttes Chaumont, with its Suicides' Bridge where jumping off had reached epidemic proportions. The overall theme is the continually renewed marvel of Paris itself.

Writing about art necessarily involves imposing oversimplified patterns of order on a confused reality. The story of modern art is usually told in terms of growing internationalization, with Paris as the capital of modern art and the cultural capital of the world. Yet because each different sort of scenery has been felt as a challenge by artists, landscape painting has continued to spread to new countries. In Canada, for instance, the Toronto-based Group of Seven tried in the 1920s to capture the distinctive qualities of their country's magnificent forests and lakes. The leader of the group, Tom Thomson, was actually drowned in a lake, in the midst of the landscape he loved. Landscape in Britain did not of course end with Constable and Turner, but continued as an essentially romantic native school. In the 20th century it was influenced by the successive avant-garde movements which arrived somewhat belatedly from Paris, so that it followed at a distance the innovations that produced modern art on the Continent.

Lucien Pissarro (1863–1944), the son of the Impressionist painter Camille Pissarro, settled in England and continued to paint in a sort of late Impressionist style influenced by Seurat, in which a concern for structure of design is combined with a pointillist technique. Many other British artists were influenced by an Impressionist preoccupation with light, from Walter Sickert to that flamboyant personality Augustus John (1878–1961), whose entire career was a restless search for his own version of the simple life and the earthly paradise. In his case, however, the result was often not so much simplicity as artificiality. John squandered most of his talent on portraits of the rich and famous, and especially of celebrities who were in some way 'larger than life', as he himself was. But John's biographer Michael Holroyd has rightly argued that 'he painted best when in the grip of some intense but fleeting mood – the intensity arising from its very transitoriness.' This is clearly seen in the small land-

scape studies he made in Dorset, Provence and Wales, in which the brilliant colours and drastically simplified forms produce richly sensual colour patterns which perfectly capture a sense of place, and of the artist's pleasure in it. John tried desperately to model his life after the myth-image of the romantic artist, and his self-conscious bohemianism led him to become a sort of pseudo-gypsy. But his close friend James Dickson Innes (1887–1914), who died from tuberculosis at the age of 27, really does embody the archetypal figure of the neglected, suffering artist, hungry for life yet doomed by disease to die young and only partially fulfilled, spending his last few years working himself feverishly to death, often buoyed up by drink. But at least Innes never had to face anything like the uncertainties or the steady progress into decline so evident in John's work. He quickly realized his true talent as a painter of small, brilliantly coloured, spontaneous landscapes in the Post-Impressionist manner, which convincingly reflect the mood of exaltation which the Welsh mountains induced in him.

Surrealism was the most powerful movement in British art in the 1930s, and this essentially romantic mode of vision combined easily with the tradition of British landscape. It gave an imaginative freedom to the early Welsh landscapes of Graham Sutherland (1903–1980), which he himself described as imaginative paraphrases of the landscape of Pembrokeshire: 'I felt I could express what I felt only by paraphrasing what I saw.' The core of his art became an attempt to express an essence which lies beyond sensible form, for instance in the surrealistic appreciation of the strangeness and metaphorical suggestiveness of natural forms. His landscapes reveal

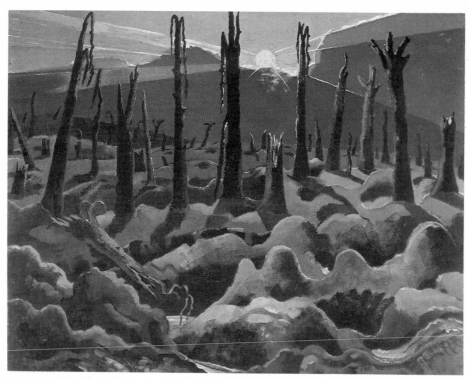

*Above* Paul Nash (1889–1946), *We Are Making a New World*, 1918. Imperial War Museum, London. Some of the most characteristic 20th-century landscapes have been those produced by the devastation of war, which Paul Nash caught marvellously in both World Wars. Here the sun rises upon a landscape of utter desolation, with the ground thrown into undulating ridges by shellfire, and the trees reduced to blackened skeletal stumps. Before becoming an Official War Artist Nash had fought in the front-line, and only the lucky accident of a broken rib had saved him from the annihilation which overwhelmed his battalion in the Ypres salient. But he found that he could best express the horrifying truth of war not through figures showing human suffering, but through what man had done to the landscape.

Sutherland's fascination with the way in which organic forms undergo disturbing and sinister transformations, taking on an uncanny presence which he also discovered in found objects: 'Their sap may have gone out of them but their form remains . . . I am fascinated by the whole problem of the tensions produced by the power of growth.' He was therefore well placed as an official war artist from 1941 to 1944 to capture the poignantly weird effects of destruction caused by bombing, which twisted iron and shattered masonry. He carried over this cruel and violent vision into his spiky nature studies, which reveal the emotional meaning he found in the tortured forms of thistles, the gnarled branches of a tree, the spikes of a thorn bush, the jumbled masses of fallen rocks. Sutherland's 'Thorn Trees' of the 1940s contain all kinds of ambiguities which make them seem charged with mysterious, enigmatic presences, as though ghostly semi-human forms or monsters are about to emerge from them, paralleling the identification of the human figure and landscape in the work of Henry Moore.

The terrible man-made landscapes created by 20th century wars have been recorded by many artists, but nowhere better than in the paintings of Paúl Nash (1889–1946), who was an official war artist in both World Wars. He shows how the trench warfare on the Western Front in 1914–18 ploughed up the ground into a sort of lunar landscape of utter desolation, with only the blackened, skeletal stumps of the trees to indicate that this had once been an area of natural growth. 'Sunset and sunrise are blasphemous,' he wrote, 'they are mockeries to man. Only the black rain out of the bruised and swollen clouds or through the bitter black of night is fit atmosphere in such a land.' Previously, war had all too often been portrayed heroically, though the 19th century Russian painter Vereshchagin had expressed his Tolstoyan pacificism in horrific paintings of the dying and dead strewn on the battlefields, their bodies eagerly devoured by vultures. But it was characteristic of Paul Nash that he used his powers of empathy to express the tragedy through the fate of the land rather than the sufferings of the men. For his special gift was the marvellous ability to convey the cruelty of human actions through the scars they left on the landscape. He realized this in an almost apocalyptic vision of a shattered landscape, so effectively that in the interval between the wars he found nothing that gave him a comparable exaltation, and described himself as 'a War Artist without a war'. Hitler soon remedied

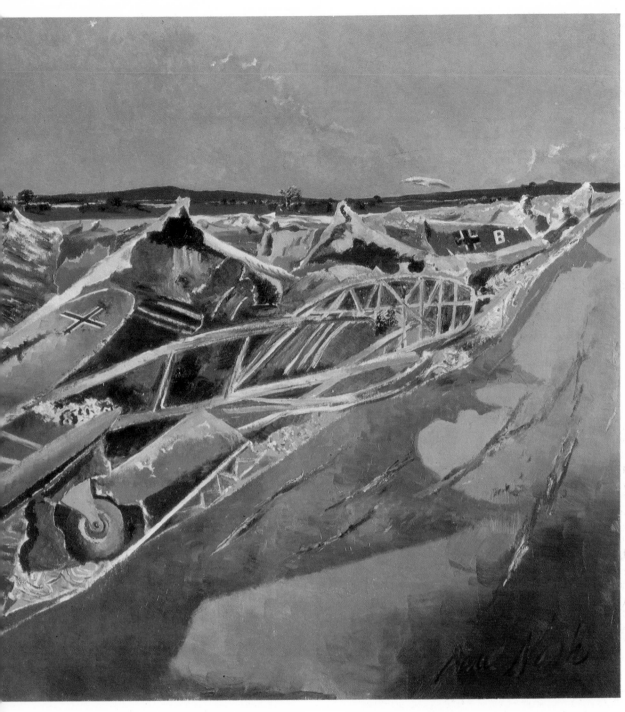

Nash, *Totes Meer*, 1940–41. Tate Gallery, London. If Paul Nash's First World War paintings are apocalyptic visions of shattered landscapes, those from the Second World War often have a surrealist quality – a sense of the strangeness of natural forms, of mystery and poetry even in these tortured landscapes. Here the German title 'Dead Sea' aptly sums up the effect of this eerie moonlit scene, though the sea lapping against the land is made up not of water but of wrecked German aircraft in a dump near Oxford. Hundreds of man-made flying creatures which invaded the country to spread destruction have themselves been destroyed. The form and the subject of wreckage have been seen as relating this painting to Caspar David Friedrich's *Polar Sea*, with its metamorphic qualities and its expression of the 'tragedy of landscape'.

that lack, and in the Second World War Nash turned his heightened perception to the war in the air, producing for instance a remarkable landscape in which a dump of wrecked German aircraft near Oxford is turned into a sea washing against the land, as he himself described it in a letter:

> The thing looked to me suddenly, like a great inundating Sea. You might feel – under certain influences – a moonlight night for instance – this is a vast tide moving across the fields, the breakers rearing up and crashing on the plain. And then, no: nothing moves, it is not water or even ice, it is something static and dead. It is metal piled up, wreckage. It is hundreds and hundreds of flying creatures which invaded these shores . . . By moonlight, this waning moon, one could swear they began to move and twist and turn as they did in the air. A sort of rigor-mortis? No they are quite dead and still. The only moving creature is the white owl flying low over the bodies of the other predatory creatures, raking the shadows for rats and voles.

The continuing appeal of landscape painting has been diagnosed by the African travel writer Laurens van der Post in his catalogue introductions to two exhibitions of works by Edward Seago (1910–74). Seago was an essentially traditional painter whose works sold quickly but tended to be dismissed by critics, if they were noticed at all, with disparaging phrases like 'a

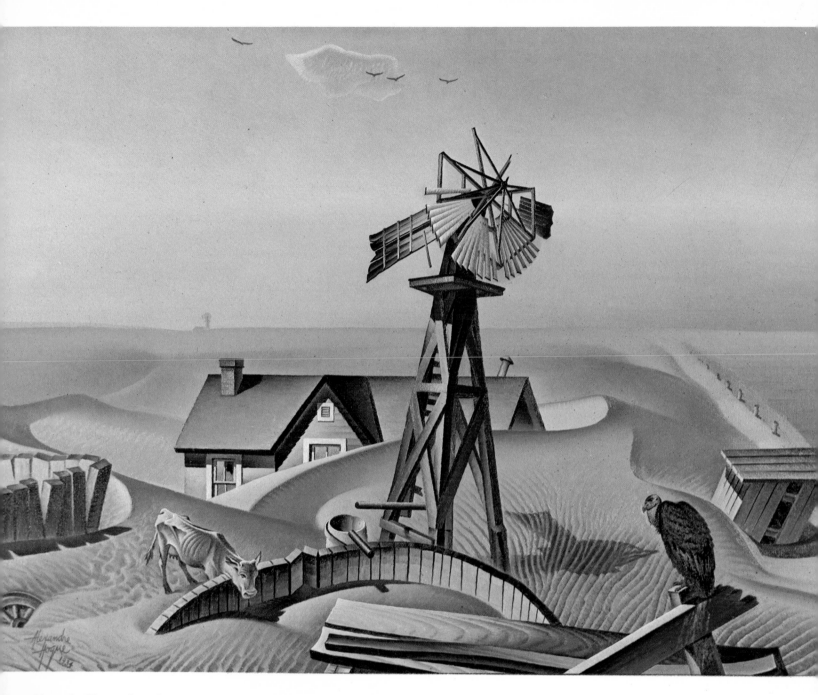

Alexander Hogue, *Drought Stricken Area*, 1934. Museum of Fine Arts, Dallas. Other characteristic 20th century landscapes are the man-made deserts and dustbowls which result from human greed and ecological incompetence. In the American midwest the ploughing up of the prairies destroyed the natural vegetation creating the dustbowls which caused such economic disaster in the Depression years of the 1930s. The American regionalist painter Hogue has eloquently depicted the resulting desolation and the plight of the farmers in this picture of a now arid farm.

typical snapshot quality'. Van der Post argues that the critics should at least have examined the reasons for such popularity:

His most significant work was a celebration of the beauty and wonder of the natural world from which modern man is so profoundly separated in the dark, satanic atmosphere of the cast-iron surround of his increasingly metropolitan life. Instinctively he feels himself impoverished, imperilled, strangely under-nourished and insecure in the midst of greater material abundance and security than he has ever known . . . Man in our desperate time is everywhere compelled more and more to live a life increasingly divorced from nature and all that is instinctive and natural . . . It is as if the ordinary man knows what many of the established critics of art, and the intelligentsia of the

world, have forgotten, namely that the key to the door out of this metropolitan prison that man has made for himself is a re-awakening, a renaissance in his senses of the importance of his natural self.

The fact of man's separation from nature, his rise or fall into consciousness (depending which way you look at it), is the root of all cultural evolution, including the development of science, art and the religious quest for meaning which self-awareness inevitably prompts. But man does not just paint landscapes: since his separation from nature he has been shaping the world around him to suit his requirements. And it is ironic that the rise of landscape painting has taken place just when the destruction and despoliation of the environment has reached unprecedented levels. The extermination of

hundreds of mammals and birds, the pro-liferation of deserts and urban wastelands, the increasing overexploitation of scarce resources such as oil and coal – all these are elements in a growing ecological crisis.

One response to this situation has been the rise of environmental art, which in a way is a contemporary development from landscape painting. This does not involve painting, but sculpting or altering the land itself, seeking to promote thought about the links between art and life, man and man, man and the environment, which provided the vital source of all the great art of the past. Richard Long, for instance, is clearly in the Romantic tradition, carrying on what has been described as 'a philosophical dialogue between the artist and the earth'. He walks through the landscape, interfering with it in some way and recording it in photographs and

maps, or bringing back some portable element such as a collection of driftwood which he arranges as a sculpture. Simon Wilson aptly calls him 'a romantic seeking to assert in the face of industial civilisation that man was once an integral part of the natural world and cuts himself off from it at his peril.'

Man-made landscapes and environmental art are of course hardly new, since they go back to the megalith builders of Stonehenge and the cutting of white horses and giants into the chalk hills of England. But these were created by societies for whom they had some common spiritual meaning, societies more in touch with the natural world than ours is. In his book *Arts of the Environment*, the painter and writer György Kepes sees one major factor in the crisis as being overspecialization and a failure of communication because of the fragmentation of experience and knowledge

Christo (b. 1935), *Wrapped Coast*, Little Bay, Australia. Environmental art modifies the actual landscape, rather than simply representing it in paintings. Packaging is characteristic of the 20th century consumer age, and the Bulgarian artist Christo sets out to explore how the environment changes when for instance a length of coastline is packaged. For him this is a temporary act of transformation, in which the original object is modified by the wrapping, which conceals or partly conceals it. This concealment does not destroy the object's identity, but draws attention to its basic forms.

into many self-contained disciplines. In his view the artist, in collaboration with the scientist and the engineer, has the task of stimulating us to a new awareness of our surroundings – 'man's only hope for survival under the threat of the new technology'.

Despite the great changes in European man's attitudes to nature over the last five centuries – changes reflected in the rise of landscape painting – the tendency of our age is still towards ever more ruthless exploitation by man, though there is a dimly growing awareness that the last word may yet be with nature. In *The Fitness of Man's Environment* (1968) Ian McHarg writes:

To all practical purposes, Western man remains obdurately pre-Copernican, believing that he bestrides the earth round which the sun, the galaxy, and the very cosmos revolve. This delusion has fueled our ignorance in time past and is directly responsible for the prodigal destruction of nature . . .

The debate on this ecological crisis has produced much discussion of its historical roots. In an influential and much-quoted paper the American historian Lynn White has claimed that the legacy of the Christian attitude to nature continues to influence western culture negatively. Though even within Christianity there has been an alternative tradition of man's stewardship and responsibility for nature, it is the Biblical directive to 'go and dominate over nature. which accounts for western man's

Hiroshige (1797–1888), *The Whirlpool of Awa*, 1857. Colour print. Honolulu Academy of Arts. The Far Eastern landscape tradition stems ultimately from the Taoist response to the creative energies of nature which shape the earth and are the basis of all life, and which have in the past been deified into gods such as Poseidon who the Greeks saw controlling the movements of the sea. Japanese artists show a marvellous ability to capture the energy of nature in their drawings of waves, and this whirlpool

blend of religion, science and philosophy produced by the rationalizers and systematizers of the Age of Reason. In their hands, as Dr Jacob Bronowski has pointed out,

> Newton's and other sciences were not tools for fresh discovery. They were used to close and enclose the world in another system as rigid as that of Aristotle, which the medieval church had put to the same use. It was an age of systematizers, who sought in science the assurance that the world could be tidied away inside the head of a rational Whig god.

In contrast to this complacent reductionism, the *real* Sir Isaac Newton displayed the humility which all the truly great scientists have possessed, summing up his own attitude to nature in a classic statement of its fundamental mystery:

> I do not know what I may appear to the world, but to myself I seem to have been only like a boy playing on the seashore, and diverting myself in now and then finding a smoother pebble or a prettier shell than ordinary, while the great ocean of undiscovered truth lay all undiscovered before me.

Science itself has come to be seen as a matter of imagination, just as art is. The only difference is that the imaginative leaps of an Einstein are promptly tested for their truth to nature. In our own century science has opened up to our imagination the astounding new worlds of the very small and the very large: the quantum world of the planetary atom and the relativistic world of vast galaxies hurtling away from one another at incredible speeds. The worlds of organic and inorganic nature which were set so radically apart by the science of the 17th century are slowly beginning to come together again. As Stephen Toulmin and June Goodfield argue in *The Architecture of Matter*,

> Today we can see, forming under our hands and eyes, this possibility of a reunified view of matter. And this is so just because our fundamental assumptions about matter have at last gone beyond both Aristotle's and Newton's . . . The chemical elements, as such, are neither organic nor inorganic . . . At every level of analysis, from protons and electrons up to living creatures, the objects which Nature is composed of have to be characterized in terms both of their structures and of their activities . . . Biological organization is not the same as life; but it is, clearly enough, the material pre-requisite for life. Only in a creature with the necessary organization are vital and mental activities possible and intelligible . . .

Out of the chaos of our present uncertainty a new and more complex view of nature is struggling to be born. But the universe revealed to us by the science of 1979 is far stranger and more mysterious than anything likely to have been predicted by an observer at the threshold of the 20th century. And it is unlikely that it can

is depicted as a seething cauldron of natural energy. Many of Hiroshige's landscape prints depict whirlpools, waterfalls, rain and snow – those natural forces which work to shape the beauty of our planet. His landscapes represent actual scenes and identifiable places. Yet his was a poetic vision which created lyrical masterpieces of sustained mood and masterly composition, revealing that special Japanese gift for showing the play of natural forces in sweeping curves and firm rhythmic lines.

long record of destructiveness. And White claims that it is the lack of feeling for the 'holiness in nature that accounts for its easy despoliation.

It was just such a numinous quality, a feeling of reverence before the ubiquitous creative energy of nature, that did characterize the landscape painting and nature poetry of the Romantic movement. Behind them lay a deep sense of the unity of nature, and of our own unity with nature – of life seen as an indivisible whole composed of man and nature. This organic view was opposed to the mechanistic view for which Blake blamed Newton: 'May God us keep, From Single vision and Newton's sleep!' But 'Newton's sleep' was not really Newton's, nor was the mechanistic universe scientific. It was a curious

be tidied away into neat little categories, as the systematizers of the Age of Reason tidied away the great new discoveries of Newtonian science. The nature poetry and the landscape painting of the Romantic period, which so decisively shaped the art that has since followed, were a protest against this on behalf of a more complex, organic view of nature. And so far from this being the sort of weird new-fangled religion that Kenneth Clark seems to suggest, the Romantics' attitude of reverence for nature and for life seems to me the only sane one for the open-minded scientist. Friedrich Schlegel's belief that the response to a scientifically explored world would still be that it is an intractable mystery has proved true with a vengeance. Each new fundamental scientific advance opens up more and more new questions, revealing a stranger and stranger universe. And so we can only regard it with awe, like the people gazing in spellbound contemplation at the natural world in Caspar David Friedrich's pictures.

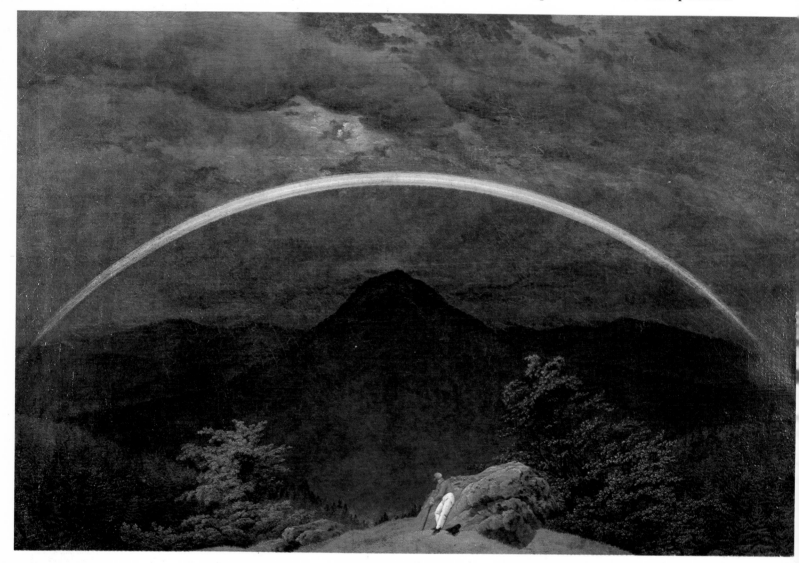

Caspar David Friedrich, *Mountain Landscape with Rainbow*, c.1810. Folkwang Museum, Essen. Despite all the changes in European attitudes to nature which are reflected in the simultaneous rise of science and of landscape painting, a new and more complex view of nature and man's relationship to it is still only struggling to be born. Twentieth-century science has revealed not only a vaster and more awesome universe, but the inescapable impasse that man is himself part of that universe he seeks to explore, or as the Danish physicist Niels Bohr put it, 'we are both spectators and actors in the great drama of existence'. Man is thus part of the mystery, and to understand nature, must understand himself. Einstein, whose great genius lay in his insight into the secrets of the universe, wrote: 'The most beautiful experience we can have is the mysterious. It is the fundamental emotion which stands at the cradle of true art and true science.' No artist has better expressed this feeling of man contemplating the ultimate mystery of the universe and of himself than Caspar David Friedrich.

# Bibliography

[B]ernt, Walter. *Die niederländischen Maler des 17 Jahrhunderts*. Munich, 3 vols, 1960. (Published as *The Netherlandish Painters of the Seventeenth Century*. Trs. P. S. Falla. London, Phaidon, 1970.)

[B]lunt, Anthony. *Nicholas Poussin*. London, Phaidon, 2 vols, 1967.

[B]orn, Wolfgang. *American Landscape Painting: an Interpretation*. New Haven, Connecticut, Yale University Press, 1970.

[B]ouret, Jean. *The Barbizon School and Nineteenth Century French Landscape*. London, Thames and Hudson, 1973.

[B]riganti, Giuliano. *Gaspar van Wittel e l'origine della veduta settecentesca*. Rome, Ugo Bozzi, 1966.

[B]riganti, Giuliano. *The View Painters of Europe*. Trs. Pamela Waley. London, Phaidon, 1970.

[C]ahill, James. *Chinese Painting*. Lausanne, Skira, 1960.

[C]apra, Fritjof. *The Tao of Physics*. London, Wildwood House, 1975.

[C]ardinal, Roger. *German Romantics in Context*. London, Studio Vista, 1975.

[C]arli, Enzo. *Sienese Painting*. Greenwich, Connecticut, New York Graphic Society, 1956.

[C]lark, Kenneth. *Landscape into Art*. London, John Murray, 1949.

[C]lark, Kenneth. *Civilisation: a Personal View*. London, BBC/John Murray, 1969.

[C]lark, Kenneth. *The Romantic Rebellion: Romantic Versus Classic Art*. London, John Murray/Sotheby, 1973.

[C]lifford, Derek. *Watercolours of the Norwich School*. London, Cory, Adams and Mackay, 1965.

[C]olvin, Brenda. *Land and Landscape*. London, John Murray, 1947, 1970.

[C]oomaraswamy, Ananda K. *The Transformation of Nature in Art: Theories of Art in Indian, Chinese and European Medieval Art*. Cambridge, Massachusetts, Harvard University Press, 1934; New York, Dover, 1956.

[C]rick, Francis. *Of Molecules and Men*. Seattle and London, University of Washington Press, 1966.

[F]lexner, James T. *That Wilder Image: the Painting of America's Native School from Thomas Cole to Winslow Homer*. Boston, Little, Brown, 1962, New York, Dover, 1970.

[F]lexner, James T. *The World of Winslow Homer*. New York, Time-Life, 1966.

[F]ranke, Robert G., and Franke, Dorothy N. *Man and the Changing Environment*. New York, Holt, Rinehart and Winston, 1975.

[F]reeman, Margaret B. *The Unicorn Tapestries*. New York, Metropolitan Museum of Art, 1976.

Friedländer, Max J. *Early Netherlandish Painting: from Van Eyck to Bruegel*. Trs. Marguerite Kay. London, Phaidon, 1956.

Fydorov-Davidov, A. *Isaak Levitan: zhizn i tvorchestvo*. Moscow, Iskusstvo, 1976.

Gaunt, William. *Bandits in a Landscape: a Study of Romantic Painting from Caravaggio to Delacroix*. London and New York, The Studio, 1937.

Gaunt, William. *Marine Painting*. London, Secker and Warburg, 1975.

Gombrich, Ernst H. *The Story of Art*. London, Phaidon, 1950; 13th edition 1978.

Gombrich, Ernst H. *Art and Illusion: a Study in the Psychology of Pictorial Representation*. London, Phaidon, 1959; 3rd edition 1967.

Gombrich, Ernst H. 'Visual Discovery through Art' in *Psychology and the Visual Arts*, ed. James Hogg. Harmondsworth, Penguin, 1969.

Gowing, Lawrence. *Turner: Imagination and Reality*. New York, Doubleday, for the Museum of Modern Art, New York, 1966.

Hall, Marie Boas. *Nature and Nature's Laws*. New York, Walker, 1970.

Hayes, John. *Gainsborough: Paintings and Drawings*. London, Phaidon, 1975.

Heisenberg, Werner. *Das Naturbild der heutigen Physik*. Hamburg, Rowohlt, 1955. (Published as *The Physicist's Conception of Nature*. Trs. Arnold J. Pomerans. London, Hutchinson, 1958.)

Heller, Erich. *The Artist's Journey into the Interior, and other essays*. New York, Random House, 1965; London, Secker and Warburg, 1966.

Holden, Donald. *Whistler Landscapes and Seascapes*. London, Barrie and Rockliff, 1969.

Hoopes, Donelson F. *Winslow Homer Watercolours*. London, Barrie and Rockliff, 1969.

Hussey, Christopher. *The Picturesque: Studies in a Point of View*. London, Frank Cass and Co., 1967 (first edition 1927).

Jeffares, Bo. *Landscape Painting*. London, Phaidon, 1979.

Jellicoe, Geoffrey and Susan. *The Landscape of Man: Shaping the Environment from Prehistory to the Present Day*. London, Thames and Hudson, 1975.

Kauffmann, C. M. *Victoria and Albert Museum: the Barbizon School*. London, Her Majesty's Stationery Office, 1965.

Kepes, György. *The New Landscape in Art and Science*. Chicago, Paul Theobald and Co., 1956.

Kepes, György (ed.). *Arts of the Environment*. Henley, Aidan Ellis, 1972.

Lee, Sherman E. *Chinese Landscape Painting*. Cleveland, Cleveland Museum of Art, 1954; New York, Harper and Row (Icon Editions), 1962.

Lee, Sherman E., and Wen Fong. *Streams and Mountains Without End*. Ascona, Artibus Asiae, 2nd revised edition, 1967.

Lockspeiser, Edward. *Music and Painting: a Study in Comparative Ideas from Turner to Schoenberg*. London, Cassell, 1973.

McCracken, Harold. *Portrait of the Old West*. New York, McGraw-Hill, 1952.

McHarg, Ian. *Design with Nature*. Garden City, New York, Natural History Press, 1969.

McLanathan, Richard. *The American Tradition in the Arts*. London, Studio Vista, 1968.

McLanathan, Richard. *Art in America: a Brief History*. London, Thames and Hudson, 1973.

Manwaring, Elizabeth Wheeler. *Italian Landscape in Eighteenth Century England: a Study Chiefly of the Influence of Claude Lorrain and Salvator Rosa on English Taste 1700–1800*. London, Frank Cass and Co., 1925, 1965.

Nash, J. M. *The Age of Rembrandt and Vermeer*. London, Phaidon, 1972.

Needham, Joseph. *The Grand Titration: Science and Society in East and West*. London, Allen and Unwin, 1969.

Needham, Joseph. *Within the Four Seas: the Dialogue of East and West*. London, George Allen and Unwin, 1969.

Newton, Eric. *The Romantic Rebellion*. London, Longmans, 1962.

Nicolson, Marjorie Hope. *Mountain Gloom and Mountain Glory: the development of the Aesthetics of the Infinite*. Ithaca, New York, Cornell University Press, 1959.

Novak, Barbara. *American Painting of the 19th Century: Realism, Idealism and the American Experience*. New York, Praeger, 1969; London, Pall Mall Press, 1969.

Parris, Leslie. *Landscape in Britain c.1750–1850*. London, The Tate Gallery, 1973.

Passmore, John. *Man's Responsibility for Nature: Ecological Problems and Western Tradition*. London, Duckworth, 1974.

Pearsall, Derek, and Salter, Elizabeth. *Landscapes and Seasons of the Medieval World*. London, Elek, 1973.

Prawer, Siegbert (ed.). *The Romantic Period in Germany*. London, Weidenfeld and Nicolson, 1970.

Read, Herbert. *The Meaning of Art*. London, Faber and Faber, 1931; Penguin, 1949.

Read, Herbert. *Icon and Idea: the Function of Art in the Development of Human Consciousness*. London, Faber, 1955.

Rees, Ronald. 'The Taste for Mountain Scenery' in *History Today*, Vol XXV: 5, May 1975, pp. 305–42.

Rewald, John. *The History of Impressionism*. New York, Museum of Modern Art, 1946; 4th revised edition, 1973; London, Secker and Warburg, 1973.

Rewald, John. *Post-Impressionism: from Van Gogh to Gauguin*. New York, Museum of Modern Art, 1956; revised edition, 1978; London, Secker and Warburg, 1978.

Reynolds, Graham. *Turner*. London, Thames and Hudson, 1969.

Rosenblum, Robert. *Modern Painting and the Northern Romantic Tradition: Friedrich to Rothko*. London, Thames and Hudson, 1975.

Röthlisberger, Marcel. *Claude Lorrain: the Paintings*. New Haven, Yale University Press, 2 vols, 1961.

Salerno, Luigi. *L'opera completa di Salvator Rosa*. Milano, Rizzoli, 1975.

Salerno, Luigi. *Pittori di paesaggio del Seicento a Roma; Landscape Painters of the Seventeenth Century in Rome*. Bilingual, Italian and English. Rome, Ugo Bozzi, 2 vols, 1978.

Santini, Pier Carlo. *Il paesaggio nella pittura contemporanea*. Venice, Electa Editrice, 1971. (Published as *Modern Landscape Painting*. Trs. P. S. Falla. London, Phaidon, 1972.)

Schrödinger, Erwin. *What is Life? The Physical Aspect of the Living Cell*. Cambridge, Cambridge University Press, 1944.

Schrödinger, Erwin. *Nature and the Greeks*. Cambridge, Cambridge University Press, 1954.

Schrödinger, Erwin. *My View of the World*. Cambridge, Cambridge University Press, 1960.

Shepard, Paul. *Man in the Landscape: a Historic View of the Esthetics of Nature*. New York, Alfred Knopf, 1967.

Southwick, Charles H. *Ecology and the Quality of Our Environment*. New York, Van Nostrand, 1972.

Stechow, Wolfgang. *Dutch Landscape Painting of the 17th Century*. London, Phaidon, 1966.

Sullivan, Michael. *The Birth of Landscape Painting in China*. London, Routledge and Kegan Paul, 1962.

Sze, Mai-mai. *The Tao of Painting*. London, Routledge and Kegan Paul, 2 vols, 1957.

Toulmin, Stephen, and Goodfield, June. *The Architecture of Matter*. London, Hutchinson, 1962.

Trueman, Arthur E. *Geology and Scenery in England and Wales*. Harmondsworth, Penguin, 1937; 2nd edition, 1946.

Turner, A. Richard. *The Vision of Landscape in Renaissance Italy*. Princeton, New Jersey, Princeton University Press, 1966.

Urban, Martin. *Emil Nolde – Landscapes, Watercolours and Drawings*. London, The Pall Mall Press, 1970.

Waddington, C. H. *The Nature of Life*. London, George Allen and Unwin, 1961.

Waddington, C. H. *Behind Appearance: a Study of the Relations between Painting and the Natural Sciences in This Century*. Edinburgh, Edinburgh University Press, 1970.

Waley, Arthur. *An Introduction to the Study of Chinese Painting*. London, Ernest Benn, 1923.

Waley, Arthur. *The Secret History of the Mongols, and other pieces*. London, George Allen and Unwin, 1963.

Weizsäcker, C. F. von. *Die Geschichte der Natur*. Leipzig, S. Hirzel Verlag, 3rd edition, 1945. (Published as *The History of Nature*. Trs. F. D. Wieck. London, Routledge and Kegan Paul, 1951.

Weizsäcker, C. F. von. *Zum Weltbild der Physik*. Leipzig and Zurich, S. Hirzel Verlag, 4th enlarged edition, 1949. (Published as *The World View of Physics*. Trs. Marjorie Grene. London, Routledge and Kegan Paul, 1952.)

White, Lynn. 'The Historical Roots of Our Ecological Crisis' in *Science*, 155: 1203–1207, 1967.

Whitehead, Alfred North. *Science and the Modern World*. Cambridge, Cambridge University Press, 1926.

Whitrow, G. J. *Einstein: the Man and his Achievement*. London, BBC, 1967.

Wiedmann, August. *Romantic Roots in Modern Art*. London, Gresham Books, 1979.

Woodall, Mary. *Gainsborough's Landscape Drawings*. London, Faber and Faber, 1939.

## CATALOGUES

*The Art of Claude Lorrain*. London, Arts Council, 1969.

*Caspar David Friedrich 1774–1840: Romantic Landscape Painting in Dresden*. Catalogue by W. Vaughan, Catalogue by W. Vaughan, H. Börsch-Supan and H. J. Neidhardt. London, Tate Gallery, 1972.

*Constable: the Art of Nature*. London, Tate Gallery, 1971.

*Constable: Paintings, Watercolours and Drawings*. London, Tate Gallery, 1976.

*Edward Seago: Paintings and Watercolours*. London, Marlborough Fine Art, 1972.

*Edward Seago 1910–1974: Memorial Exhibition*. London, Marlborough Fine Art, 1974.

*France in the Eighteenth Century*. London, Royal Academy, 1968.

*French Landscape Drawings and Sketches*. London, British Museum, 1977.

*Gauguin and the Pont-Aven Group*. London, Tate Gallery, 1966.

*The Impressionists in London*. London, Arts Council, 1973.

*Jan Van Goyen: Poet of the Dutch Landscape*. London, Alan Jacobs Gallery, 1977.

*Landscape in French Art 1550–1900*. London, Arts Council, 1949.

*Landscape Masterpieces from Soviet Museums*. London, Royal Academy, 1975.

*The Origins of Landscape Painting in England: Catalogue of Summer Exhibition at Iveagh Bequest, Kenwood*. London, Greater London Council, 1967.

*The Romantic Movement*. London, Arts Council, 1959.

*Salvator Rosa*. London, Arts Council, 1973.

*Shock of Recognition: the Landscape of English Romanticism and the Dutch seventeenth-century school*. London, Arts Council, 1971.

*Sung and Yüan Paintings*. New York, Metropolitan Museum of Art, 1973.

*Turner 1775–1851*. London, Tate Gallery, 1974.

*Turner in the British Museum: Drawings and Watercolours*. London, British Museum, 1975.

## Acknowledgements

The publishers would like to thank the following individuals and organisations for their kind permission to reproduce the photographs in this book.
Acquavella Galleries, New York (Cooper Colour Library) 178 above; Addison Gallery of American Art, Phillips Academy, Andover, Massachusetts 144–145; Alnwick Castle 78 above; Alte Pinakothek (Kunst-Dias Blauel) 35 left, 43; Art Institute of Chicago 93, 138 above. Ashmolean Museum, Oxford 32, 48, 132; Baltimore Museum of Art 156–157; Beit Collection, Ireland (Cooper Bridgeman Library) 64–65; Bowes Museum, Barnard Castle, Co. Durham 119; British Museum 33 above, 45 below, (Cooper-Bridgeman Library) 11 above; Castello Sforzesco, Milan (Scala) 79; The Clark Estates 138 above; Cleveland Museum of Art (Gift of Hanna Fund) 170 above left; City of Manchester Art Galleries 180 (Cooper-Bridgeman Library) 181; Colmar Museum (Snark) 34 above; Courtesy of Cooper-Hewitt Museum, The Smithsonian Institution's National Museum of Design 144 below left; Dallas Museum of Fine Arts, Dallas Art Association purchase 184; Detroit Institute of Arts (Gift of Julius H. Haass in memory of his brother, Dr. Ernest W. Haass) 60 above; Derby Art Gallery 89; Edward James Foundation (Cooper Colour Library) 178 below; Fitzwilliam Museum 129 below; Folkwang Museum, Essen (Regine Zweig) 188; The Frick Collection, New York 56 below; Galleria Pitti, Florence (Scala) 51, 52; Gallerie dell'Accademia, Venice (Scala) 37; Galerie du Jeu de Paume (Snark) 131 above; Gemeentemuseum, The Hague 174–175, 176, 177; Glasgow Art Gallery 125 below; Photo Harry Shunk 185; Reproduced by Gracious Permission of Her Majesty Queen Elizabeth II 35 right, 36 above; Hermitage, Leningrad (Cooper-Bridgeman Library) 171 below right; Hessisches Landesmuseum, Darmstadt 28–29; Honolulu Academy of Arts, The James A Michener Collection 186–187; Imperial War Museum 182 above left; India Office Library 20; John Hay Whitney Collection, New York (Cooper-Bridgeman Library) 172–173; Kunsthalle, Hamburg (Ralph Kleinkempel) 106, 108–109, 121 above; Kunsthistorisches Museum, Vienna (Photo Meyer) 33 below, 84–85, 113; Kunstmuseum Basel (Colorphoto Hans Hinz) 10 left; Kunstmuseum, Berne 109, 115; Leeds City Art Galleries (Temple Newsam House) 76 above left; Louvre, Paris (Snark) 69 below right, 72, 74 left, 118 below, 122–123, 124, 125 above, 126–127, 127 right, 129 above; Metropolitan Museum of Art (The Cloisters Collection, Gift of John D. Rockefeller, Jr., 1937) 23, (Gift of Darius Ogden Mills and Gift of Mrs. Robert Young, by exchange, 1973) 58, (Gift of the Dillon Fund 1973) 14, 16–17 above, 17 above right and below, (Gift of George A. Hearn) 146, 147 above, (Bequest of Mrs. H. O. Havemeyer, 1929 The H. O. Havemeyer Collection) 59 below, (The Lillie P. Bliss Collection) 161, 163 above, (Gift of J. Pierpont Morgan, by exchange, 1973) 15 below, (Reisinger Fund, 1926) 110, (Rogers Fund, 1907) 142–143, (Gift of Mrs. Russell Sage, 1908) 142 above left, (Gift of Samuel Avery, Jr., 1904) 142 below left, (Bequest of Theodore M. Davis, by exchange, 1973) 16 below; Minneapolis Institute of Arts (The William Hood Dunwoody Fund) 158, 163 below, (The Julius C. Eliel Memorial Fund) 168–169; Musée d'Art et d'Histoire, Geneva 26, 111 above and below; Musée du Petit Palais (Snark) 73; Musée Fabre, Montpellier (Snark) 120; Musée National, Compiegne (Snark) 68; Musée Saint-Denis, Reims (A. C. Cooper) 116–117; Museo Civico, Verona (Scala) 78 below; Museo del Prado 24–25; Museum of Art, Carnegie Institute, Pittsburgh, Pennsylvania 130; Museum of Art, Rhode Island School of Design (Gift of Mrs. Murray S. Danforthy) 128, (Jesse Metcalf Fund) 134–135, 140 left; Museum of Fine Arts, Boston (Gift of William Sturgis Bigelow) 139, (M. and M. Karolik Collection) 140–141; Museum of Fine Arts Budapest (Corvina Archives, Budapest) 30–31; Museum voor Schone Kunsten, Ghent 27; Museo Nazionale, Naples (Scala) 19; N.Y. Carlsberg Glyptotek 166; National Gallery, london 10–11, 22 below, 28, 34 below, 38–39, 42, 45 above, 46, 47 above, 49, 50, 57 above, 62–63, 71, 96–97, 133, (A. C. Cooper) 4–5, 47 below, 62 left, (Cooper-Bridgeman Library) 40–41; national Gallery of Art, Washington (Chester Dale Collection) 121 below; National Gallery of Canada, Ottawa 131 below; National Gallery of Scotland 80–81, 82 above; National Gallery, Prague 112; National Museum of Wales (Cooper-Bridgeman Library) 82 below; Nationalmuseum,, Stockholm 60 below, 174 left; National Museum Vincent Van Gogh, Amsterdam 3, 162, 164–165; Neue Pinakothek (Kunst-Dias Blauel) 102–103; Collection of the New York Public Library. Astor, Lenox and Tilden Foundations 141 right; Niedersächsisches Landesmuseum Hannover 21; Norfolk Museums Service (Norwich Castle Museum) 83 below; Österreichische Galerie, Vienna (Fotostudio Otto) 12; P. Levy Collection, Troyes (Cooper-Bridgeman Library) 170–171; The Phillips Collection, Washington D.C. 147 below; Pinacoteca Nazionale, Siena (Scala) 22 above; Private Collection 179, (A. C. Cooper) 168 above left, (Cooper-Bridgeman Library) 83 above, 160, (Hamlyn Group Picture Library) 118 above, (Colorphoto Hans Hinz) 158–159; Reynolda House, Inc. (Cooper-Bridgeman Library) 144 above left; Rijksmuseum, Amsterdam 54–55, 56, 57 below, 61, 66–67; The Royal Pavilion, Art Gallery and Museums, Brighton 69 below left; Science Museum 90 below; Courtesy of the Smithsonian Institute, Freer Gallery of Art, Washington D.C. 15 above; Soloman R. Guggenheim Museum 6–7; Staatliche Museen Preussischer Kulturbesitz, West Berlin 76–77, 107; Städtische Galerie im Lenbachhaus, Munich 152–153, 154–155, 155 below; Tate Gallery 8–9, 83 below, 67 left, 90 above, 91 above, 92, 94–95, 95, 137, 182–183; Tretyakov Gallery, Moscow (B. Mezentsev) 148–149, 150, 151; Tyne and Wear County Council Museums, Laing Art Gallery 167; Victoria and Albert Museum, Crown Copyright 87 right, 96 above left, 98, 100–101, 114–115 (Cooper-Bridgeman Library) 12–13, 91 below; Verwaltung der Staatlicken Schlösser und Gärten, West Berlin 104–105; Wadsworth Atheneum, Hartford, Connecticut 136; Walker Art Gallery, Liverpool 53, 88; Wallace Collection (John Freeman Group) 59 above, 70, 74–75; Worcester Art Museum, Massachusetts 86.
© A.D.A.G.P. Paris, 1980 6–7, 152–153 154–155, 170–171, 172–173, 174 left, 178 above.
© COSMO PRESS, Geneve and A.D.A.G.P. Paris, 1980 115.
© S.P.A.D.E.M. Paris, 1980 128, 129, 131, 133, 168 above left, 171 below right, 174 left, 174–175, 176, 177.